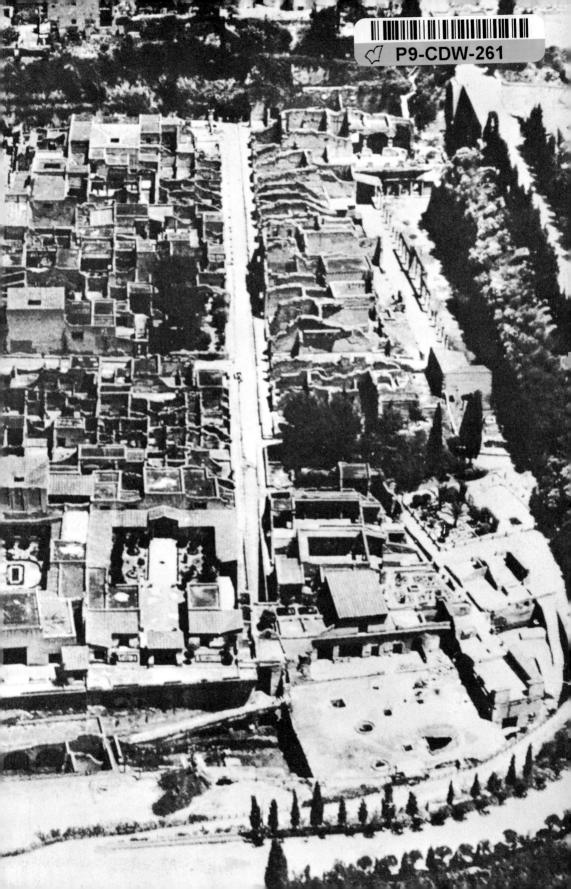

HERCULANEUM

A CITY RETURNS TO THE SUN

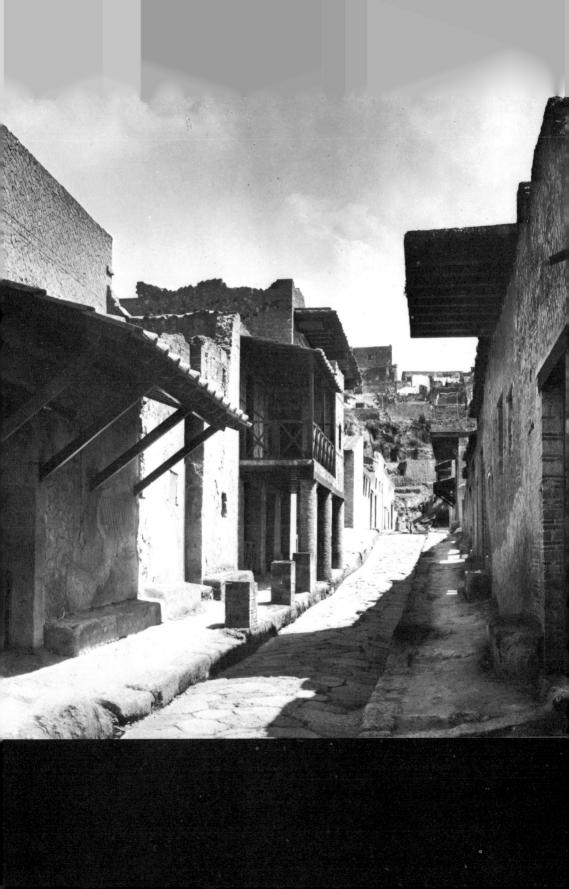

COLGATE UNIVERSITY LIBRARY

HERCULANEUM

A CITY RETURNS TO THE SUN

≈ JOSEPH JAY DEISS ≫

(gl.) 1966 \$7.50 T.Y. Growell.

SOUVENIR PRESS

LONDON

The translation of Philodemus by F. A. Wright is used by permission of Routledge & Kegan Paul, Ltd., London; the translation of Petronius by William Arrowsmith is used by permission of the University of Michigan Press; the extract from *Apicius—The Roman Cookery Book* is by permission of George G. Harrap & Co. Ltd., London.

PHOTOGRAPH CREDITS

Pages ii, 16, 74, 77, 96, 141; 146, 147: Mansell-Alinari. Pages 32, 50, 51, 55, 57 (left-hand picture), 145: Vincenzo Carcavallo, Naples. Page 165: Fotocielo, Rome. Pages xviii, 59, 66, 115: Fototeca Unione, Rome. All other photographs are reproduced by permission of the Superintendent of Antiquities for Campania, Naples.

Copyright © 1966 by Joseph Jay Deiss All rights reserved. First published in U.S.A. by Thomas Y. Crowell Co., New York.

First published in Gt. Britain 1968 by Souvenir Press Ltd., 95 Mortimer Street, London, W.1. No part may be reproduced in any form without permission in writing from the publisher except by a reviewer who wishes to quote brief passages for the purposes of a

> review. Designed by Laurel Wagner SBN 285.50056.2

Made and printed by offset in Great Britain by William Clowes and Sons, Limited, London and Beccles

TO THE PRESENT EXCAVATORS OF THE PAST, WHO SEEK TO UNDERSTAND THE FUTURE

FOREWORD

Herculaneum is probably archaeology's most flagrant unfinished business. It is unfinished not only in the sense that it has not been fully unearthed, but because comprehension has not yet filled it with a re-created reality of life. It is flagrant, because the scenery and props have been made so nearly complete by Vesuvius and the skill of archaeologists. Perhaps the trained and circumspect imagination is overwhelmed by the evident material richness of everyday life. Perhaps the minuteness of the gaps in the picture counsels waiting to see them filled, while waiting blunts the picture's sharp immediacy. Perhaps, meantime, what is wanted is the uncompromised vision and fresh passion of this book.

To evoke a population from its surroundings would seem to demand a discipline of self-abnegation greater than that which is asked of a biographer, always in some degree held in check by his written documentation. It would seem to require a sort of fond familiarity with *things*, less akin to that of an antiquarian treatise than to that of the documentary film fashioned from objects. Here, too, the transmission of re-created life must depend on the confrontation of the audience with objects—Herculaneum itself, or its image in word and picture. Only so is the author's vision to be shared in its fullness and in its haunting incompleteness, the incompleteness that the archaeologist must one day make good.

> FRANK E. BROWN, Director The American Academy in Rome

AUTHOR'S NOTE

This book, though drawing freely on other books, is based mainly on what is perceptible to the eyes and to the emotions at Herculaneum. It is therefore a firsthand account of a slowly emerging Roman town after nineteen centuries in the grave.

So familiar have the streets and houses become, so intimate the details of daily life in Herculaneum, that it seems almost like my own home town. Even Vesuvius has become a normal part of the landscape, and it is difficult to believe that so quiet a mountain could explode and bury so pleasant a site under cascades of volcanic mud. As each structure reappears in the sunlight, I never cease to feel amazed that a town wholly lost can be found again. And I am deeply grateful to the generations of dedicated scholars and workers who have made it possible for men of the atomic age to walk the streets, browse in the shops, rest in the gardens of antiquity.

I am also grateful to the present group of Italian archaeologists who have made it possible for me personally to develop such familiarity with so unique and important an historic phenomenon. They have opened every door, answered every question, offered every aid within their power. Without them this book would have lost much detail, much immediacy of impact—for they are not strangers to the past but in its fellowship.

So I wish to nominate particularly for my thanks: Dr. Alfonso de Franciscis, the recently appointed Superintendent of Antiquities for Campania, one of the world's richest archaeological zones, who cleared my way; Dr. Giuseppe Maggi, new curator of the National Archaeological Museum in Naples, who placed the Museum at my disposal; the late Dr. Oscar Onorato, who touched me with some of his fire; and Dr. Giuseppina Cerulli Irelli, newly in charge of excavations at the Herculaneum site, who was very patient with my innumer-

AUTHOR'S NOTE

able demands. I want to thank, too, the Chief of Services, Signor Luigi Fusco, who over the years has come to know every nook and cranny of the town of Hercules, and who more than once took me in tow as a privileged tourist.

And finally deserving of mention in the Italian group are the custodians, who were unfailingly polite and helpful—even on the hottest days, after closing hours, and especially on the harrowing occasion when all the lights shorted out in the damp Theater tunnels ninety feet below the surface.

Special thanks of course are due to Dr. Frank E. Brown, archaeologist and Director of the American Academy in Rome, who was willing not only to read my book in typescript, but to write a foreword. I hasten to add that he holds no responsibility for any error or opinion.

From my experiences at Herculaneum, I have again been impressed with the truth of American archaeologist Paul MacKendrick's statement: "To come to know a fragment of our past is to recognize a piece of ourselves."

It is my hope that through this book many moderns will come to recognize and appreciate new pieces of themselves.

CONTENTS

Ι	LIFE OF A ROMAN TOWN	1
ΙI	ORIGINS AND LEGENDS	5
III	DEATH OF A ROMAN TOWN	10
ΙV	THE LONG SLEEP, AND RESURRECTION	20
V	TREASURE REVEALED—THE GREAT DIG	29
VI	HOUSES OF THE RICH PATRICIANS	37
VII	ROMAN LUXURY—THE "VILLA OF THE PAPYRI"	47
VIII	HOUSES OF THE "POOR" PATRICIANS	58
ΙX	STORY OF A ROMAN LAWSUIT	71
Х	HOUSES OF THE MIDDLE CLASS	80
ХI	THE PLEBES—HOUSES AND SHOPS	94
XII	THE BATHS—EVERYBODY'S CLUBS	110
XIII	SPORTS—THE PALAESTRA	123

xi

С	0	N	Т	Ε	N	Т	S
---	---	---	---	---	---	---	---

XIV	CURTAIN TIME—THE THEATER	129
XV	THE BASILICA—A ROMAN COURTHOUSE	138
XVI	MAIN STREET AND THE FORUM AREA	149
XVII	ANTIQUITY'S TREASURE TROVES	156
	BIBLIOGRAPHY	167
	INDEX	170

ILLUSTRATIONS

Frontispiece	ii
Patrician houses lining walled embankment	xviii
Excavated portion of Herculaneum	6
Garden of the House of the Mosaic Atrium	14
Atrium of the House of the Mosaic Atrium	16
Floor plan of the House of the Mosaic Atrium	17
Direct view of the House of the Stags	25
Cupids playing hide-and-seek, painting for House of the Stags	27
"Sleeping Eros" sculpture from the House of the Stags	28
"Drunken Hercules" statue from the House of the Stags	32
Marble "Satyr with Wineskin" from the House of the Stags	32
Cooking pots on charcoal stove from House of the Stags	35
Atrium of the House of the Relief of Telephus	38
Marble bas-relief from the House of the Relief of Telephus	42
Incomplete plan of the Villa of the Papyri	48
"Resting Hermes" sculpture from the Villa of the Papyri	50
"Sleeping Faun" statue from the Villa of the Papyri	50
"Boy Wrestlers," statues from the Papyri garden	51
Bronze charcoal brazier from the Villa of the Papyri	55
Bronze deer from the Papyri garden	55

ILLUSTRATIONS

Bronze busts from the Papyri villa	57
Adjoining patrician and plebian houses	59
Windlass and original rope from the plebian House of Opus Craticium	60
Atrium of the Samnite House	63
Christian chapel in the House of the Bicentenary	65
Peristyle of the House of the Bicentenary	66
Wooden shrine for Roman household gods	67
Wooden bed, restored, with chamber pots	72
Love-making fresco of satyr and nymph	73
Divan from the House of the Carbonized Furniture	74
Dining-room picture of rooster and grapes	75
Jars and glassware	76
Bronze oil lamps from Pompeii and Herculaneum	77
Fresco scene of matron supervising toilet of daughters	78
Jewelry from Pompeii and Herculaneum	82
Silver discs used on backs of mirrors	83
Bronze colander and silver spoons	86
Silver plates and cups	87
Folding stool with bronze legs	87
Bronze handles for doors and chest drawers	88
Medical instruments uncovered in Herculaneum and Pompeii	89
Snack bar with wall painting	96
Walnuts found on counter top	97
Bakeshop of Sextus Patulcus Felix	98
Shop of the gem-cutter, with inlaid bed	100
Tinker's shop, with statuette and lamp stand	101
Fish net and repairing instruments	102

ILLUSTRATIONS

Cloth press from cleaner's shop	103
Shop from the House of Neptune and Amphitrite	105
Mosaic of Neptune and Amphitrite	107
Ground plan of the Forum Baths	112
Men's waiting room of the Forum Baths	113
Bronze water valve and pipe	114
Tubular bricks stacked in the Suburban Baths	115
Vestibule of the Suburban Baths	116
Stucco warrior from waiting room in Suburban Baths	121
Grand Hall of the Palaestra	124
Bronze serpent with five heads	125
Convivial scene fresco from the Palaestra	126
Painting of the "Actor-King"	131
Heroic bronze statue of the Emperor Claudius	132
Bas-relief of Bacchic procession	135
Bronze portrait of Marcus Calatorius	141
Fresco of Chiron instructing youth Achilles	142
Fresco of Hercules and son Telephus	142
Bronze horse from entrance to Basilica	145
Marble equestrian statue of Marcus Nonius Balbus Junior	146
Equestrian statue honoring Proconsul Marcus Nonius Balbus	147
Portrait statue of Proconsul Balbus' mother, Viciria	151
Close-ups of statues of Balbus and son	152
Statues of Aphrodite from Pompeii and Herculaneum	159
Shrine of the Augustales	160
The Forum	163
Air view of Herculaneum	165

"The great aim of archaeology is to restore the warmth and truth of life to dead objects."

—Philippe Diolé 4,000 Years Under the Sea

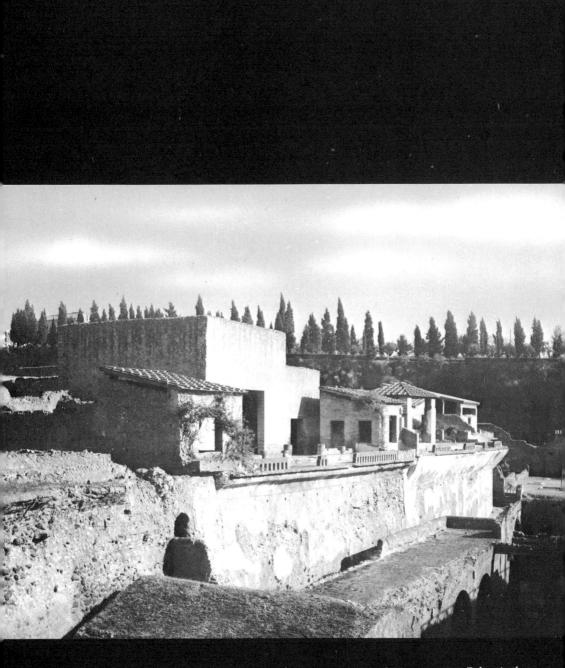

Patrician houses lining the walled embankment over the Herculaneum marina. Below is the roof of structures of the sacred area, also overlooking the marina. To the left is the summer dining room of the House of the Mosaic Atrium; to the right, the pergola of the House of the Stags.

Ι

LIFE OF A ROMAN TOWN

AT SUNRISE ON AUGUST 24, A.D. 79, NO ONE IN THE LITTLE TOWN OF HERCULES COULD have guessed that the hot luminous morning would be stillborn. The Bay of Naples was blue and glassy calm. The mountain called Vesuvius was green with olive groves and vineyards. No clouds obscured the sky.

The citizens, this day as every day in Herculaneum, arose at dawn and leisurely went about their accustomed affairs. Birds sang in cages. Lizards basked in the torrid sun. Cicadas rasped unceasingly in the cypress trees. The ninth day before the Calends of September, according to the Roman calendar, seemed destined to be essentially no different from any other of that untroubled summer.

It was true that for some days mild earth tremors had been felt in the region of the Bay of Naples. The town of Pompeii, situated ten miles away on another flank of Vesuvius, had felt the shocks; and the great city of Neapolis, farthest from the mountain, had felt them, too. But in this zone they were not at all unusual. The movement of the earth was so slight, in comparison with the disastrous earthquake of seventeen years earlier, that the tremors seemed of little or no significance. Also, wells in the countryside suddenly had dried up; but nothing was rare about dry wells in August—a baking month of parched landscape, dusty roads, no rain...

In the sculpture-filled courtyards and gardens of Herculaneum, bronze, marble, and mosaic fountains played and tinkled as usual amid palms and blooming oleanders. At street corners, public fountains flowed in a never-ceasing stream, and women of the poor fetched water in jugs carried on their heads or their shoulders. The fountains, the swimming pools, the new public baths, the public latrines, the well-to-do private houses, all had water aplenty. One fruit of the Roman administration had been an aqueduct from the mountains; another, a large efficient sewer. August was hot, but in Herculaneum—cooled and shaded and on a promontory overlooking the sea—the month was far from unbearable.

The town, beloved and protected by the hero-god Hercules, was in one of its gayest moods. The festival celebrating the official birthday of the long-dead Emperor Augustus had been in progress for some days. As was customary during festivals, athletic events in the Greek fashion were being held at the Palaestra. At the Theater a cycle of Greek and Roman plays, given in the afternoon, drew the crowds. (Mornings were reserved for rehearsals.) The Basilica was empty because the law courts were closed for the holidays; but the Forum was jammed with people—summer vacationers and peasants come to town to see the sights. Ladies passed in litters borne by slaves, or if on foot, were protected from the sun by green parasols carried by their maids. Outside every major gate to the town were lines of hawkers and vendors selling melons and early grapes, coral charms for potency, cheap glass trinkets, sulphur matches, sandals and shoes, votive images, straw hats, and scores of other items. There also were jugglers and acrobats, fortune-tellers, street musicians, and pimps.

In late morning the heat mounted. At the bakeshop of Sextus Patulcus Felix, the baker and his helpers prepared to take from the oven the bronze pans containing cakes and tarts. That the cakes would not fall was assured by the protective phallic emblem over the oven. Not far away, at another bakery where bread alone was the specialty, two tiny asses wearing blinders walked in an endless circle turning a stone mill to grind flour. Like all their kind, they flicked their tails and ears against the flies, and brayed occasionally in patient protest against their harness.

The men's section of the Public Baths, near the center of town, had opened. Attendants had assisted the earliest comers to undress and had carefully folded the clothing. Men were raking the cinders with a large iron poker while firing the boiler. At the Suburban Baths near the marina, a group of naked young bloods laughed over the latest amatory drawings on a white plaster wall. And all over town, boys called Marcus and Rufus and Sabinus and Manius and Florus and Julius were scribbling their names on walls; one was called David.

At the tinker's shop on the edge of the Forum, a bronze candelabrum and a small statue of the wine god Dionysus had been brought for repair. The tinker set them temporarily not far from some metal ingots by the forge. Also near the Forum, overlooking a triumphal arch decorated with bronze equestrian statues, was the Collegium or shrine of the priests responsible for the cult of the deified Emperor Augustus and his successors. Within, a small room had been partitioned off and its window barred; here, closed in, a despairing man flung himself upon the bed.

Along the streets all the snack bars had opened, vending bread, cheese, wine, nuts, dates, figs, and hot foods. At the bar with the sign of Priapus—the god had been painted on the wall with an erect phallus half as large as himself—a jar near the marble counter had been freshly filled with walnuts in anticipation of the holiday demand. Other shops, selling grains and vegetables, cloth and fishing gear, had been open for hours displaying their wares.

At the shop of a gem-cutter, a sick boy lay upon an elegantly veneered bed. Chicken had been prepared for his lunch to tempt his appetite. Nearby, a woman worked at a loom. In all the small workshops activity was at its morning peak. The mosaicists were busy with their tesserae—bits of glazed stone and glass. The dyers were busy at their vats. The wooden cloth press, with its worm screw almost as large as a man, was in full operation. Cabinetmakers were hammering, nailing, sawing, planing, or shaping wood with lathes. Marble-workers were cutting and polishing polychrome marbles and alabaster. An artist dipped his brush in paint to put the finishing touches to a woodframed panel of cupids. A surveyor was busy with his calipers and triangle. A woman sewing put down her thimble in her basket. Along the marina fishermen were mending nets. A baby in a wooden cradle gurgled and cooed.

The morning athletic events in the Palaestra were nearing completion. Boy victors in the stone-toss, naked and sun-tanned, were preparing to receive their olive-wreath crowns. Traditionally the crowns were spread out on the broad marble table in the great apsed hall. The playing field was surrounded by a columned portico, and in its center was a swimming pool in the shape of a cross. At the pool's center, a giant bronze serpent sprayed water as usual from five heads. Officials, guests, and fans sat in a shaded loggia on the north side, protected from the sun's glare, and cheered the victors.

In the patrician houses built upon the abutments of the wall overlooking the waterfront, maids groomed ladies using combs, hairpins, mirrors, and perfume. The ladies' jewel cases contained necklaces, bracelets, anklets, earrings, brooches, rings of gold and silver and precious stones. In the shaded summer dining rooms nestled among hanging gardens or fountain-splashed courtyards, tables were set for the light luncheon Romans preferred. At an elegant house known for its possession of a fine marble bas-relief of Telephus, son of Hercules, servants were serving hard-boiled eggs, bread, salad, small cakes, and fruit. Whole loaves of fresh bread had been placed on tables throughout Herculaneum. At one house, lunch was being rushed; the bread had been broken and placed on the tablecloth—the first bite was already in the diner's mouth.

Near the Forum a shipment of expensive glassware had just arrived and was placed under a colonnade. The glass was of beautiful design, sure to be the subject of admiration at the next dinner party. A special case carefully packed with straw shielded it from breakage. So eager were the owners to see their newest treasure that luncheon was temporarily ignored and a servant was ordered to open the case at once. The first protecting layer of straw was torn away.

Suddenly, without warning, a violent cracking sound split the air. The earth heaved and shook. Enormous bull-like roars seemed to come directly out of the earth itself. The yellow sunlight turned abruptly to a brassy overcast. Acrid sulphuric odors choked nostrils. From the mountain a gigantic cloud in the shape of a mushroom billowed into the sky.

People screamed that Vesuvius had exploded. All who could abandoned everything and ran wildly into the streets. It was the seventh hour, Roman time. A holocaust had begun....

Π

ORIGINS AND LEGENDS

AT THE MOMENT OF ITS DEVASTATION, HERCULANEUM WAS ALREADY AN OLD TOWN. How old we can only guess. From bits of pottery it has been established that the Greeks settled on Ischia, an island in the Bay of Naples, as early as the eighth century B.C. Fragments of the fifth-century Greek walls of Neapolis, enormous blocks of stone without mortar, are still to be seen in the modern city of Naples. Also in the area were the Italic people called Oscans. They built the original walls and towers of Pompeii, and the military inscriptions above the gates are in the Oscan language. And Oscan names are scribbled in some of the houses of Herculaneum. So it is easy to understand what the Romans meant when they talked about "the ancients."

Were the Oscans the original founders of Herculaneum? The Greek geographer Strabo, writing in the first century B.C., said yes, and added, ". . . Next came the Etruscans and Pelasgians, and thereafter the Samnites." All were Italic peoples. Though modern scholars believe Strabo's statement must be taken with caution, the Samnite houses in both Pompeii and Herculaneum tend to bear him out at least on one point. The Samnite houses are handsome houses of the old Italic tradition and were built at least two hundred years before Christ. They are products of the period when all the Neapolitan region of Campania, except Neapolis itself, fell under Samnite rule—toward the end of the fifth century B.C. Rome, in two wars a century later, found the tough and resourceful Samnites difficult adversaries to subdue. The Samnites spoke Oscan, a language related to Latin, and were thoroughly familiar with Roman arms and tactics.

Like so many ancient cities, the founding of Herculaneum is lost in legend. Dionysius of Halicarnassus, a Greek scholar who came to Rome late in the first century B.C., wrote a history of Rome to convince the Greeks of their good fortune at having been conquered by Rome. He remarks: "When Herakles

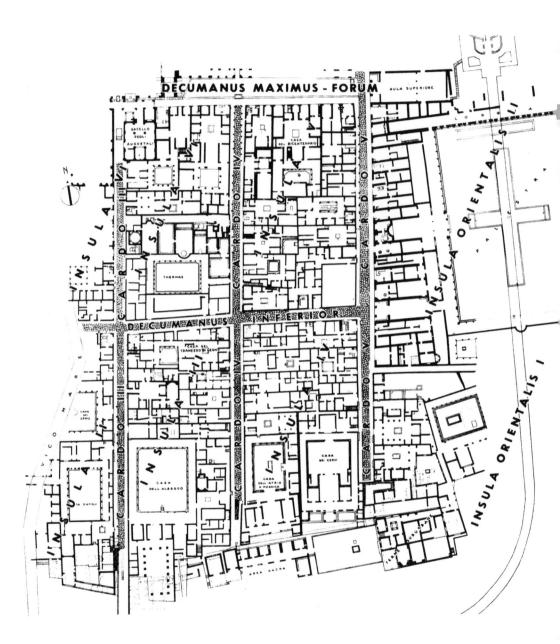

The excavated portion of Herculaneum.

had settled all his affairs in Italy as he wished, and when his fleet had arrived safely from Spain, he sacrificed a tithe of his spoils to the gods, and founded a small city at the place where his fleet lay." In the fourth-century-B.c. works of Theophrastus—that energetic pupil of both Plato and Aristotle who has been called the father of botany—the name of the town was given as Herakleion. Phanias of Lesbos, a countryman and friend of Theophrastus, tells a tale of "Heraklea, a city in lower Italy." The town was governed by a tyrant, he says—a tyrant who became enamored of a local boy and who was slain by the boy's jealous friend and protector. On the tyrant's death, the grateful citizens erected bronze statues to both the boy and his friend, Hipparinus and Antileon. It is not impossible that the statues still exist.

Herakles, or Hercules as the Romans called him, seems to have been the patron deity of the town from earliest times—just as Pompeii was sacred to Aphrodite, or Venus, and Vesuvius was sacred to Dionysus, or Bacchus. Hercules in myth was the best loved son of Zeus, and was worshipped as half-hero, half-god. His mother was Alcmene, the wife of Amphitryon, whom Zeus had seduced by assuming the form of Amphitryon. Even in infancy Hercules had gigantic strength, and while still in his cradle strangled two serpents. They had been sent to destroy him by none other than Zeus' jealous wife, Hera. (Hera-kles means renowned through Hera.) In manhood his strength was accompanied by gluttony and prodigious sexual powers, such as the night he copulated with the fifty daughters of Peneus. He happened to come to Italy after performing the tenth of the twelve mighty labors set upon him by Hera, who harassed him throughout his life with her unrelenting hatred. That labor was to steal the red oxen of the three-headed giant Geryones in the "far west." Hercules succeeded in taking the oxen and killing the giant when he came in pursuit. Then Hercules displayed the oxen through the Mediterranean lands as he journeyed homeward toward Greece. Boys in the Vesuvian area are still given his name, along with other names from antiquity such as Achilles, Hector, Hyacinth, and Dionysus.

And where Herakles traveled during his many adventures, the language, commerce, religion, philosophy, art, and theater of Greece also traveled. It was Greek culture—democratic, scientific, intellectual—which civilized the barbarian world around the shores of the Mediterranean Sea. The town of Herakles in Italy, however, could have been no more than a satellite to the major Greek city on the bay, Neapolis. As such, its nearness and freedom from commerce made it a suitable spot for suburban houses. Here the well-to-do could escape from the noise, heat, and odors of Neapolis—a city no less teeming then than now.

But Herculaneum did not come into its own as a choice suburban residence until after the Roman conquest. Military operations against the Samnites continued intermittently between the years 343 and 290 B.C., and the military role of Herculaneum, if any, is totally unknown. But in 89 B.C. it joined Pompeii and other Campanian towns in a revolt against the Romans, and was quickly taken by the Roman legions under the ruthless general Sulla. The marks made by the Roman siege engines may still be seen on the walls of Pompeii—and someday when the walls of Herculaneum are uncovered, perhaps signs of the Roman battering will be found there too. Afterward neither Pompeii nor Herculaneum had any need for walls, because of the tranquility brought by the Roman peace. With peace came prosperity, and the construction of new and even more elaborate and beautiful houses and villas.

By the time of the Roman Republic's end, with the dictatorship of Julius Caesar some fifty years before Christ, Herculaneum had become one of the most fashionable centers on the Bay of Naples. Its population was only about five thousand—one indication of its exclusiveness. It was almost as smart and desirable an address as Cumae or Baiae. Solid old Cicero, who complained about almost everything (though mostly about Caesar), counted Herculaneum among the most important centers of Campania. Later, the mad emperor Caligula was said by Seneca to have owned a villa there. It was undoubtedly a delight, or such huge and luxurious villas as the one now called the "Villa of the Papyri" would not have been built in Herculaneum's immediate vicinity.

Thus, due to the mild climate, the beauty of the spot, and the new prosperity, Herculaneum became a favored town among both the Roman aristocracy and the new rich. Despite its Greek origins, it came to reflect Rome in its manners, its taste, its way of living. Its art, architecture, and daily life reveal to us much about Rome that the ruins of ancient Rome cannot tell us. Nor was the "Greekness" of Herculaneum any barrier to its success with the Romans, for all things Greek gradually became fashionable. The Roman upper classes spoke Greek as a second language; Roman architecture, art, and theater were derivatives of the Greek. And the artisans of Herculaneum were workmen in the skilled Greek tradition. The town of Herakles seemed to lack for nothing, in Roman eyes.

As for Vesuvius, on whose slopes Herculaneum had been constructed—it was merely an enticing green mountain where nymphs and fauns dallied. Its heights were silvery with the leaves of gnarled old olive trees, and its terraces grew fruit and grapes of enormous size. No one could have believed that this pacific mountain of groves and goatherds was in reality a slumbering volcano. True, those with sharp eyes noted its volcanic shape. The indefatigable Strabo climbed its sides in his old age and remarked that it was a "spent" volcano. Vitruvius, too, had observed the same. But at no time within human memory had so much as a puff of smoke issued from the wooded cone. Today, geological evidence suggests that it had been in "repose" for at least three thousand years.

Volcanic activity, however, did exist in the Bay of Naples area. Only twenty miles from Herculaneum were the Phlegraean Fields—known since remote antiquity for their smoking caverns and geysers of steam and water. Here in a grotto at Cumae dwelled the Sibyl, famed for prophecies. Here was the infernal Lake Avernus, with waters as black as those of Hades. Here the legendary entrance to the underworld, exhaling poisonous mephitic gases. Here too the celebrated spa Baiae, where hot mineral waters gushed in abundance from the earth and the Romans built luxury baths on a scale suitable to emperors. But on horseback or on *asinus* (donkey), by wagon, boat, or litter, or on foot, the Phlegraean Fields with their steaming earth seemed far away.

Though forgotten as a volcano, Vesuvius had another kind of fame. It had been the scene of part of the drama of Spartacus, the able Thracian gladiator who in 73 B.C. led a full-scale slave revolt against the Roman masters. Though the slaves had no historians to present their point of view, the revolt of Spartacus was the third major slave insurrection recorded in Roman history by the historians of the masters. At one point, Spartacus sought safety with seventy of his followers in the rugged, wooded hollow on the summit of Vesuvius. The Romans, under Clodius, thought that he was trapped. Instead, the rebels braided chains of wild vines and, unperceived, let themselves down on the steep side. Stealthily they approached the Roman camp, surprised and captured it. The seventy, before the revolt was over, had swelled to seventy thousand; but Spartacus lost. After brilliant victories, the slave armies finally were crushed by Crassus and by Pompey. Spartacus, for his un-Roman activities, was crucified, and the Appian Way outside Rome lined with the crosses of his followers.

One hundred and fifty years later the name of Spartacus, to slave owners and slaves alike, was only a remote memory associated with Vesuvius. So it was that nothing seriously disturbed the peace of mind of the good citizens of Herculaneum that ninth day before the Calends of September. The golden days stretched on, comfortable, serene, without anguish for the past or anxiety for the future.

Indeed, from the past of sleepy little Herculaneum no one could have guessed its future: that historically it was to become one of the most important cities of the world.

III

DEATH OF A ROMAN TOWN

IN DEATH, HERCULANEUM LEFT BEHIND THE DETAILED RECORD OF ITS LIFE TWO THOUsand years ago. The record is unusually complete—more so than any other site from antiquity thus far explored by archaeologists. The whole town, with its daily minutiae, was submerged by a torrential flow of mud lava from the volcano, sealing everything as if in plastic. Miraculously, it is a time capsule for posterity.

The circumstances of the burials of Herculaneum and Pompeii were very different. Pompeii lies to the southwest of Vesuvius, on the Bay of Naples; Herculaneum lies to the northwest, also on the bay. Farther to the northwest, some four miles from Herculaneum, lies Naples—or Neapolis. On the day of the eruption the prevailing wind was toward the southwest. Thus Pompeii received the mass of ash and pumice stone (lapilli), Herculaneum received the waves of mud, and Neapolis escaped with earth shocks and a blanket of ash. Also, ash fell lightly on many other cities in Italy.

Considering the extraordinary nature of the disaster, it is remarkable that so few written reports of the cataclysm have survived from antiquity. Martial (Marcus Valerius Martialis) makes a contemporary reference to it in one of his epigrams. And a hundred years after the event, Dio Cassius gives an account of it. But the only eyewitness description that has come down to us is that of Pliny the Younger (Gaius Plinius Caecilius Secundus), in two letters written to the Roman historian Cornelius Tacitus.

Some twenty-six years after the eruption Tacitus, in the process of gathering material for his histories, wrote to Pliny for an accurate record of the death of

During reign of Titres. ATH OF A ROMAN TOWN

Pliny the Elder (Gaius Plinius Secundus), the naturalist. The Emperor Titus, shortly before the eruption, had appointed Pliny the Elder commander of the Roman fleet at Misenum—a strategic base on the Bay of Neapolis. It was in the capacity of admiral that the elder Pliny had at his disposal ships and men for rescue operations. Young Pliny, not quite eighteen at the time, deeply respected his uncle, who had become his adoptive father after his own father's death. His letters are masterpieces of understatement.

In the first he wrote:

My dear Tacitus—You ask me for an account of my uncle's death, so that you may hand on a more reliable report of it to posterity. Thanks for this. I am sure that your recording of his death will immortalize his memory....

2-3PM

He was at Misenum in command of the fleet. On the ninth day before the Calends of September, at about the seventh hour, my mother informed him that a cloud of extraordinary dimensions and appearance had been seen. He had finished sunbathing, his cold plunge, and lunch, and was at work on his books. He then demanded his sandals, and climbed to a high point for the best possible view of the remarkable phenomenon. The cloud was rising; watchers from our distance could not tell from which mountain, though later it was known to be Vesuvius. In appearance and shape it was like a tree—the [umbrella] pine would give the best idea of it. Like an immense tree trunk it was projected into the air, and opened out with branches. I believe that it was carried up by a violent gust, then left as the gust faltered; or, overcome by its own weight, it scattered widely—sometimes white, sometimes dark and mottled, depending on whether it bore ash or cinders.

It was natural that a man of my uncle's scientific knowledge would decide that so grandiose a spectacle deserved close study. He ordered that a light galley be made ready, and gave me the opportunity of accompanying him if I wished. I answered that I preferred to study, as he himself had assigned me some work to do. Just as he was leaving the house, he received a note from Rectina, Caesius Bassus' wife, who was alarmed at the nearness of danger. Her villa was on a slope of the mountain where no escape was possible except by sea, and she begged him to save them from their peril. He now saw his expedition in a new light; what he had begun in the spirit of a scientist, he carried on as a hero. Quadriremes were launched, and he boarded with the intention of rescuing not only Rectina but many others as well—for the charm of the coast had attracted many

24 Ang 79 A.D. people. So he hurried in the direction from which others were fleeing, and set the helm for a course straight into the danger—yet keeping so calm and cool that he noted all the changing shapes of the phenomenon and dictated his observations to his secretary.

And now the ashes were falling on the ships, thicker and hotter the closer they approached; and also pumice stones and cinders, blackened, scorched, and scattered by the fires. Shallows suddenly were encountered, and landing was made difficult because the shore was blocked by rubble from the mountain. The pilot urged that they turn back; and my uncle hesitated. Then he said: "Fortune favors the brave—steer toward Pomponianus!"

This man lived at Stabiae, on the far side of the bay (for the sea thrusts in between curved surrounding shores). There the danger was not yet immediate, though very near and very evident as it increased. Pomponianus had collected all his movables on shipboard, with the intent to sail the moment the opposing wind died down. My uncle, favored by this same wind, reached land. He embraced his anxious friend, and cheered and encouraged him; and, to calm fears by an appearance of unconcern, he asked for a bath. Then after bathing he sat down to eat with gusto, or at least (no less admirable) making a pretense of gusto.

From Mount Vesuvius, meanwhile, great sheets of flame and extensive fires were flashing out in more and more places, their glare and brightness contrasting with the darkness of the night. My uncle, to relieve his companions' fears, declared that these were merely fires in villas deserted by their peasants. Then he lay down and slept. His sleep was unmistakable, for his breathing, heavy and stertorous because of his bulk, was heard by those who listened at the door. But the courtyard on which his room opened was being choked by a rising layer of cinders and ash, so that if he delayed any longer it would have become impossible to escape. He was awakened, and went to join Pomponianus and the others, who had not slept. They discussed whether to remain in the house or go outside. The walls of the house were swaying with repeated violent shocks, and seemed to move in one direction and then another, as if shifted from their foundations. Nevertheless they dreaded the rain of pumice stones, though small and light, in the open air. After deliberation they chose the latter of the two dangers-my uncle moved by the stronger reasons and his companions by the stronger fears. With strips of linen they tied pillows to their heads, and went out.

Elsewhere day had come, but there it was night, blacker and thicker

than any ordinary night, though relieved by torches and flares of many kinds. They decided to go down to the shore, to see at first hand whether it was possible to sail; but the waves continued tumultuous and contrary.

There my uncle lay down on a sailcloth which had been cast ashore, and called repeatedly for water, which he drank. Then the approaching flames, and the smell of sulphur which heralded the flames, put the others to flight. Aroused, my uncle struggled to his feet, leaning between two slaves; but immediately he fell down again. I assume that his breathing was impeded by the dense vapors, and his windpipe blocked—for constitutionally it was narrow and weak, and often inflamed. When daylight returned (on the second day after my uncle had last seen it), his body was found intact, without injury, and clad as in life. He looked more like a sleeper than a dead man.

Meanwhile mother and I were at Misenum. But that is not to the purpose, as you did not want to hear anything more than the facts of his death. So I will conclude. . . .

But Tacitus did want to hear more, and Pliny wrote a second time—about what happened at Misenum:

... After my uncle's departure, I gave the rest of the day to study—the object which had kept me at home. Afterward I bathed, dined, and retired to short and broken sleep. For several days we had experienced earth shocks, which hardly alarmed us as they are frequent in Campania. But that night they became so violent that it seemed the world was not only being shaken, but turned upside down. My mother rushed to my bedroom—I was just rising, as I intended to wake her if she was asleep. We sat down in the courtyard of the house, which separated it by a short distance from the sea. Whether from courage or inexperience ... I called for a volume of Titus Livius and began to read, and even continued my notations from it, as if nothing were the matter....

Though it was the first hour of the day, the light appeared to us still faint and uncertain. And though we were in an open place, it was narrow, and the buildings around us were so unsettled that the collapse of walls seemed a certainty. We decided to get out of town to escape this menace. The panic-stricken crowds followed us, in response to that instinct of fear which causes people to follow where others lead. In a long close tide they harassed and jostled us. When we were clear of the houses, we stopped, as we encountered fresh prodigies and terrors. Though our carts were on level ground, they were tossed about in every direction, and even when weighted with stones could not be kept steady. The sea appeared to have shrunk, as if withdrawn by the tremors of the earth. In any event, the shore had widened, and many sea-creatures were beached on the sand. In the other direction loomed a horrible black cloud ripped by sudden bursts of fire, writhing snakelike and revealing sudden flashes larger than lightning....

Soon after, the cloud began to descend upon the earth and cover the sea. It had already surrounded and obscured Capreae, and blotted out Cape Misenum. My mother now began to beg, urge, and command me to escape as best I could. A young man could do it; she, burdened with

Garden of the House of the Mosaic Atrium. The fountain still plays in the marble basin. Plants of the same types grow in the same spaces. To the left is a sitting room, with bedrooms on either side. The walkway between the rooms was sheltered by large glass panels in wooden frames.

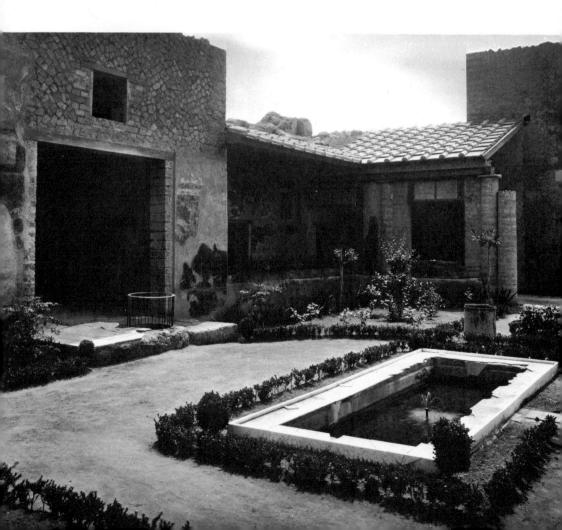

age and corpulence, would die easy if only she had not caused my death. I replied that I would not be saved without her. Taking her by the hand, I hurried her along. She complied reluctantly, and not without self-reproach for hindering me.

And now came the ashes, but at first sparsely. I turned around. Behind us, an ominous thick smoke, spreading over the earth like a flood, followed us. "Let's go into the fields while we can still see the way," I told my mother—for I was afraid that we might be crushed by the mob on the road in the midst of the darkness. We had scarcely agreed when we were enveloped in night—not a moonless night or one dimmed by cloud, but the darkness of a sealed room without lights. To be heard were only the shrill cries of women, the wailing of children, the shouting of men. Some were calling to their parents, others to their children, others to their wives -knowing one another only by voice. Some wept for themselves, others for their relations. There were those who, in their very fear of death, invoked it. Many lifted up their hands to the gods, but a great number believed there were no gods, and that this night was to be the world's last, eternal one. Some added to the real danger with false or illusory terrors: "In Misenum," they would say, "such and such a building has collapsed, and some other is in flames." This might not be true, but it was believed.

A curious brightness revealed itself to us not as daylight but as approaching fire; but it stopped some distance from us. Once more, darkness and ashes, thick and heavy. From time to time we had to get up and shake them off for fear of being actually buried and crushed under their weight. I can boast that in so great a danger, I did not utter a single word or a single lamentation that could have been construed as weakness. I believed that one and all of us would perish—a wretched but strong consolation in my dying. But the darkness lightened, and then like smoke or cloud dissolved away. Finally a genuine daylight came; the sun shone, but pallidly, as in an eclipse. And then, before our terror-stricken gaze everything appeared changed—covered by a thick layer of ashes like an abundant snowfall.

We returned to Misenum, where we refreshed ourselves as best we could. We passed an anxious night between hope and fear—though chiefly the latter, for the earthquakes continued, and some pessimistic people were giving a ghoulish turn to their own and their neighbors' calamities by horrifying predictions. Even so, my mother and I—despite the danger we had experienced and the danger which still threatened—had no thought of leaving until we should receive some word of my uncle....

3

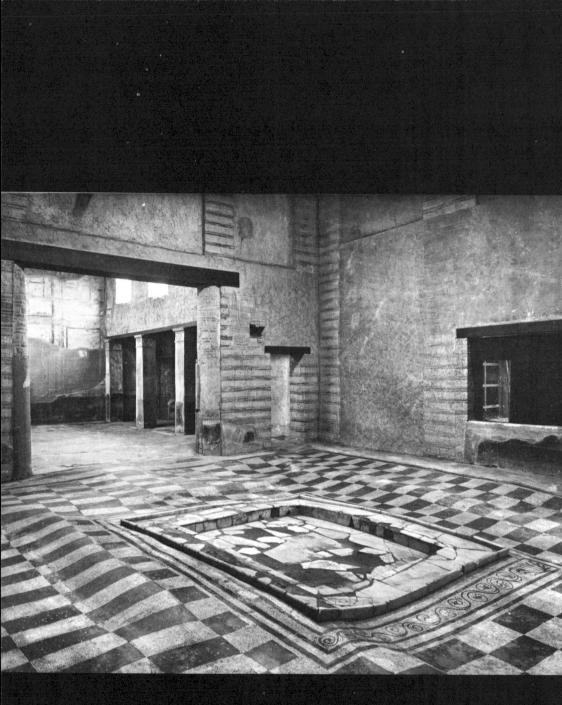

Atrium of the House of the Mosaic Atrium, revealing how both mosaic floor and marble basin buckled under the weight of the volcanic mud. To the left is the tablinum, with a portion of the original frescoes preserved on the rear wall. These two rooms were largely stripped by the 18th-century tunnelers.

0

Plan of the House of the Mosaic Atrium: The two entrances are at (1) and (2), from the street. The solarium is the terrace overlooking the marina. The kitchen is at the right of the entrance.

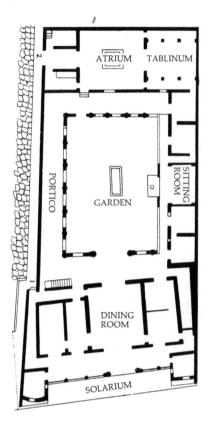

Eventually the news arrived, to young Pliny's great distress. But he was fortunate in being so far away from the center of the eruption. The pumice stones that dropped on Pompeii were nearly red-hot, burning or pitting everything they touched. The whole top of the mountain had been blown off, and most of this matter, plus ash, settled on the area around Pompeii. Thus the city of twenty thousand inhabitants was covered to an average depth of twentythree feet—so that only its outline was vaguely recognizable. No lava flowed over Pompeii; hence the city was not totally destroyed, though totally covered.

The fate of Herculaneum was, if anything, more horrifying and dramatic. For scenic reasons and coolness it had been built on a promontory between two streams that flowed down the slopes of Vesuvius. Volcanologists today assume that during the eruption escaping steam condensed and cascaded down the mountain as a river of volcanic mud. The viscous substance was composed of ash, pumice, earth, and had the consistency of molasses. This liquid mixture followed the course of the eroded stream beds—the path of least resistance. Herculaneum found itself an island in a steaming sea of mud. Rapidly the mud rose and engulfed the town to depths ranging from 65 to 85 feet. It was obliterated. Not even a trace of its outlines remained.

The mud lava, as it is now called to distinguish it from true lava, was hot but not so hot as the pumice that fell on Pompeii. In some places it was hot enough to carbonize foodstuffs and wood; in others, hot enough merely to scorch cloth and papyrus; and in still others, wood, rope, eggs, and even fishnets were left almost totally unburned. In some houses wax tablets remained unmelted. These temperature differences account for the different texture of most bronzes taken from Herculaneum and Pompeii: those from Herculaneum are nearly in their original state, while those from Pompeii usually are pitted and badly oxidized.

The force of the stream of mud also varied greatly. At some points its pressure felled walls and columns, smashed furniture, and carried away statuary. (Geologists state that nonvolcanic mudflows only a few feet in height can move boulders weighing 85 tons or more for hundreds of feet across slopes as gentle as 5°.) At other points it rose so gently that it oozed over eggs without breaking them and filled rooms without disturbing the position of pots on a kitchen stove or a cradle in a nursery. As the mud cooled, everything in Herculaneum was sealed tight. Occasionally it assumed the hardness of limestone, but mostly its density is similar to the light volcanic stone called tufa—one of the major building materials, sawed into blocks, in the Neapolitan area today. The town of Hercules resembled those Paleozoic insects trapped in amber, preserved until their discovery by men eager to know the history of living things.

The dead in Herculaneum raise intriguing questions—especially as in comparison with Pompeii they are thus far so few. The dead in Pompeii have been estimated at about a tenth of the population—though truthfully such an estimate has little meaning. How many died on the roads while attempting to escape? How many died in the sea, while fleeing by boat? From the attitudes of the bodies at Pompeii, it appears that the asphyxiating gases were more lethal than at Herculaneum. Many persons seem to be in the process of escaping, but are felled when they can no longer breathe: a man sits in a corner, hands clasped above nose and mouth; a father lifts himself on one arm as he attempts to crawl toward his children.

Because the bodies at Pompeii were covered with ash, it has been possible to make plaster casts of the space displaced—thus providing a likeness of each individual's last moments of agony. But at Herculaneum the hot mud, which sealed everything else so perfectly, destroyed the flesh and left us only the skeletons of victims. They are none the less poignant. Two were found twentyfive feet above the street level of the ancient city; they had boiled up in the mud.

It is thought that the ash and hot pumice began to fall on Pompeii almost instantly after the explosion of Vesuvius, whereas the rivers of mud took longer to arrive at Herculaneum. Thus the inhabitants of Herculaneum had a better chance to escape. Though the earth shocks were strong enough to fell statuary, buildings were not overturned and people therefore were not crushed under them. But if they dallied they were irretrievably lost once the mud had reached the level of the bridges over the streams.

At Herculaneum, as at Pompeii, there was not time to save precious objects (at Pompeii, many who so attempted paid with their lives). Herculaneum was abandoned with its smallest valuables untouched: jewels, gold coins, fibulae (antiquity's safety pins) of gold and silver, rings, silver plate, rare perfumes, legal documents. People fled as they were—the men at the baths perhaps without their clothes, the actors at the Theater probably in the costumes of rehearsal. The refugees who jammed the road to Neapolis must have resembled closely the refugees from Misenum as described by Pliny. But for the people of Herculaneum the onrushing mud added an additional element of horror.

The dreadful news was flashed to Rome by the signal towers. In the most efficient Roman manner the region of Neapolis was declared a disaster area for Pompeii and Herculaneum were not the only towns lost. The popular Emperor Titus dispensed emergency aid with his own funds in addition to the funds of the State. He himself visited the survivors, and comforted them. The crushing extent of the disaster can be judged from a Senate decree that the assets of extinct families should be divided among all survivors. Yet no aid could compensate for so total a loss. A few people returned—to dig hopelessly.

As only a relatively small portion of Herculaneum has yet been uncovered, we have no more than samples of the amazing details of daily life preserved in the mud. Excavations at Pompeii lend evidence, and though less complete than Herculaneum, certain assumptions can be made. But the best evidence of how people lived in a Roman town in the first century comes from the limited excavations in Herculaneum itself.

Luncheon is still waiting on tables; snatches of poetry, erotic phrases, and scores of names in Latin and Greek—and even in Oscan—are legible on the walls; the case of fine glassware was found half-packed; the candelabrum and bronze Dionysus await repairs; the sick boy in the house of the gem-cutter lies on the bed, his lunch of chicken uneaten; the baby remains in the cradle.

In the lives of the people of Herculaneum there has been only a pause . . . of nineteen centuries.

IV

THE LONG SLEEP, AND Resurrection

SLOWLY THE DEAD CITIES WERE ERASED FROM HUMAN MEMORY. NOT ONLY THE SITES but their very names were totally forgotten. The writings concerning them were destroyed or lost. The slopes of Vesuvius grew green again and were cultivated as though Herculaneum and Pompeii had never been.

But Vesuvius did not again permit its savage nature to be forgotten. In A.D. 203 the volcano erupted for a week, and in 306 for several days. In 471 began a series of eruptions which lasted for three years without respite eruptions so severe that ashes were blown as far as Constantinople. The first recorded lava streams were in 513 and 533. From 1306 to 1308 lava burst periodically from the sides of the mountain. In 1631 lava—true fire lava, not mud—reached the site where Herculaneum had been, and buried even more deeply portions of the stricken town. And in 1759, while exploration at last was in progress, a vast and terrifying eruption occurred.

In modern times the eruptions have continued, erratic but not infrequent, and following much the same pattern. Nevertheless, the lower slopes of Vesuvius remain verdant with orchards and vineyards; a new Pompeii of a sort has arisen; and a slum called Resina festers where beautiful and elegant Herculaneum once stood.

Through all those years history was swirling about the volcano with a violence equal to the molten magma within the cone. The sack of Rome by the Visigoths under Alaric in A.D. 410, and its second sack by the Vandals under Genseric forty-five years later, meant that the proud and powerful Roman State after a thousand years of existence had reached an end. Italy lay helpless as one wave of invaders broke over another. After the Goths and the Vandals came the Huns. After the Huns the old civilization momentarily rekindled under the Byzantines, but only in parts of Italy, for the Longobards—"the most barbarian of all the barbarians"—had swept down from the north. Then the Franks arrived. The Dark Ages had reached their darkest hours.

With the Middle Ages came the enlightened Saracens; then the Normans, the Germans, the Angevins, the Aragonese, the Turks (who never gained more than a foothold—fortunately for Western civilization, as the ruins of Greece testify). They were followed by the French, the Spaniards, the Germans, the Spaniards, the Austrians, the Bourbons, the Austrians, the Napoleonic French, the Bourbons, and the Austrians again. And in the twentieth century, Italy endured the German invasions counterposed by the British and American Allies. A long, long agony—during a millennium and a half. Somehow the people of Italy survived; somehow they managed to avoid the complete extinction of their great culture inherited from antiquity.

After the barbarian invasions, the Roman cities dropped apart stone by stone. Some were burned and destroyed; others collapsed from lack of care. The aqueducts cut by the barbarians were not restored. The public baths fell into disuse; the inhabitants of Rome drank the muddy water of the Tiber; filth and disease increased. Systematically the early Christians smashed the images of the pagan gods; the greatest sculptures were not exempt. The pious wrecked the temples, or sometimes converted them into churches. In the Middle Ages the priceless marbles were burned for lime. Earthquakes leveled much of what remained upright. Weeds and vines grew among the ruins. Desolation reigned where once had pulsed the fairest cities ever known to men. Yet under the earth, preserved by Vesuvius, lay ancient towns amazingly intact, waiting only for the excavator's spade.

Gradually medieval ignorance and obscurantism gave way to the Renaissance—truly a rebirth. By the fifteenth century, antiquity fever had taken such hold of Italian minds that an ancient bronze or marble statue might almost be worth its weight in gold. The greatest artists copied the works of the Greeks and Romans. Prospecting and digging went on all over Italy though not at Herculaneum and Pompeii. The ancient manuscripts were read once more, and once more the existence of the buried cities became known. But the sites remained a mystery—though local rumors of buried treasure at the foot of Vesuvius had never ceased. Scholars again began to mention the cities in their works. And an inspired topographer, Ambrogio Leone, making a map of Campania, marked Herculaneum not far from its actual site. The year was 1503.

Some ninety years later, a Neapolitan aristocrat decided to divert the waters

of the little Sarno River—a river that once had flowed into the harbor of Pompeii. The aristocrat needed water for the fountains of his country villa, Torre Annunziata. So a channel was dug directly across the site of Pompeii and inscriptions turned up that accurately gave the name of the buried town. Ironically, the inscriptions were tossed aside because they were thought to refer to Pompey the Great. The aristocrat lost his chance to be the last hero of the Renaissance. And both Pompeii and Herculaneum slept on.

The long night was not disturbed until 1709—and then chance, not reason, led to the discovery of Herculaneum. In the town of Resina, which had grown in a disorderly jumble above the site, was a monastery. While sinking a well for the monks in their courtyard a workman struck an upper tier of seats in Herculaneum's Theater. He brought up samples of rare and beautiful marbles. It happened that nearby, at Portici, an Austrian prince was building a luxurious villa; and, as he had need for marble, the find was called to his attention. The prince, whose full name was Maurice de Lorraine, Prince d'Elbeuf, was an officer in the Austrian forces occupying Italy. Like so many other invaders, he had married an Italian girl and decided to remain in Italy. Hence the new villa.

From the quality of the marbles the prince realized that the well-digger had stumbled on an important edifice. He was not concerned, however, with the structure, but solely with the materials it might yield for his own project. Lacking even the slightest archaeological interest, he ordered that the well be deepened and that lateral exploratory tunnels be dug. But the prince never recognized the nature of his find, never realized that here was an ancient theater completely intact. While his villa was in construction, he continued his plunder. Finally satiated, in 1716 he gave up the explorations and left Herculaneum to its gravelike peace.

Not until 1738 was the Theater identified for what it was, and shortly thereafter the town itself. An inscription was found that established the site beyond all doubt as Herculaneum. At last the town of Hercules had returned from limbo to the map. This new drama came about through a series of apparently extraneous historical events.

The first of the Spanish Bourbons had assumed the throne of Naples as Charles III. In 1734 at the age of nineteen, he had led a Spanish army to drive out the Austrians. Once secure on the throne, King Charles turned his attention to other matters. His interest was quickly stimulated by the treasures so fortuitously discovered by the Prince d'Elbeuf. He decided to finance further explorations; but deficient in any sense of scientific method, he assigned the work to a colonel of engineers who had come from Spain with his army— Rocco Gioacchino de Alcubierre.

King Charles could hardly have made a worse choice for an archaeologist or a better one for a treasure hunter. Alcubierre enlarged the original shaft to the Theater into a gaping hole, letting in daylight on a few of the upper seats. Existing tunnels were converted into galleries; new tunnels were begun in all directions. Soon the diggers realized that they were in the hidden town itself.

From this busy anthill came new finds of dramatic appearance and great value. Everything was carried to the Royal Palace at Portici—thus beginning the nucleus of the collection eventually to rest in the National Archaeological Museum in Naples. Alcubierre, hot for spectacular discoveries, paid little heed to anything else.

This military engineer was guilty of such stupidities as removing bronze letters without first recording the inscription. Everything was haphazard. Digging was done on whim. Though daily reports were issued, and a diary kept in Spanish, no record of the details of each find—its place, position, relation to other objects—was kept. No plans and elevations were made. The burrowing went on everywhere about the town—along streets, over roofs, through frescoes, mosaics, wooden doors, vaults—undermining, smashing, snatching.

It was not until the appearance of a young Swiss architect, Karl Weber, that any order was introduced into this chaos. With Weber began the first disciplined archaeological approach to the explorations, and we today are greatly in his debt. Nor is it surprising that he suffered from the jealousy of Alcubierre, his superior, who constantly sought to denigrate his work and interfere. The two men must have been very unlike in outlook and temperament. Alcubierre had the ear of the king, but Weber became too valuable to discharge.

It was Alcubierre, when the treasures at Herculaneum became scarce, who persuaded the king to switch to the site of Pompeii. Lately some peasants had made finds which caused the area to look promising, and the crumbly volcanic covering obviously was much easier to remove than the solidified mud of Herculaneum. Alcubierre recruited twenty-four diggers, half of whom were convicts, and in March of 1748 turned the first spadeful of earth and ash. It was Alcubierre's luck to hit the temple of the Fortuna Augusta; he had justified himself in the eyes of the king. But his good fortune did not continue, and Alcubierre, disheartened, resumed operations at Herculaneum the following year. It was not until 1763 that *la Città* (The City), as the Pompeiian ruins were called, was definitely established as ancient Pompeii.

For several years the diligent Weber had the opportunity to pursue his more systematic tunneling. He faced grave obstacles. The passages, deep underground, were little different from those in a mine. Water and slime dripped from the walls. The work was slow and dangerous; carbonic gases constantly threatened asphyxiation. The only light came from feeble lamps or smoky torches. Normal architectural forms under such conditions assumed grotesque shape. No wonder that little knowledge was gained of the general character of the town, though the tunnels reached the Basilica, several temples, and the Palaestra. The work of these Neapolitan *cavamonti* was truly a labor of Hercules.

Through it all, Alcubierre continued to harp on Weber's "incapacity" and "ignorance"—and went so far as to remove timber-proppings of the galleries, so that ceilings would collapse. But the undaunted Weber was supremely vindicated by the discovery of the Villa of the Papyri, called by Amedeo Maiuri "... the most valuable and richest villa of the ancient world" yet discovered.

This villa lies slightly outside the town of Herculaneum. Its existence was revealed in 1750 when well-diggers struck a circular marble pavement suitable for a palace (it was the rotunda of a garden belvedere). Weber immediately recognized the importance of the find, and proceeded with great care to explore the structure. It is one of the most impressive bequeathed from antiquity—a private villa with a front more than eight hundred feet long, according to Weber's unfinished measurements. As he worked in his dark tunnels, Weber made a rough plan of this villa. But size is one of the least aspects of its importance. From it Weber brought up not only the circular marble floor, but the greatest single collection of ancient bronze statuary ever found. So fine are the pieces that copies of several are to be seen today in the Parliament Square in Athens, and so famous that they were a prime object of Hermann Goering's thievery during World War II. Safely recovered, they remain one of the most valued treasures of the National Museum in Naples.

For fifteen years, before the tunnels were refilled with earth, incredible finds continued to be removed from the villa, including the first complete ancient library. This discovery created a sensation and helped to give a new emphasis to the science of archaeology. With great impatience the learned world waited for the deciphering.

Just before the end of Weber's tenure, a new personality joined the explorations—an architect named Francesco La Vega. In his fresh enthusiasm he attempted to draw up a town plan of Herculaneum, which, after many years, was to prove its usefulness. In 1765 those tunnels that had not been refilled were closed, and emphasis was shifted to Pompeii, where sensational new finds had occurred. More dramatic than the musty Herculanean tunnels was the sight of an ancient city resuming its place in the sun.

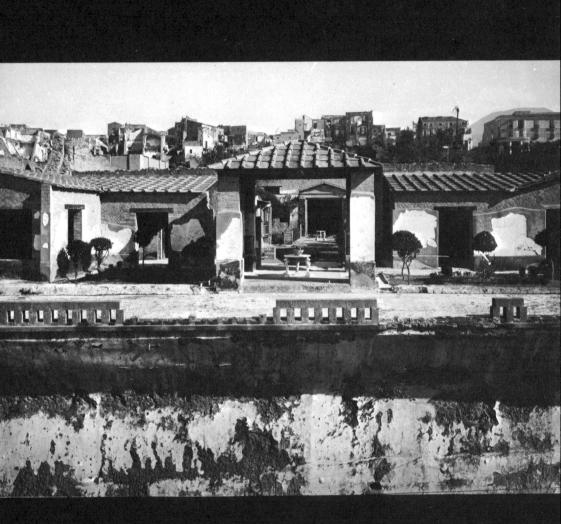

Direct view of the House of the Stags on the embankment, looking through the pergola and the garden to the mosaic-flanked outer portal of the dining room. The marble tables are in their original places. In the background are houses of the modern town, Resina.

Quickly the name Pompeii became known throughout the entire civilized world, and the art and architecture there revealed had a profound effect on Western culture. A revival of classicism swept the educated and the fashionable. Romantic engravings of the ruins became the rage. The winged phallus became notorious. Furniture, clothing, dishes, silver, painting, sculpture, and architecture all reflected the impact of the discoveries at Pompeii and at Herculaneum. In America, interest in the classic was most clearly demonstrated by Thomas Jefferson's own designs for silver, and for his house Monticello (Little Mountain). Like many Americans, he made a trip to Italy and came away deeply impressed. He both spoke and wrote Italian. It was no accident that he gave his house an Italian name.

But for all the eighteenth-century concern with antiquity, archaeology was not yet a science; and the diggers, though their methods had improved, were far from archaeologists. The subsequent history of the excavations at Herculaneum, until modern times, is a series of starts and stops, of eager enthusiasms and dashed hopes. Slowly archaeology—and its patrons—matured.

While the silence at Herculaneum remained undisturbed, history was grinding on in its irrevocable way. The Bourbons in Naples had fallen; Napoleon had conquered Italy and fallen; the Bourbons had returned to Naples. Young King Francis I of that house proved deeply moved by Pompeii. Moody and romantic, he loved to take moonlight strolls among the ruins. In 1828, after a lapse of sixty-three years, he ordered a resumption of digging at Herculaneum.

Meanwhile, excavations at Pompeii had gone on more or less continuously under the various regimes—sometimes intensely, sometimes laxly, and with varying results. Much had been accomplished in the Napoleonic period under the regimes of Joseph Bonaparte and the impetuous Joachim Murat in Naples. Thus it was felt by King Francis and his advisers that Herculaneum ought to be brought out into the open, like Pompeii. The tunnels, therefore, were wholly ignored, and work was undertaken in an area that did not lie, like the Theater, under the teeming streets of Resina. With strenuous effort—hacking away at the solidified mud—a few houses of the ancient city were uncovered. People began to speak of Ercolano as if, once again, it were a contemporary Italian town. And this is the name it bears in Italy today.

After seven years the results did not seem equal to the efforts. The techniques of excavation were so crude that the Herculanean houses were wrecked as they were revealed, and appeared as almost total ruins. Rich finds were rare. The languid king lost interest, and the project was dropped.

For a long span of years pick and shovel were unheard at Herculaneum. The

Austrians and the Bourbons finally were driven from Italian soil. Garibaldi with his Redshirts—"The Thousand"—in 1860 marched half the length of Italy, liberating, unifying. One of his most ardent supporters had been the Frenchman Alexandre Dumas, famed and fiery author of *The Three Musketeers*. In gratitude, Garibaldi appointed Dumas père director of the Museum in Naples and of the excavations at Herculaneum and Pompeii—probably the most unlikely choice of supervisor in the history of archaeology. Dumas, hardly fitted for the post, soon resigned.

The way was left open for the appointment of the first scientifically minded director of excavations: Giuseppe Fiorelli, a true archaeologist, and a man who had suffered both blacklist and prison because of his revolutionary efforts for a united Italy. As a very young man, under the Bourbons, Fiorelli had been appointed Inspector of the Excavations at Pompeii. In the revolt of 1848 he had managed to secure two cannon, and trained his twenty diggers as artillerymen. When the revolt failed, he was arrested. With the coming of the mature Fiorelli, the first journal of excavations at Pompeii was established. Careful data were amassed. Whenever possible, finds were left in place. The day of the happy-go-lucky treasure hunter was over.

Under Italy's King Victor Emanuel II, in 1869, the excavations at Hercu-

Cupids playing hide-and-seek—one of the series of little paintings of cupids at different games that decorated the enclosed portico of the House of the Stags. Another was blind-man's buff.

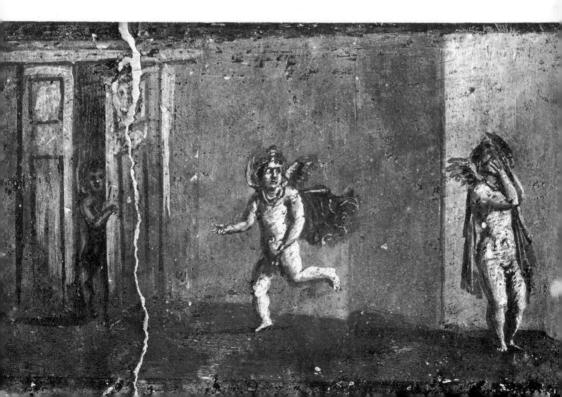

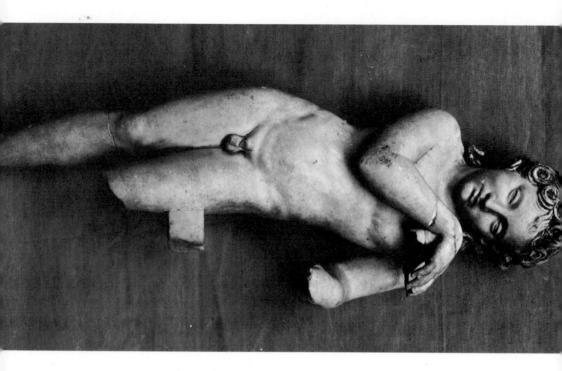

"Sleeping Eros," the delicate sculpture in Greek marble found on the terrace of the House of the Stags. The curls are painted red.

laneum were resumed. But the physical conditions of work—pitting strong arms and strong backs against the solidified mud—had not improved; progress was slight. As the digging approached the jumbled houses of Resina, a new difficulty arose: the flinty opposition of the landlords. The *padroni* were not interested in the knowledge gained through archaeology. They preferred the bursting slums of the present to the empty villas of the past. In 1875 they forced a stop. It seemed that Herculaneum was to remain forever buried.

Despite international efforts to revive the Herculaneum project at the turn of the century, work did not begin again until 1927. The Italian Government then determined to schedule the excavations at a steady pace, as had been done at Pompeii. New machines, new techniques, were available. And so was a new man, Amedeo Maiuri—steeped in the spirit of Fiorelli.

The slow and arduous process of returning the streets and houses of Herculaneum to the light of day, intact, at last had begun.

V

TREASURE REVEALED— The great dig

IT IS ONE OF THE TRAGIC IRONIES OF HUMAN ENDEAVOR THAT THE SUFFOCATING MUD did less damage to Herculaneum than the earliest excavators. From the point of view of scientific archaeology, it is fortunate that the efforts of the first excavators met with such limited success—though Weber's exploration of the Villa of the Papyri, given the times, circumstances, and dangers, can only be praised as a heroic undertaking.

To the task can now be brought all the tools of modern archaeology. Here is a list drawn up by Paul MacKendrick for the most limited dig: clinometer for measuring slopes, plane table for measuring angles, alidade for showing degree of arc, prismatic compass for taking accurate bearings, leveling staves marked in centimeters for measuring elevations, templates for recording the curves of moldings; brooms, brushes, and mason's tools for cleaning architectural finds; zinc plates and sodium hydroxide pencils for electrolysis of coins; measuring tapes of all sizes, mechanical-drawing instruments, trowels, marking pegs, cord, squared paper, filter paper for taking "squeezes" of inscriptions; catalog cards, India ink, shellac, cardboard boxes, small cloth bags, labels, journal books, field notebooks, technical manuals, and cameras.

For a major dig like Herculaneum this list is not sufficient. To meet the challenge of the solidified mud, the traditional pick and shovel and refuse basket must be augmented by compressed-air drills, electric saws, bulldozers, narrowgauge railway, dump trucks, and related equipment. For restorations the most skilled masons, mosaicists, fresco-painters, marble-workers, bronze-casters, carpenters, and cabinetmakers are needed. Useful, too, is the chemist, for determining the content of jars and bottles, paints, or the precise ingredients of a pot of dehydrated soup. Sometimes a metallurgist is required. The physicist may be called upon for dating with the radioactive isotope carbon 14. Finally, specialists in languages must be available; to experts in Latin and Greek must be added those who know the Oscan tongue, and, sometimes, Egyptian hieroglyphics.

The modern excavations, under the initial guidance of Amedeo Maiuri, have had the stated aim of restoring the town as closely as possible to its original appearance. A citizen of Herculaneum, returning after almost two thousand years, ought to be able to enter his house and find it much as he left it—the familiar objects all in place, food in the cupboard, flowers blooming in the courtyard, fountains running. This objective of course is very difficult to achieve. Yet in many cases frescoes have been left on the walls, statuary in the gardens, grain in the storage vats, bread in the pans. Restoration—if any —has been clearly indicated. Where extensive damage was done by the Bourbon tunnelers, no such reconstitution is possible—and the ruins are left as ruins.

Invariably the question is asked, "How big was Herculaneum?" And the answer is that nobody really knows. The population estimate of four to five thousand is based on the seating capacity of the Theater and certain limiting aspects of the terrain. The actual area covered by the town can be only a guess because the Bourbon diggers never succeeded in pushing their subterranean corridors very far under the streets of Resina. Some achaeologists have estimated that Herculaneum's area is about a third of Pompeii's 163 acres, or about 55 acres. But the true answer to the question must await the more extensive explorations of some distant future.

Though much is not yet known about the town as an entity, some characteristics have been made clear by the tunnels and the limited zone of complete excavation. It is obvious that the town plan, in its orderly succession of rectangular blocks, with the short sides facing the waterfront, is similar to the plan of ancient Neapolis. It is therefore Greek in conception and Greek in execution, in contrast to Pompeii's meandering walls and old section of tangled streets. The streets of Herculaneum were paved with the trachytic Vesuvian stone still used in Naples, and also, in places, with a smoother calcareous stone. Unlike the streets of Pompeii, they rarely show the ruts worn by the wheels of heavily laden carts, and never show the stepping-stones to keep pedestrian feet dry. The stepping-stones in fact were not needed, as Herculaneum boasted an excellent drainage system—a sizeable underground sewer expertly constructed. Though Herculaneum's water supply was based on an adequate flow through aqueducts from the mountains, all buildings had not been converted to the municipal system. Many private wells and cisterns continued in operation; and, curiously, the Public Baths near the Forum continued to use well-drawn water. That the municipal system's pressure was adequate is testified to by the existence of a water tower at a suitable height. A filtration system was included. Though public latrines have not yet been located, no doubt they were supplied and flushed with a constant stream of water; and perhaps like other Roman latrines, their rows of marble seats were handsomely decorated.

As for the private houses of Herculaneum, they appear to be more evolved, more advanced in their planning, than those of Pompeii. Houses were important possessions in both towns. They were built not only for the generations, but for the centuries. They were designed for a single family, its dependents, and heirs. Often they were modified, kept up-to-date, by changes in layout or décor. But the house was the *domus*; it never lost its familial and ancestral aura of sanctity. No matter how rich or how poor the house, the household gods as local saints in Italian houses today—always had their place. So the house and its deities had a personality—a personality both unique and strong. Especially in the houses of Herculaneum, though empty of their inhabitants for nineteen hundred years, we can feel this personality the moment we enter. And the personality remains, vibrant, so long as the stones stand.

The old Italic house followed a well-established form: a living room in the literal sense (the atrium), with the impluvium, a basin for rainwater, in the center, covered by a downward sloping roof with an opening in the center (the compluvium). Terra-cotta drains collected rain for the basin and cistern. Originally, the roof opening let out the smoke from the hearth. The nuptial bed was placed in the adjoining room, the tablinum, and shielded by curtains for privacy. Sometimes a separate dining space, the triclinium, existed. Statuettes of the household gods, Lares and Penates, were kept nearby on a shelf, or in a shrine or niche (the *lararium*); sometimes they were painted on the wall. They represented the spirit of the house and the spirits of the ancestors. Devout old Romans made daily offerings to them of a portion of the food on the hearth.

In Herculaneum the shrines of the household gods remain, but their positions vary greatly. Extensive deviations occur in the room arrangements of Herculaneum houses. The atrium may become no more than a grandiose reception room, nor are the roofs necessarily open. Many an impluvium has been transformed into a fountain. The hearth has given way to separate kitchens, serving winter and summer dining rooms. The nuptial bed has disappeared

4

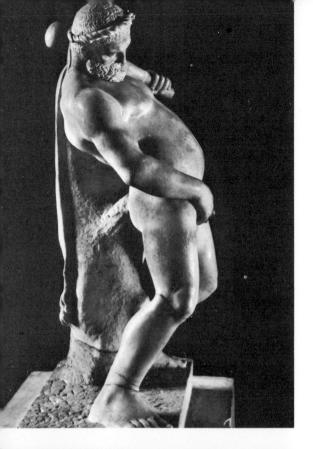

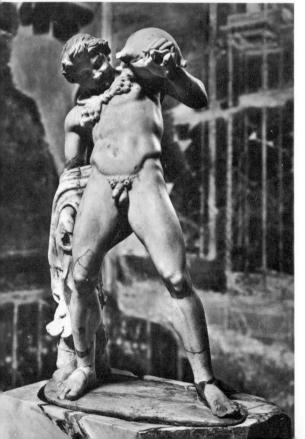

"Drunken Hercules," a Roman satire on the foibles of the god. This statue was uncovered in the garden of the House of the Stags.

Marble "Satyr with a Wineskin" from the Stags' garden is very similar to a bronze satyr-and-wineskin found at Pompeii. from the tablinum, which may be part of the reception room or even an office or study. Separate bedrooms (cubicula) open off courtyards or gardens. Portions or perhaps all of the house may be more than one story. Added are luxurious terraces for sunning, covered pergolas for dining, glass-enclosed corridors, and small quiet-rooms for resting or reading during the heat of the day.

Changes in decorative fashions ran parallel at Pompeii and Herculaneum during the period from about the fourth century B.C. until the date of Vesuvius' eruption. In each style the wall was considered an area for adornment. The earliest or "first" style consisted of simple planes of different colors, sometimes imitating blocks of polychrome marbles. The "second" style introduced the new conception of adding space to a room through illusion, using perspective to simulate depth in the rendition of architectural forms. The "third" style adapted the same principle in an impressionistic manner, using imaginary architecture with slender columns, small repetitive motifs, and human and animal figures in swift, bold strokes. The "fourth" style became ornate, baroque, depicting fantastic architecture with vast depths of perspective, often based on theatrical scenes. In all styles, rich, vivid colors were used with opulence.

As at Pompeii, many of the Herculaneum patrician houses have been divided into apartments and shops to-let, indicating the economic decline of the old aristocracy and the rise of new commercial classes. Already discovered is a large apartment house of several stories, resembling the five- and six-story apartment houses built at Rome and Ostia, the port of Rome. Foreshadowed are both the Italian medieval multiple-dwelling houses with an inner courtyard and outdoor stair, and the Renaissance courtyard overlooked by a loggia. Also to be found at Herculaneum is the Roman answer to the perennial housing crisis: a cheap light construction used to partition spacious rooms or build small houses in their entirety. All survived the mud lava and the earth shocks.

The rising mud, in fact, performed the useful function of preserving the upper stories of Herculaneum houses, whereas at Pompeii the upper portions collapsed from the weight of ash and stone. In Herculaneum it is possible to walk along a sidewalk shaded by the overhanging upper stories of buildings—and still having almost the exact appearance of two thousand years ago.

The mud, though at a scorching temperature, performed another useful function: wood, though often carbonized, was not destroyed. The testimony of Herculaneum has shown that the amount of wood used in ancient building was much greater than formerly supposed. Beams, window sills, doors, shutters, and stairs of wood are still in their original places. Many pieces of furniture—beds, chairs, cupboards, cabinets, shrines, tables—have remained whole. The quality of the cabinet work is often superb. Double-leaved doors still swing on original hinges; folding wooden grills can be made to fold. Intact are a wooden winch and an entire cloth press. Even "temporary" scaffolds supporting a sagging roof have been preserved.

About the economic life of the town it is too early to draw any final conclusions. Thus far the extensive installations of the Pompeiian fullers and fishsauce manufactories have not appeared; nor is there any indication of wine making, or the bustling activity of a trading port. Herculaneum, smaller and quieter than Pompeii, apparently was more concerned with fishing—if the volume of nets, hooks, and other gear is an indication. The chief commercial activity within the town, aside from the shops, snack bars, and taverns, seems to have been the work of skilled artisans. Certainly the demand for their handicraft was substantial. Their descendants—wrought-iron workers, wood carvers, mosaicists, gilt applicators—are still to be found in Naples.

As for the oldest profession, no lupanar, or brothel, has yet been discovered. Prostitution was certainly openly practiced, as it was not illegal. Sexual attitudes frequently reveal themselves in the painting and statuary favored by their owners. Nudity was not shocking. The men are portrayed as deeply bronzed, the women as creamy white. Scenes and situations deemed pornographic by heirs of the Judeo-Christian tradition seemed merely satiric or amusing to the inhabitants of Herculaneum. Their point of view was one of easygoing naturalism. The erect phallus was a potent charm, and it appeared and reappeared everywhere: on shop signs, on equipment, on jewelry, in paintings, and on statues. A Herculanean marble relief of Priapus—that unfortunate god (a son of Aphrodite and Dionysus) condemned to perpetual erection -shows him riding in the country. All living things, and even the spout of a fountain, respond in kind, for this was a joke. At the doors of shops and private houses, the handle of the bellpull was frequently a phallus. The cord rang multiple bells attached to the feet, arms, and phallus of a statuette of Priapus. Homosexual relations, incidentally, were accepted as a matter of course by the Greeks and by most Romans. Paintings and statues of Jupiterin the guise of an eagle—carrying off the handsome boy Ganymede to be his cupbearer offended no one. All the sexual follies and foibles of humankind were reflected in the gods themselves, and their stories were graphically related in hundreds of paintings on Pompeiian and Herculanean walls.

Concerning the religious life of Herculaneum, little specific information is

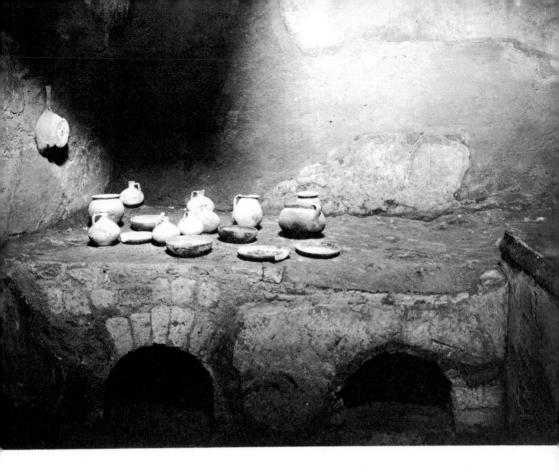

Cooking pots on a charcoal stove just as they were left nineteen hundred years ago in the kitchen of the House of the Stags.

at hand—not one temple has been uncovered as yet. The shrine of the Augustales is the only religious structure thus far exhumed, indicating the active practice of the cults of the divine emperors—a unifying factor in the Roman empire not unlike the role of the royal family in the British Empire. A temple to Hercules the protector must certainly exist. A graceful life-size statue of Aphrodite has been found. An inscription, carried by the current of mud, reveals that the Emperor Vespasian restored the temple of the Mater Deum. (The "Mother of the Gods" was the eastern goddess Cybele. Her priests were castrated and her festivals were celebrated with orgies, though the Roman officials frowned on such things. Her worship was permitted in Rome for political reasons.)

What other gods were the favorites of the town's citizens? In the small house

of the prosperous shopkeeper C. Messenius Eunomus, who left his silver cups and gold rings behind, a statuette of Hercules was discovered, just as statuettes of Jupiter, Aphrodite, and Mercurius were discovered in other houses. But in Eunomus' house were also a libation bowl inscribed with the words "Saluti Sacrum" and a devotional oil lamp and sacred oil container, suggesting the practice of a domestic cult. And along the marina is the "sacred area" where a number of structures, perhaps chapels, have survived. But chapels for which gods? There are no clear indications.

For the rest, we are faced with a series of questions. Did the cult of Isis, with its mysteries of death and resurrection, thrive in Herculaneum as in Pompeii? A Herculanean painting shows tonsured, white-robed priests of Isis performing their rituals. Most intriguing of all is the imprint of a cross, hastily ripped from the wall of a simple Herculaneum apartment near the Forum. Was it actually a cross—or a cross-shaped shelf? Is it genuine evidence that the cult of Christus had a following in the town of Hercules? Finally, what significance can be attached to the statue of the Egyptian sun-god Aton, so recently discovered? (Aton's worship was temporarily established in Egypt in the fourteenth century B.c. by the monotheistic Pharaoh Amenhotep IV, or Ikhnaton, husband and brother of the glamorous Nefertiti.) Such provocative religious questions may be resolved in future excavations.

One of the most impressive revelations about Roman towns has been the extent of their public services and public buildings. This comprehensiveness was no less true of tiny Herculaneum, with its Baths, Theater, Palaestra, Basilica, Market, and Forum. Of them all, only the two sets of bathing establishments are in large part visible. The elegant Suburban Baths are the most complete Roman baths ever discovered. An extensive portion of the Palaestra has been laid bare. Of the Basilica, only a few columns may be seen. Excavation of the Forum has just begun. The Theater remains entombed, paralyzed by the tons of volcanic matter which weigh it down.

In the dank tunnels of the Palaestra, the Basilica, and the Theater, the present visitor best realizes the enormity of the disaster which overtook Herculaneum ... and the enormity of the task of freeing it from the alluvial stone.

VI

HOUSES OF THE RICH PATRICIANS

IT IS BECAUSE WE WALK INTO THE HOUSES OF HERCULANEUM AS UNEXPECTED GUESTS that we learn most about the life of the people. Thus none of the owners is able to put up a false front, tidying rooms normally in disorder, or changing the pictures and statuary to avoid shocking our Puritan sense of propriety. Everything is as it was—including a wry scribble in a latrine. So it may be said that the citizens of Herculaneum are dealing with us in complete frankness. We must, therefore, deal with them in the same spirit, putting aside our prejudices and maintaining open minds. And if we view them with the omniscience of gods, we should also view them with charity.

Approaching Herculaneum from the sea side on that fatal August morning, we would have noticed first the sunlight reflecting brilliantly from the gilded equestrian bronzes on the distant public buildings, then the deep green of cypress, palms, and oleanders in the shady gardens. Drawing closer, we would have seen a cluster of variegated structures along the marina, including statues, fountains, and the Suburban Baths.

Above, on top of the walls facing the marina, was a row of distinctive houses much more colorful than houses today. These were the patricians' homes, built overlooking the sea for the breezes and the view. They were equipped with terraces, loggias, hanging gardens, fountains, pergolas. Usually the columns of their porticoes were painted red, the rich color now called Pompeii red. Their roof tiles were a yellow terra-cotta; their mosaics glinted with blue and gold. These were luxurious and elegant houses, perfectly designed for the seashore and the hot summer days.

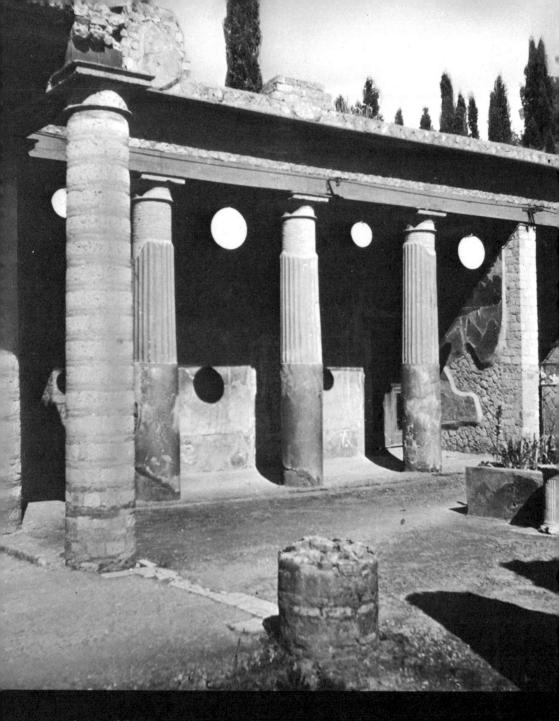

Atrium of the House of the Relief of Telephus. Mosaic floor and upper story now are missing, but the round marble *oscilla* hanging between the columns survived both volcanic

HOUSES OF THE RICH PATRICIANS

Now the sea is far away from its former boundaries, driven back by the counter waves of mud. Nevertheless it is possible to approach Herculaneum from the bay side on land, and view a portion of the panorama that existed nineteen centuries ago. The first of the open excavations began in this area, and gradually several important houses were uncovered (including one with a private bath). They are now, however, little more than heaps of ruins, thanks both to earlier indiscriminate excavation techniques and to inadequate protection. The houses of the new excavations give a totally different impression. They crown the bluff as in the past, their terraces, gardens, pergolas, intact. One almost expects a figure in Roman dress 'to come out, wave, and call a friendly greeting.

A steep incline leads through the Marine Gate (Porta Marina) into the town. Entrances to the patrician houses face on the streets, with portals opening directly on the sidewalks. One of the best preserved is the "House of the Mosaic Atrium" (Casa dell'Atrio a Mosaico). Inside the portal is a vestibule with a small room on either side—the right is the domain of the cook; the left, the domain of the doorkeeper, *ianitor*, and probably his dog. (Hence the famous sign: CAVE CANEM—"Beware of the Dog.") The mosaic in the atrium is a geometrical design of large black and white rectangles, forced into undulations by the enormous pressure of the mud. In the center of the atrium, under an old-style opening in the roof, is a white marble impluvium. This basin, too, has been forced out of shape by the weight of the mud. The room has great dignity.

Opening at the far end is a large and handsome tablinum. It is unusual, in that narrow aisles on the sides, with pilasters and windows, give it a plan not unlike a miniature basilica. The decoration of the walls is elegant but restrained. Missing is the statuary that undoubtedly adorned these rooms swept away, perhaps, by the flow of mud down the slope toward the sea, or removed by the tunnelers.

As the owners wished to take full advantage of the site, a second house, in effect, was built on the edge of the wall abutment and an appropriate connection devised between the two sections. This was possible because the town walls were no longer needed for defense. In the building process, the architects took into consideration the demands of the climate: hot summer days with brilliant sunlight; cool spring and autumn days with bright sunlight; winter days sometimes rainy and overcast, sometimes clear but cold with a strong wind from the northeast; rarely ice and snow. Closed porticoes were the architects' answer. Between the two sections of the house a garden was laid out and porticoes constructed on either side. The portico which faced the east and the strong winds was brick-enclosed for protection, with windows for light. The opposite portico, facing west, was glass-enclosed, with large sheets of glass held in place by narrow strips of wood. Much of the wood in the window frames, the beams, the sashes—though carbonized—is the original.

In the garden the indigenous plants of twenty centuries ago have been replaced. The paths, where peacocks once strutted, are graveled as before. A jet of water splashes upward in a rectangular marble basin, where goldfish swim. The original lead pipe to the fountain is visible. Behind the glass portico is a pleasant sitting room (exedra) overlooking the garden. The walls are colored an azure blue, with light architectural motifs, and adorned with two landscape paintings. One shows "The Punishment of Dirce," who for her cruelty was tied by her hair to a bull; the other shows "Diana Bathing." On either side of the sitting room are two bedrooms with red walls and stuccoed ceilings. In one is a round three-legged table, with each leg carved as a cat's head, carbonized. On the table is a round loaf of bread, carbonized.

Not far from the edge of the town wall, with a sweeping view of the sea, was built an imposing dining room—unfortunately now deprived of its furnishings. Here once rested the traditional three couches and low table for relaxed dining. Each couch held three persons. (In early Republican times, women sat at table while men reclined. Later, both reclined.) Additional tables and couches could be introduced when needed. In such a house as this, the table would have been of bronze and marble, the couches of wood inlaid with silver or gold and mother-of-pearl, amber, or ivory. For the additional comfort of the diners, the couches sloped upward at one end. Often the frame of the rise was curved in the shape of a swan's neck. The cushions were of various colors and of the finest soft materials. Dishes, knives, and spoons probably were of silver. Forks were not used at table by the Romans. Meat was cut in advance by a servant called the *scissor*. As for the decorations, only the paint on the walls has survived in spots, as well as traces of the elaborate marble floor.

Outside the dining room, facing south, is a covered loggia, and just beyond, a small uncovered terrace or sun deck, the solarium. At either end of the loggia is a small shaded room for afternoon repose. These little rooms, *cubicula diurna*, were located to catch both the sea breezes and the panorama from their windows—delightful spots to nap during the heat of the day.

Some of the objects found in the house are now displayed in various rooms: a colander with holes pierced in a pleasing design, handsome bronze bowls and glassware, a hatchet, decorations for a horse bridle, a wax tablet, ladles for soup, bells, oil lamps, door handles of bronze, a statuette of Venus, a fishhook, bronze candlesticks, perfume flasks, a bowlful of dates, a lead water tank intricately decorated.

Such a house fulfilled Roman requirements for gracious living. All the needed elements are present: sun and air, shade and view, active living space, and space for quiet repose. And of course a garden with a fountain. What more could any family ask?

Some did—much more. The next door neighbor, for example.

The "House of the Stags" (Casa dei Cervi)—so-called from two of its statues—is built around a rectangle more than 140 feet long. It abandons the traditional Italic house almost completely, and utilizes space in accord with characteristics of the site and demands of the owner. Its construction and decoration are of the time of the Emperor Claudius or Nero—that is, some twenty-five years before the eruption. It was, for its period, the most modern of houses. The chief architect must have greatly enjoyed his creative freedom and taken much pride in his work.

Like the House of the Mosaic Atrium, this house is divided into two major sections. To the north, and farthest from the sea, is the street entrance. The entrance itself, with its marble floor, immediately sets the tone. From a small reception room other rooms open off, very much like a twentieth-century house. Above are servants' quarters and storage rooms.

In the center, the dining room opens toward the garden. It is decorated with architectural motifs on a black background with alternating red bands. In contrast, its pavement of marble intarsia glows with color. Behind the dining room is a long corridor leading from the entrance hall to the *culina*, or kitchen, and adjoining *latrina*. The slow-simmering terra-cotta cooking pots are still in place on the charcoal stove. (These charcoal stoves remained virtually unchanged in rural Italy until the recent introduction of bottled gas. As a result, much more fried food has entered the Italian diet.) Nearby is an elegant small bedroom with red walls and a marble floor. Lighted by a small high window, it is dim and cool.

In front of the dining room and paralleling the longer sides of the rectangle, runs a covered gallery without columns. Here an amateur artist tried his hand at sketching deer and also a gladiator in combat. The glass windows make the gallery contemporary in appearance. The floor is of black and white mosaic. Along the length of the corridor, panels showed cupids at play—games like blindman's buff and hide-and-seek. Most were removed by the earlier excavators, and are now in the National Museum in Naples. In the center, giving

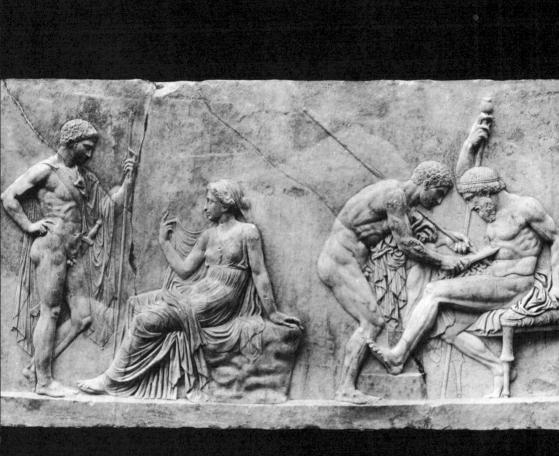

Marble bas-relief gives the House of the Relief of Telephus its name. Part of the myth of Telephus, son of Hercules, and his encounter with Achilles is portrayed here.

access to the garden and allowing a view of the garden from the dining room, is an opening with a pediment of glazed mosaics. In dominant colors of blue and gold, cupids ride sea horses, and a carved head of Oceanus adorns the peak.

To the south, directly overlooking the sea, is a large drawing room, flanked by bedrooms on two levels. Slabs of alabaster are stepping-stones for two entrances. Beyond the covered gallery of the drawing room is a roofed pergola. In its center is a white marble table with three legs carved as griffin heads; and on the table is a bowl of flowers. The pergola also is flanked with two rooms these two for afternoon rest. Below, at the edge of the embankment, is a sun terrace. Unluckily the floors and decorations of this section suffered serious damage from the Bourbon pillagers, who rooted all about the house like moles.

In the palm and oleander garden some statuary remains and from it we gain an idea of the owner's taste. The two stags, from which the house derives its name, are finely sculptured in marble. They have been set upon by dogs, and are being torn to pieces with gruesome realism. More relaxed is the "Satyr with a Wineskin," a naked and joyous young satyr carrying a bursting wineskin over one shoulder. Another statuette—found on the terrace—of extraordinary quality is the "Boy Eros," a nude adolescent with swirling curls (once painted red) and dreamy face. As the marble is of Greek origin, this statue was perhaps a Hellenic import. But most celebrated is the "Drunken Hercules," a Roman satire on the hero-god in an age of little faith. Good old Hercules, heavy, too fat, is excessively drunk—so drunk that only with fumbling difficulty can he attempt to urinate.

In this house was found an unusual object, a bronze bathtub—unusual because most Romans favored the public baths. Here too were the normal objects: the uncut bread, the lamps, the glassware, the tiny statuettes, the kitchen weights, the bowls, the bells for calling servants, the perfume flasks, a necklace, and a pair of dice.

The adjoining "House of the Gem" (Casa della Gemma) derives its name from a jewel engraved with the portrait of a handsome woman of the Claudian period, who easily could have been the mistress at the time of the disaster. It might have been called the "House of the Sundial," from the large sundial mounted in an open space. The owners of this house need not have relied on the sun for time, as they were wealthy enough to afford a water clock. (Time, for the Romans, was vague. The day, from sunrise to sunset, was divided into twelve equal hours; thus hours were longer in summer, shorter in winter. At night, without a water clock, people could only guess at the time. The simplest water clocks worked like an hourglass; the most complex had dials and a pointer to indicate the hour.)

The atrium of this house is of the old-fashioned Italic (specifically Etruscan) type, with roof supports of visible wooden beams strengthened by pillars. The red and black decoration was done by highly skilled hands and retains its quality. The remainder of the house plan is dominated by the requirements of the site, for limited space was available at this point of the embankment. Below are portions of the ancient fortified wall. The house is, therefore, irregular in form and compressed almost as tightly as living quarters on a ship. The rooms were notable for their decoration before being stripped by the Bourbons. A superior mosaic floor of geometric design somehow was overlooked in the dining room. Also missed was a cradle containing an infant's bones—though it seems incredible that a baby could have been abandoned to the mud.

Apparently the house itself, among its much larger and more pretentious neighbors, was a little gem. In any case, the owner unquestionably moved in the highest Roman circles, as a sardonic graffito proves. A curved corridor leads directly from the atrium to the kitchen and latrine, linked, as so often in Roman houses, for the more efficient and economical use of plumbing. In the kitchen a kettle and a vessel for boiling water are still on the stove. In the latrine, the earthiness of Roman humor is to be seen. Still scribbled on the wall is this sentence: *Apollinaris medicus Titi imperatoris hic cacavit bene*. (Literally, "Apollinaris, physician of the Emperor Titus, here shitted well.")

Worth recalling is the fact that Titus became emperor only a month before the explosion of Vesuvius. Was the jolly Dr. Apollinaris also caught in the eruption ...? In the latrine ...?

Of all the houses discovered on the Herculaneum embankment, the "House of the Relief of Telephus" (Casa del Rilievo di Telefo) is by far the most grandiose, though only a portion has been wheedled from the mountain of mud. In studying the irregularities of the ground plan, one gets the impression that the owner had tried to buy the House of the Gem for its view of the bay, and frustrated, had built all around the House of the Gem, almost swallowing it like a gigantic amoeba. As too-intimate neighbors, the owners must have greeted each other daily with a very testy "good morning."

The House of Telephus is a sophisticated house on many different levels: the embankment itself, styles of architecture, decoration. There is reason to believe that the owner may have been none other than Herculaneum's leading citizen, Marcus Nonius Balbus, Proconsul of Crete and Cyrenaica, a Roman colony in North Africa. From their statues, found in the Basilica, the names and appear-

HOUSES OF THE RICH PATRICIANS

ance of the entire family are known to us. Balbus, enormously wealthy, had supported Vespasian in the civil wars that took place A.D. 68–69, and on Vespasian's success had been generously rewarded. Balbus had died not long before the eruption, and a public memorial had been erected to him. At his death, his young son, Marcus Nonius Balbus Junior, became head of the clan.

The assumption of Balbus' ownership has been made because of interconnecting passages between the Suburban Baths and the House of Telephus the one above, on the walled embankment, and the other below, against the walls on the marina. Apparently the Suburban Baths were a gift of the Proconsul to the town of Herculaneum. Both hypotheses remain to be proved.

Unfortunately the house lay directly in the path of one of the strongest currents of mud. Portions of it were almost completely swept away. The wanton destruction of this house cannot be charged to the Bourbons: the preservation of the floors and the low level of the remaining walls show that Vesuvius alone was the villain. The Bourbon treasure hunters would have removed the floors with shouts of joy, for one floor in particular is the most sumptuous and beautiful ever found in a private house of antiquity. But it is better to return to the street and enter the house as a visitor, coming in due course to the drawing room with its spectacular marble decorations.

The atrium is on the street level, lying behind the House of the Gem, which blocks it completely from the sea. The harmony of the room, however, removes any sense of oppression, for it has the grace, simplicity, and dignity of the old Greek form from which it is derived. The room is viewed between two columns at the entrance. Parallel columns, solid at the base and fluted above, form two aisles at either side. The columns and the background walls are painted a bright, glossy red. In the intercolumnar spaces, white marble revolving discs (*oscilla*) hang from the beams, on both sides portraying Bacchic scenes. In the center of the black-and-white-mosaic pavement is a square fountain, surrounded by a trough of earth for flowers. The statue, which surely once adorned it, is missing.

In the atrium are displayed some of the items found in the collapsed rooms above: satyrs and sileni carved on marble, a necklace of amulets, household objects, bread, cakes, and eggs.

From the atrium small doors open to the passages leading to the stables, equally accessible from the street. Also from the atrium a ramp leads downward to the peristyle (*peristylum*). This courtyard apparently was a later construction, judging from the remains of older constructions in the subsoil. Columns, statuary, decorations, all were lost in the mud. Only the rectangular

blue-painted fish pond and stumps of the columns remain. On this level was a terrace, the drawing room, and several smaller rooms. Perhaps on this level, too, were the main dining room and most of the bedrooms; but beyond this point we are faced with a massive wall of hardened mud. Below, the rooms and corridors remain packed with mud. An exception is a chamber with extraordinarily intricate decorations, resembling those in the Golden House, Nero's fabled palace in Rome. (It was largely demolished by Vespasian to build the Colosseum on the site.)

On a wall, a snatch of light popular verse—or perhaps part of a current song—had been scribbled:

We came We came Here full of desire; Now our desire is to leave.

In one of the smaller rooms on the floor above was found the marble basrelief that gives the house its name—a scene from the life of Telephus portraying his encounter with Achilles. A copy now hangs on the wall; the original is in the Museum in Naples. The male nudes and female draperies are handled with extreme delicacy. The work is a product of the late Hellenistic school about first century B.C.—and must have been a treasured possession.

But the true showpiece of this house is the drawing room of marble, so elaborate and luxurious that it was suitable for an emperor's palace. The room is 22 feet wide and 30 feet long, and not only the pavement but the walls are of marble—and what marble! The floor is polished polychrome, in itself a masterpiece of the marble-worker's art. The walls are decorated with horizontal and vertical panels of rare marbles (African, purple, cipolin, black, green serpentine) enclosed by bands, and separated by slender, spiral, fluted halfcolumns with delicate Corinthian capitals. The colors blend and harmonize, and the result is magnificent—a masterly use of color in one of the most difficult of all mediums. The one remaining wall has been reconstituted from the fragments hurled down into the mud, and is a good example of the patience and skill required to restore the complex works of antiquity.

After viewing these patrician country houses built in a small seaside resort, we may well pause to wonder about the owners' town houses in Rome. For the people of Herculaneum the eruption of Vesuvius was a tragedy; but for us it is a tragedy that not one of the great houses of Rome has come down to us as intact as the "small" houses of Herculaneum.

VII

ROMAN LUXURY—THE "VILLA OF THE PAPYRI"

THE TRUE SPLENDOR OF A RICH PATRICIAN HOUSE IN ROME IS BEST SUGGESTED BY THE "Villa of the Papyri" (Villa Suburbana dei Papiri)—in the near vicinity of Herculaneum. Though the villa cannot be seen, the detailed plan drawn by the Swiss Karl Weber, during the eighteenth-century explorations, gives us a clear idea of the villa's vast extent. And the marbles, the sculptures, the library retrieved from the subterranean depths, indicate the opulence and sophistication of the owner. Even more will be learned if the villa eventually is rescued from its oppressive 65 to 80 feet of mud and lava—for Weber's tunneling was far from complete.

The existence of such suburban villas of antiquity had been indicated earlier when the foundations of the royal palace at Portici were being laid. The discovery of the Villa of the Papyri was to be the first of a series of intermittent discoveries of suburban villas near Pompeii (including the important "Villa of the Mysteries"), Boscoreale, Castellammare di Stabia (ancient Stabiae), and Positano (unexcavated). Of them all, the "Papyri" was most exciting.

It was a low edifice of colonnades and red-tiled roofs surrounded by gardens and fountains, cypress trees and palms—and stretching, in its entirety, at least a thousand Roman feet (about 800 modern feet) along an embankment above the Bay of Naples. Below was a beach equipped with private docks and boathouses. Stairs ascended by terraces to the villa level. The entrance, accessible either from the sea or from the main coast road, was an impressive columned portico. Clearly this villa was the residence of a most important family.

5

ROMAN LUXURY-THE "VILLA OF THE PAPYRI"

In this house, the once sacrosanct atrium had become no more than a convenient entrance hall. In the middle of its black-and-white mosaic pavement was a traditional impluvium—but here the marble pool was surrounded by an elaborate mosaic band and eleven statues: satyrs pouring water from wineskins, and cupids pouring water from the mouths of dolphins. Jets of water all around the pool transformed it from an old-fashioned cistern collectionbasin into a fanciful fountain for nymphs. In the left wall was a niche containing the basin of another fountain. To it were attached the bronze heads of thirteen tigers, from whose mouths water sprayed into the basin. In other niches were busts—Hellenistic royal portraits; and in still others, statuettes of fauns, one a dancing faun, and another a bearded satyr, with goat hooves, playing a pipe.

Unconventionally, the atrium opened directly into a square peristyle with ten columns on each side and a long, narrow pool in the middle. Streams of water spurted into the pool from conch shells set between the columns. Here was found the bronze head of the Doryphoros (the lance-bearer) adapted as a herma—that is, a pillar of stone topped by a bust and sometimes showing the male genitals. It is the finest existing copy of the head of the original by Polyclitus (a Greek sculptor, fifth century B.C., who first established the ideal

Incomplete plan of the Villa of the Papyri, as drawn by the 18th-century tunnelers, also indicates tunnels: 1: Rotunda of the belvedere. 2: Upper terrace of the garden. 3: Terrace retaining wall. 4: Small room. 5: Grand peristyle and garden. 6: Long fishpond. 7: Covered walkway. 8: Tablinum. 9: Lararium (?) 10: Peristyle. 11: Small fishpond and fountain. 12: Atrium. 13: Vestibule. 14: Entrance portico. 15: Library. 16: Living quarters. 17: Bath. 18: Room of colored marble. 19: Cortile.

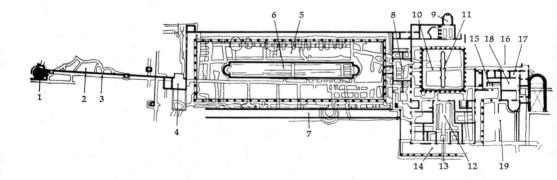

48

proportions of the human body), and was signed by the first-century-B.C. copyist Apollonius of Athens. On either side were bronze projections, where daily were hung fresh garlands of flowers as a tribute to the triumphant athlete. The original, a full-length nude, was one of the most celebrated sculptures of antiquity because of its perfect proportions (an excellent copy was found at Pompeii). In the peristyle also were uncovered the head of an Amazon on a herma, a copy of an original probably by Phidias, and a number of busts of philosophers.

In a nearby room, richly decorated with a polychrome marble pavement and wall frescoes, more Greek greats turned up: fine portraits of Demosthenes, Epicurus, Hermarchus, Zeno of Sidon. From this room probably also came the bronze head of a bearded Dionysus (or perhaps a priest of the Eleusinian mysteries), a classic work of the school of Praxiteles. Oddest find was a bronze portable sundial. Most Priapean was a handsome bronze charcoal brazier supported by three goat-footed laughing satyrs, each with left hand outstretched in warning not to touch, each with phallus erect. (In antiquity, the nude male never wore fig leaves; these were an innovation of certain museums.)

The exit from the peristyle to the grand peristyle led through a columned antechamber reminiscent of the architectural form of the Acropolis entrance in Athens. Here stood an archaic marble statue of the goddess Athene, impressive in contrast to the smoothly naturalistic pieces which dominated the villa's collection. Again, more bronze portrait busts were aligned in two rows, including one that may be the Roman hero Scipio Africanus, conqueror of Hannibal. He is shown as almost bald, the line of his scant hair indicated by a kind of tattooed marking on the skull. Dispersed on the floor of this room were scrolls of papyrus and wax tablets, apparently not scattered by the flowing mud but dropped by some human hand.

Outside was the great garden peristyle, a rectangle 330 feet long and 122 feet wide. Sixty-four columns surrounded the peristyle. On one side, in addition, was an enclosed, windowed walkway for wintertime. The area was equal to the forum of a small town. In the center of the garden was a fish pond as large as the swimming pools in the Imperial baths in Rome: 217 feet long and 23 feet wide. Here were found sculptures, between the columns and in the garden, sufficient to supply a whole gallery. Beyond the peristyle, at the end of a graveled pathway, stood the rotunda of the belvedere, remarkable for its palatial marble floor. Concealed was a subterranean aqueduct and the ingenious hydraulic system used to supply the house, the fountains, and the ponds with water.

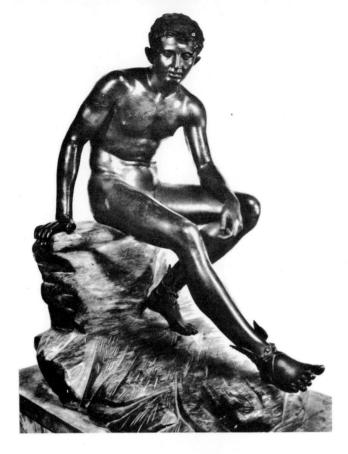

"Resting Hermes" (Mercury) from the garden of the Villa of the Papyri. The Papyri sculptures, all of the highest artistic skill, were the greatest single find of bronzes from antiquity ever made.

The "Sleeping Faun," like the Hermes, was reflected in the waters of the Villa of the Papyri fishpond. It is considered one of the most evocative statues of antiquity.

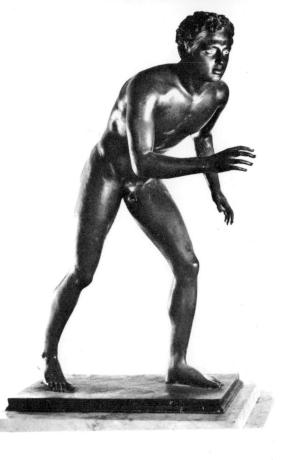

"Boy Wrestlers," a bronze group from the garden of the Papyri villa, are modeled with exceptional facility. Their eyes are made of glass paste, and traces of red paint remain on their lips. They are 4th-century B.C. Greek in origin.

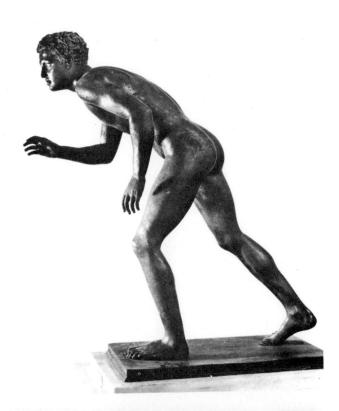

ROMAN LUXURY-THE "VILLA OF THE PAPYRI"

As for the sculptures, they are well worth attention in detail for their quality. They ranged from archaic to first-century contemporary, and when not originals they were copies of masterpieces by copyists who were masters. Maiuri, the initiator of the modern excavations, has pointed out that they had been chosen "with the eclectic taste of a connoisseur and lover of the arts."

Near the portal to the room of the archaic Athene, under the portico, were four marble portrait statues of which three were intact: Aeschylus, Homer, and an unlabeled Greek orator. In the garden, among flowers, were two bronze deer counterposed to one another, a jumping piglet balanced on one foot, and various bronze busts. At the curve of the pool, placed on an irregular marble base so as to reflect in the water, was the justly famous "Sleeping Faun," a lifesize bronze. The young faun, nude, sits with right leg thrust forward and right arm thrown back over his tilting head as he drowses, mouth open. From his forehead, under thickly curling hair, sprout horns; and from the sides of his cheeks dangle little goat wattles. The faun is one of the most evocative sculptures of antiquity. Who was the sculptor? No one knows; there is no signature.

Toward the center of the portico were five life-size statues of young women dressed in the simple Doric peplos, a long garment draped from the shoulders. Today they are called the "Dancers of Herculaneum." Scholars assert they are not dancing, but just what they are doing in their restricted but rhythmic arm movements, nobody can decide. Their eyes are made of glass paste, and their bronze garments along the hems show traces of color. Nearby, in the garden, were five marble busts and a marble group, "Pan with a She-Goat." The great god Pan, himself half-goat, is graphically shown in the process of intercourse to the Romans a satire on the bestiality inherent in all men.

The sculptured riches continued on the opposite side of the portico: more busts in marble, double hermae of historians and poets, the bronze bust of a Ptolemy prince of Egypt, and the bronze bust of a striking woman thought to be the poetess Sappho of Lesbos. Here too was the notable portrait bust of an old man at first thought to be the Roman philosopher Seneca; but this was an error, as the bust was not in the style of Seneca's time. Though copies of the bust have been discovered elsewhere, the subject remains unidentified. The best guesses today are for some well-known poet or philosopher.

In the garden near the pool were still more sculptures: a young woman wearing a peplos, in an attitude of prayer—a work of severe style; two wrestlers; the "Drunken Silenus" (foster father of Dionysus and leader of the satyrs); and "Hermes in Repose" (the Roman Mercurius)—all bronzes, all life-size. The wrestlers are young boys, naked, apparently about to close with

one another. Their bodies are modeled with the utmost grace; the eyes are of glass paste; and the lips show traces of red. The "Drunken Silenus" is amazing for its authoritative handling of a once-athletic body approaching middle age. The Silenus, or old faun, as he is sometimes called, lies drunk next to an inflated wineskin. Raising himself on his left arm, he snaps the fingers of his right hand and laughs hilariously. He is saying that he is not old yet. So realistic is the portrayal of this rascal that a couple of teeth are missing. He is going soft, and it is interesting to compare the anatomic detail with the equally mature, but taut, body of the "Dancing Faun" of Pompeii. The sculptor is unknown.

An unquestioned masterpiece is the world-renowned "Hermes in Repose." A young Hermes, naked except for the wings strapped to his ankles, pauses on a rock for a moment of rest before again taking flight—an admirable counterpose to the "Sleeping Faun." In the slimness of the god's body and the litheness of his arms and legs, in the smallness and delicacy of his head and the grace of his position, the influence if not the handiwork of the great Lysippos (contemporary and favorite sculptor of Alexander the Great) has been inferred. Hermes' lips, too, are touched with red. Part of the head had been smashed, and its reconstitution is a tribute to the extraordinary skill of the Italian experts. Hermes sits before us today no less beautiful than he appeared in the villa garden.

What of the total haul? From this one villa had come ninety pieces of sculpture: thirteen large statues in bronze and seven in marble; eighteen bronzes of medium and small size; thirty-two busts in bronze and fifteen in marble. Most had been recovered undamaged or only slightly damaged, in spite of the difficulties of chipping the hardened mud away from such delicate portions of anatomy as ears and noses, toes and fingers. Imagine the eerie effect of seeing the grotesque face of Pan taking shape by torchlight! No wonder that superstitious peasants gathered about the tunnel entrances, whispering in apprehension and fascination, as form after form of naked pagan "demons" literally emerged from the bowels of the earth.

Unquestionably more demons remain. Of the living quarters, Weber succeeded in exploring only a small apse (a *lararium* for the household gods?), a bath, and the library. Had not a single piece of sculpture been found, the library alone would have established Weber's dig as one of the most extraordinary feats in the history of archaeology. This was the first ancient library to be discovered; no one dreamed that the sands of Egypt might also conceal original ancient manuscripts.

Aller

It was not until the third year after the discovery of the villa that a tunnel reached a small room with an elegant marble floor, clearly a study. Close by was another small room; but this had wooden shelves, carbonized, stacked with what appeared to be cylindrical briquettes of charcoal. In the center of the room was a stand, with the briquettes stacked on both sides. The briquettes, when examined, proved to be rolls of papyrus badly scorched by the hot mud. But despite the illegibility of the manuscripts, the find excited the world; how fortunate that the villa's owner had preserved his books on papyrus, not paper. A count showed a total of 1787 volumes. The problem now was to unroll and read.

In the eighteenth century no scientific techniques existed to aid in such a task. King Charles called in a painter, whose diligent efforts resulted in a few words deciphered and many scrolls damaged. The attempt was abandoned. Later, Father Antonio Piaggio, a specialist on old manuscripts, was brought from the Vatican Library, and a new effort was begun. A machine was devised to unroll the papyrus; it resembled a contrivance used in wigmaking, and unrolled a scroll at about the rate of one centimeter an hour. After four years of trial and error, and the destruction of many scrolls, the machine produced results. Three scrolls were unwound, and scholars read a fragment of the *Treatise on Music* by the Greek Epicurean philosopher Philodemus.

Slowly new scrolls were examined. Piaggio himself worked on them for forty years. By 1806, some ninety-six had been deciphered. So eager was the world, waiting for great new discoveries of the lost literature of antiquity, that outsiders like King George IV of England engaged scholars to come to Italy and lend a hand. And in the mid-nineteenth century, such diverse personages as Pope Pius IX and Czar Nicholas I of Russia came to Naples to see the papyri. At length the general character of the library became clear; and today only eight hundred scrolls remain unread in the Biblioteca Nazionale of Naples.

The fragile papyri included an almost complete collection of the works of Philodemus, as well as some works of Epicurus and others. Most of the papyri were in Greek. Of the few in Latin, one in particular was beautifully transcribed. It was a fragment of an epic poem on the war between Octavian (Augustus) and Mark Antony. It had been written in the same period as Vergil's *Aeneid*, but the author's name was lost. (Subsequently this scroll was presented to Napoleon.) But the anticipated unknown plays, poems, and writings on philosophy, history, and music by the classic masters were missing. The ensuing disappointment was profound. How could so cultivated a person as the owner of this stupendous villa have collected so specialized a library? Who,

Same.

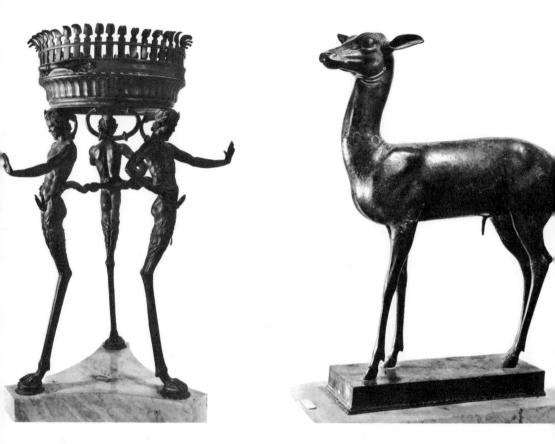

LEFT. Bronze charcoal brazier supported by ithyphallic satyrs from the Villa of the Papyri. It is possible that Julius Caesar once warmed his hands at this brazier, as the villa probably belonged to his father-in-law, Lucius Calpurnius Piso.

RIGHT. Bronze deer, one of a pair, found in the Papyri garden. Other sculptured animals in the garden were two rams, a leaping piglet, and a marble she-goat in fornication with the goat-god Pan.

other than a patron, would stock his shelves mainly with the works of a single author, neglecting the many brilliant authors of his own and earlier times ...?

Thus was provided a clue as to the possible ownership of the villa—a true literary detective story.

Philodemus lived in Rome in the period of Julius Caesar. Cicero, who was

personally acquainted with Philodemus, remarks in his writings that the patron of Philodemus was his own bitter enemy Lucius Calpurnius Piso Caesoninus. Now it happened that another bitter enemy of Cicero, Caesar, had taken for his third wife Calpurnia, the daughter of Lucius Calpurnius Piso. Cicero, it seems, respected Philodemus as a philosopher in spite of his link to Piso, but deplored his racy epigrams, for Philodemus heartily approved the full enjoyment of life, especially in youth. Apparently Piso liked his lascivious verse. Among Philodemus' surviving poems was one addressed to Piso:

> To Piso from his pet friend— This letter, Sir, to you I send, And beg you graciously to come Tomorrow to my humble home.

At four o'clock I you invite To celebrate our annual rite; A feast of friendship and of verse Sweeter than Homer can rehearse.

'Tis true we have no vintage wine Or fatted paunch whereon to dine. Yet if you will but smile on me Our meal a banquet soon will be.¹

As another branch of the Piso family is known to have had a villa at Baiae, it is not unreasonable to suppose that Lucius Calpurnius Piso also had a villa in the Neapolitan area. And why not near Herculaneum?—an ideal place, after the bustle and din of Rome, to relax and contemplate the Epicurean philosophy of a dependent friend and "client."

So it seems probable that none other than Lucius Calpurnius Piso used to sit contentedly in the beautiful marble-floored rotunda, looking seaward at Capri and Ischia, hazy blue in the distance. Behind was visible the serene bulk of Vesuvius. Piso might have held a scroll of Philodemus in his hands. Perhaps he dozed over the dull parts, but laughed in delight at the phrases his pompous enemy Cicero so smugly disapproved. And as Caesar had a villa at Baiae, it is not improbable that, with his wife, he came here to visit his father-in-law. They must surely have laughed together, for Caesar was a great one for salacious songs and jokes.

¹Translated by F. A. Wright (*Palatine Anthology*, 11.44)

ROMAN LUXURY—THE "VILLA OF THE PAPYRI"

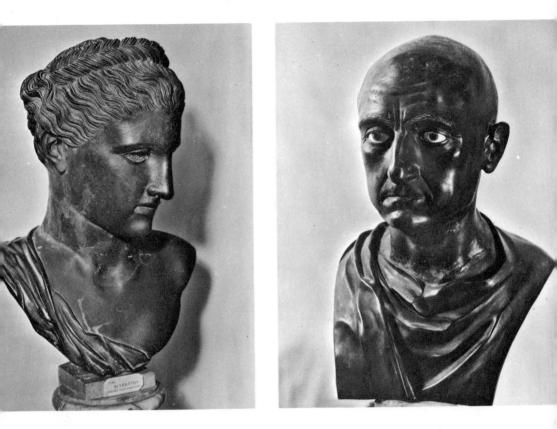

Bronze busts from the Papyri villa. The female head is Greek, probably Artemis (the Roman Diana), goddess of the moon and chase. She was a daughter of Zeus and twin sister to Apollo. The male head is a Roman portrait, once thought to be Scipio Africanus, conqueror of Hannibal.

In time, with the total excavation of the villa, some inscription may reveal the truth. Such excavation clamors to be undertaken someday, for much of this greatest of all known villas remains untouched. Yet to be discovered are the decorations, furniture, statuary, jewels, and private articles of the living quarters. Yet to be discovered, the kitchen, workshops, servants' quarters, garden sheds, boathouses, and all the paraphernalia necessary to the operation of a great country house.

Thus it may be said that new discoveries, no less fabulous than the old, remain to be made in the Villa of the Papyri.

VIII

HOUSES OF THE "POOR" PATRICIANS

ALL ROMAN PATRICIANS WERE NOT RICH. TRUE, BY THE TIME OF VESUVIUS' ERUPTION, the Roman upper-class structure had become rigidly stratified on the basis of wealth. To be or to become a member of the Senatorial Order—the pinnacle the possession of a minimum of 1,000,000 sesterces was legally required. To be or to become a member of the Equestrian Order—next highest of the patricians—the possession of a minimum of 400,000 sesterces was legally required. These figures are meaningful when we consider that a quality cloak, in the time of Nero, cost 98 sesterces; that an income of 10,000 sesterces per year from a farm was considered not bad. Wealth was steadily concentrated in fewer and fewer hands.

The story of the decline of some elements among the old aristocracy and the rise of a new commercial class can be read in the houses of Herculaneum. Only a few people could afford the costly houses built along the embankment overlooking the sea; only a very few could afford so sumptuous a villa as Piso's. The rest of the patricians lived in less assuming, though often elegant, houses. And as economic pressures accumulated, the newly impoverished tended to become small landlords, splitting up their houses into apartments and shops and living off rentals.

The sense of continuity with Herculaneum's past is most clearly defined in the patrician "Samnite House" (Casa Sannitica). And also continuity with the future—for this house is a prototype of the Italian Renaissance houses with their spacious loggias, to be constructed a millennium and a half later. Actually the house was built during Herculaneum's pre-Roman period, or at least three centuries before its submersion under mud.

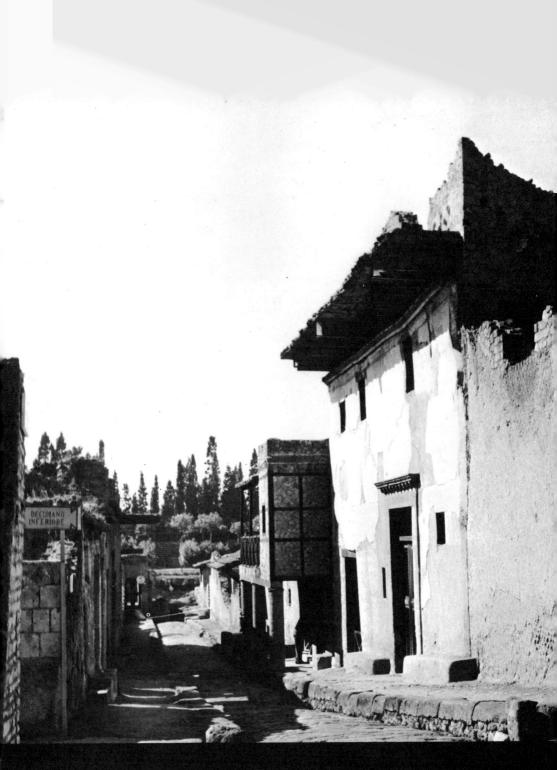

Adjoining patrician and plebian houses: large one is the House of the Wooden Partition; small one is the House of *Opus Craticium*—a flimsy, jerry-built structure for two families. The wooden hears everhapping the street in the patrician roof, are the original

HOUSES OF THE "POOR" PATRICIANS

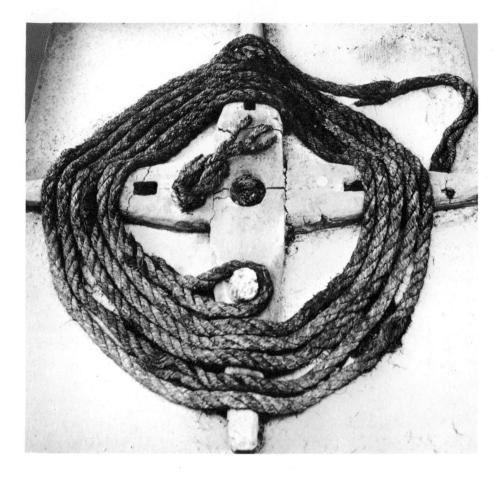

Windlass and original rope, only slightly scorched, used by the inhabitants of the plebian *Craticium* to draw water from their well, though Herculaneum was served by a highly efficient aqueduct.

When the house began its history it had space—a peristyle, a garden, additional rooms. Its entrance door was impressive, with squared piers and Corinthian capitals. Its vestibule was enlivened with relief slabs carefully painted to resemble polychrome marble, a type of decoration known at Pompeii and Herculaneum as the "first" style. Its atrium was of the old Etruscan type favored by the Samnites. Its impluvium was set in a *signinum* floor—bits of stone smoothed down in waterproof cement. All was serene and dignified. To this

HOUSES OF THE "POOR" PATRICIANS

basic Italic house was added a loggia and walkway on the upper floor, Greek in inspiration and form. Between small Ionic columns ran a perforated railing set in rounded honeycomb design. The room took on new grace and was full of light and air.

The other ground-floor rooms were not large. They were decorated with care. The smallest—no more than a cubicle—was done in a delicate sea-green monochrome, with architectural shadings. A small painting portrayed "The Rape of Europa"—when Zeus transformed himself into a bull. Another room was decorated in red. The floor of the tablinum was of high-quality tessellated work.

But in Roman times the house was changed. Three sides of the loggia were filled in. The upper story was slightly extended. A new opening was made on the street, to give access by steep stairs to a tiny apartment to-let. When the adjoining peristyle and garden were sold, the owners were restricted to what remained of the ground floor. The house had fallen on hard times—closed in upon itself. The sense of repose was not entirely lost, but the owners must have felt cramped and constantly irritated, even caged. The narrow stairs to the rental unit betray anxiety, not serenity.

Today in the red room may be seen a name scratched on the wall in Oscan letters, reading from right to left: SPUNESLOPI. Was this perhaps the idle work one day of a bored son of the original owner—a boy confined to bed with a cold? Or did the house remain in the hands of a Samnite family until the end?

Now in the house is a mutilated statuette of Venus putting on her sandals; fragments of wooden table legs carved in the form of dog feet; a bowl of cookies. And another graffito not in Oscan but in Latin: "Here love burned."

The front of the "House of the Wooden Partition" (Casa del Tramezzo di Legno) is the most completely preserved of any house in Pompeii or Herculaneum. With its little windows on the street side it might easily be a present-day house in, say, Fiesole—an ancient Etruscan town, now a suburb of Florence—or in certain parts of Trastevere, in Rome. The chief difference would seem to be that the wooden beams supporting the cornice are carbonized.

Once this house was a big house, running the entire length of the block, with separate entrances on opposing streets. But at some point (perhaps after the great earthquake occurring A.D. 62, when so much remodeling was undertaken), rooms along the street fronts were converted into shops and dwellings for artisans. And another story was added, with a separate entrance for the stairs, proving that this great *domus* no longer was inhabited by a single patrician family but by several families.

This was a typical noble house of pre-Roman days. Its large atrium and tablinum are spacious and distinguished. The rooms are high, and were decorated to the top. The basin of the impluvium reveals the story of an earlier remodeling: changes intended to make the house more elegant. The impluvium, constructed in Republican times, was originally of *signinum*; in the time of Claudius or Nero a new bottom of marble was placed above the old. And an elegant marble table was placed beside the basin; it stands there still. The Etruscan compluvium is decorated with terra-cotta spouts in the form of dogs' heads.

But the most striking feature, which gives the house its name, is the large wooden partition used to close off the tablinum from the atrium, and thus provide privacy for both rooms. The partition originally was made of three beautifully paneled double doors, but the central section was destroyed by the careless tunnelers, who bored straight through mud, wood, and all. The doors' reconstruction in their original place is a triumph of the art of restoration. The two-thousand-year-old wood swings on its two-thousand-year-old hinges. The bronze handles are just as they were formerly. The bronze supports, designed like ship's ornaments, still hold lamps. It is clear that the ancient carpenters and woodworkers, though lacking power tools, would need no lessons from us today.

The rest of the house is in keeping with the taste of the atrium. A small room to the right of the entrance has a handsome mosaic floor set in a geometrical design. A table of rare marble, against the wall, is supported by a single leg carved in the form of the Phrygian god Attis. (Attis was an extraordinarily handsome young man who castrated himself for the sake of the goddess Cybele; henceforth her priests did likewise to insure their celibacy.) The walls are painted in a pattern of delicate peach blossoms. To the left of the main entrance are two small bedrooms, which still retain the frames of their wooden beds.

A cozy, pleasant garden opens behind the tablinum. Around the garden is a small portico, with several rooms opening into it. The garden, as if the owner were not content with real flowers and shrubs, has been supplemented with a garden-painting: a trellis, plants, a marble water basin, and ducks. The largest chamber off the portico is the dining room. It was discovered during the first excavations, and unprotected, its decorations have suffered irreparable damage. On the wall of one room some angry person wrote a denunciation of "Mouse" as a "low-life."

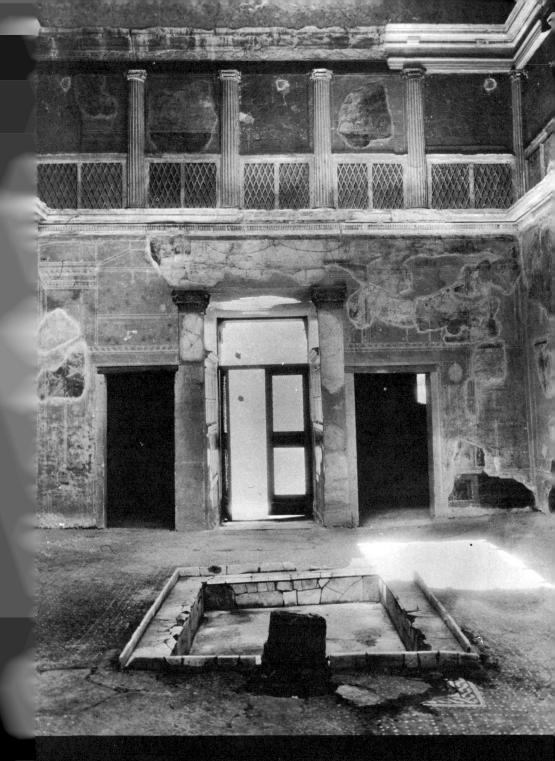

Atrium of the Samnite House, one of the oldest in Herculaneum, was built about two hunlred years before Christ. The loggia above, Greek in inspiration, was walled in after Roman conquest of Herculaneum. It foreshadows the loggias of the great Italian Renaissance During the later excavations many small objects—some of them highly perishable—were found. We see, for example, the pulls for a chest of drawers exactly like ours today. And also exactly like ours are the strap hinges, the pincers, the bowls, the ladles, the glass jars, the belt buckles, the bells, the lock and key, the beads, the hatchet-hammer, the blue chalk, the chick-peas. The perfume flasks are somewhat different. The needle is bronze, not steel. The straw from a broom is straw, not plastic. The black and white "backgammon" chips are a little different from ours, but the dice are exactly the same. The sandals for horse hooves (to prevent slipping on stone) are woven of cord, like modern beach sandals. But the most astonishing object of all is a piece of bread, broken from a loaf by a person who was just beginning lunch when Vesuvius erupted. Fused to the bread by the volcanic mud, and carbonized, is a portion of the tablecloth.

Not small and not grandiose is the patrician "House of the Black Salon" (Casa del Salone Nero), overlooking the Forum, and very recently excavated. This house is distinctive in the severity of its elegance, and gives the impression of having been lived in by extremely correct and conservative people. It too did not escape the fate of other big houses, for two shops were formed of rooms abutting the main street to the Forum. However, even if financially pressed, the owners did not allow the house to deteriorate, as its handsome decorations prove.

In the black salon, the walls were divided into rectangular blocks, and painted so glossy a black that they gleamed almost as mirrors. Each panel is flanked by painted pillars and candelabra in bright colors, to contrast with the solid black. In defiance of the principles of light reflection, the vaulted ceiling also is painted black; but the largeness of the skylight, which seems like a painting of the sky, is emphasized.

In this room is another miraculous wooden survival: a shrine in the form of a miniature temple. The fluted columns are of wood, the capitals of marble. Preserved within are the statuettes typical of a *lararium* maintained by people who remained devout in the old Roman faith.

The columned portico surrounding the courtyard is unusually elegant, as are the rooms opening off the courtyard. The painted ornamental motifs are of high quality. It would be especially interesting to know the cost of decorating this house.

In 1938, just two hundred years after the beginning of organized explorations at Herculaneum, one of the most significant of the patrician houses was restored to the light. Now called the "House of the Bicentenary" (Casa del

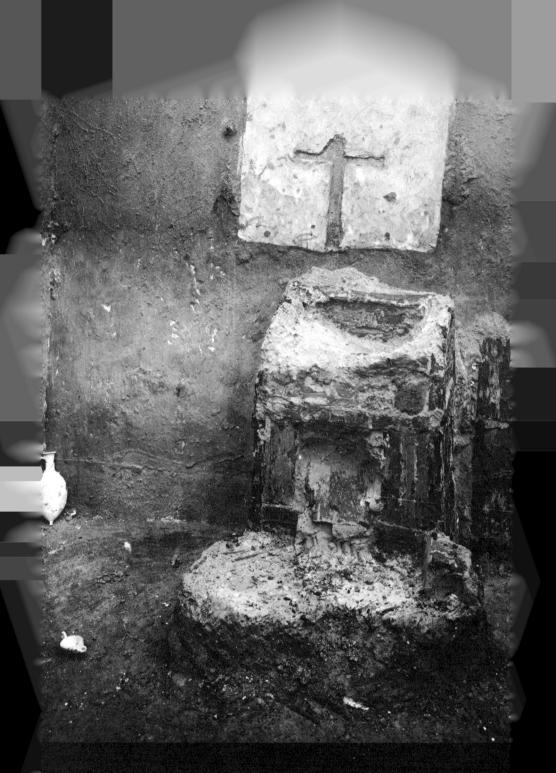

The Christian chapel in the House of the Bicentenary exactly as unearthed, before the wooden pratory was fully cleansed of its encasing mud. The mark of the cross is inset in a panel o white plaster, distinctly different from the wall

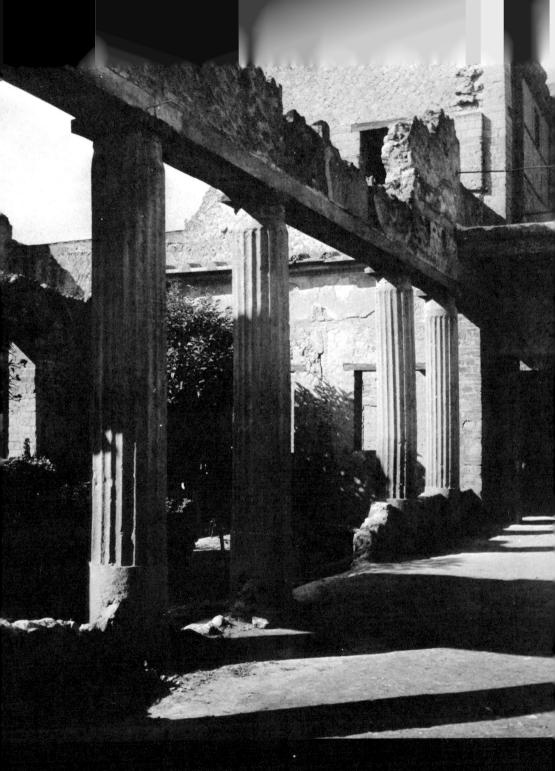

Peristyle of the House of the Bicentenary, showing a portion of the upper floor. The small door is the entrance to the room with the "Christian oratory" The wooden stairway not

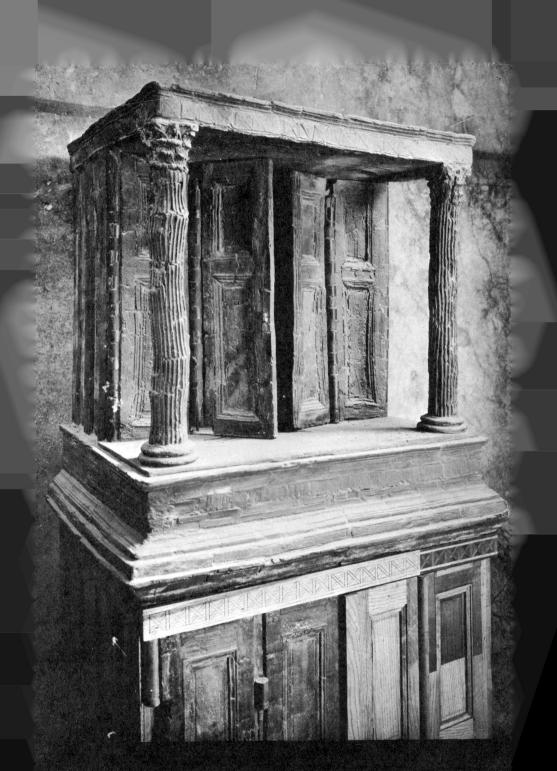

Wooden shrine for traditional Roman household gods, the Lares and Penates. Below is a cupboard for ordinary household objects. The cabinet work, with its inlaid woods, is of the highes quality. Slight rectoration is indicated at the bottom Bicentenario) because of the date of its excavation, it has fueled a controversy among archaeologists and historians which even today is not entirely resolved. In one of its rooms was found what may well be the mark of a crucifix.

Not far from the House of the Black Salon, and also overlooking the Forum, the "Bicentenary" is the largest and richest private dwelling yet uncovered in the area. It was, in addition, a beautiful house—beautiful in its harmonious proportions, in its pavements, in its painted decorations, in its woodwork, and no doubt in its statuary before the owner moved away. For it too could not avoid the changing economic demands and was rearranged to provide several shops and rooms or apartments to-let. Probably a late tenant—not the owner —was the subscriber to the communal cult of the Jew Chrestus, as the Romans called him, radical in its doctrine and near-revolutionary in its implications.

But for all the changes in the house, the ancient plan of the ground floor was not abandoned. The atrium was square, with a sloping valley-roof and the traditional compluvium (the beams have been restored to their original positions). The impluvium was white marble, set in a black mosaic floor sprinkled with small white tiles and emphasized by a mosaic band. The walls were painted a dark porphyry red, and burnished; interspersed were panels with architectural motifs and small animals. The *lararium* was decorated with painted snakes, the sacred serpents of the hearth.

The tablinum not only maintains but heightens the effect. The pavement of small white tiles is striped with black, and in the center is a rectangular panel of polychrome marble-simulating a multicolored carpet. The walls are the finest example of the "fourth" or last style of mural decoration yet uncovered in Herculaneum. The walls are divided into panels, flanked by medallions, showing busts of satyrs and nymphs. The band of the cornice has scenes of cupids hunting, painted against a black background; interspersed are elaborate designs of vines, flowers, and masks. In the center of each panel is a figure painting done with high skill. One depicts in a country landscape the myth of Daedalus and Pasiphae, including the bull. (Daedalus was the designer of the Labyrinth for King Minos of Crete; Pasiphae was Minos' wife and mother of the Minotaur—half-man, half-bull, sired by a bull. Daedalus also designed the artificial cow in which Pasiphae received the bull.) The other painting depicts Venus and Mars, with Mars nude and Venus partially undressed, the prelude to their affair. Usually in this scene Mars is portrayed with one hand on Venus' breast.

Two wings open off the tablinum. The one on the left is empty. The one on the right is closed by a wooden partition with a parapet; but the partition

HOUSES OF THE "POOR" PATRICIANS

actually is a folding gate the height of a man, similar to the folding gates used nowadays to block stairways to small children. And this gate still folds on its bronze pins, still slides into place! At the top is a cornice, inlaid with rare woods in a design reminiscent of the most elaborate eighteenth-century furniture. Behind the gate is nothing. What, originally, could have been in the enclosed space? Probably the images of the patrician family's ancestors—set apart, protected, but not barred from view because of the openings of the folding gate. When the family departed, long before the eruption, the images (death masks or paintings) departed with them—as did the furniture, to our great loss.

Among the small finds were a bronze seal inscribed M. HELVI EROTIS, a mortar and pestle with an opening for liquid to flow out, two bits for horses, money, rice and walnuts, dice, many lamps, a graceful marble statuette of Venus at her bath, and a portrait of a young prince of the Claudian family.

This house also preserved unique treasures. On the upper floor, in a room set apart from the modest rental apartment, was found a white stucco panel on the wall. In the center of the panel was the mark of a wooden cross, apparently ripped away in haste. If only a shelf, the mark was of extraordinary shape; and more extraordinary, the fixing nails were driven at top and bottom, not laterally—hardly a secure manner for a weight-bearing shelf. A wooden cabinet, like a small oratory, was found below the white panel. The cabinet had a platform in front, as if for praying on the knees. Also in the room was a terra-cotta jug in one corner, a plate, a bowl, a pot with a handle, and a lamp.

Most authorities now accept the authenticity of the mark as indicating the presence of a Christian crucifix, though the assent is by no means unanimous. The Apostle Paul landed at nearby Puteoli (modern Pozzuoli) A.D. 61, and it has been surmised that the existence of this Christian cell was the result of his teaching. Nothing similar has been found at Pompeii or at any other excavation sites dating from the first century after Christ. If the Herculaneum find is evidence that the cross had come into use as a Christian symbol as early as 79, it is indeed significant.

Who were these early Christians? They might have inhabited the apartment on the upper floor, or the rustic rooms surrounding the small peristyle and garden on the ground floor. As the Roman patrician owners apparently had left, perhaps the house was occupied by two or more families who, joining other Christians for the communal meal on Saturday, used the room of the cross as a chapel.

These questions cannot be precisely answered. Nevertheless, the House of

the Bicentenary has bequeathed to us some fascinating information about at least one family that lived there. In this house were found eighteen wax tablets, inscribed in triplicate and sealed in such a manner as to preclude tampering. They remained legible. When transcribed they proved to be legal documents concerning a lawsuit that involved one of the tenants of the house —Gaius Petronius Stephanus.

The tale is worth telling in its entirety, for it has dramatic elements reminiscent of the Roman stage.

IX

STORY OF A ROMAN LAWSUIT

SHORTLY BEFORE OR AFTER THE GREAT EARTHQUAKE, A.D. 62, A BABY GIRL WAS BORN in the quarters of Gaius Petronius Stephanus. The child was called Justa. The mother's name was Vitalis; the father's name, if known, was not publicly acknowledged.

Vitalis had been bought as a slave by Gaius Petronius, probably at the time of his wedding as a gift to his new wife. He had married a freedwoman known as Calatoria Temidis—a name evidently derived from the patrician Calatorius family of Herculaneum (of whom more later) to whom she herself may have belonged as a slave. Gaius Petronius was a member of the lower middle class, and it was not inappropriate that he should marry a freedwoman.

Nor was it inappropriate that the slave-woman Vitalis in due course should be freed, most probably by purchase of herself. Also it was necessary to pay the State a freedom tax equal to 5 percent of her assessed valuation. Vitalis assumed her master's name, and henceforth was called Petronia Vitalis. And the girl Justa was accepted into the master's household and brought up "like a daughter"—though definitely labeled illegitimate. For a decade and more all were in accord, all harmonious and happy.

But the peace dissolved at the birth of children to Gaius Petronius. Friction arose between his wife Calatoria and the freedwoman Petronia Vitalis. Arguments were unresolved, jealousies sharpened. Petronia Vitalis, as a freedwoman, could no longer be constrained to remain in her master's house; she chose to leave. She wanted a home of her own and economic independence. Apparently she was willing to work hard for what she wanted. But her master and his wife refused to relinquish Justa: a child brought up like a daughter, she was looked upon as their own. Now quite grown-up, she was intelligent and pretty, an asset to the household.

Indignant at being deprived of her daughter, Petronia Vitalis brought suit against Gaius Petronius. After extensive negotiations, the case was settled with the award of Justa to her mother, provided that Gaius Petronius be reimbursed for the cost of Justa's food and upkeep during the years of her childhood and adolescence. Petronia Vitalis, who had done very well for herself, immediately made the payment and received her daughter into her own home.

This happy state of affairs for Petronia Vitalis and Justa was to be all too short, for Petronia died. And, at about the same time, so did Gaius Petronius. It seemed that this drama of little people in the town of Hercules had been played to the end. Not so. The widow of Gaius Petronius, Calatoria, brought suit to recover Justa and all the property she had inherited from her mother, on the grounds that Justa had been born while Petronia Vitalis was still a slave hence Justa was a slave.

Beds and couches in Herculaneum were usually of wood, sometimes richly inlaid with rare woods and fitted with metal intaglios of silver or gold. Legs were of wood, sometimes of bronze. Fine-combed wool mattresses were placed above slung ropes or wooden slats. Here a bed, restored, is shown with chamber pots.

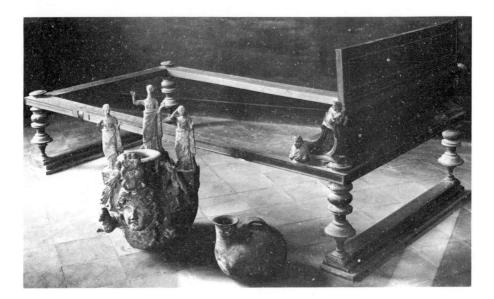

STORY OF A ROMAN LAWSUIT

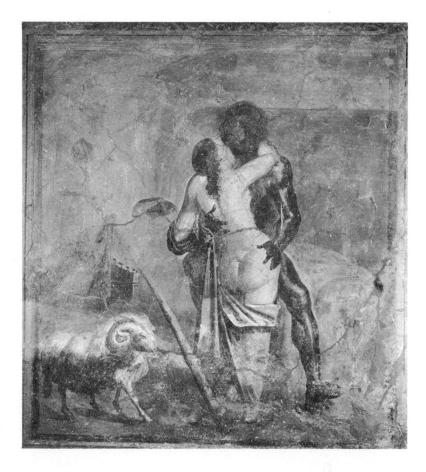

Love-making was a favorite theme for frescoes on bedroom walls. Typical is this embrace of satyr and nymph. Males were frequently shown nude and deeply bronzed by the sun; women, partially clothed, and white.

It appears from the depositions that Petronia Vitalis had amassed considerable assets, and Calatoria was more interested in this wealth than in the girl herself. As slaves had no property rights, with the reversion of Justa to slavery all she owned would become the property of her mistress.

Justa fought back.

No substantiating documents existed for either side. Before the enormous growth of slavery in Rome, manumission had been a rather complicated process, always legally recorded. A formal statement of freedom was made before the magistrates, or the new freedman's name was recorded in the censors' register, or the master inserted a clause of emancipation in his will. But when the large majority of the population became slave, the cumbersome rites were dropped; and a letter, or even a verbal declaration by the master in the presence of witnesses, was considered sufficient. In the freeing of the slave Vitalis, Gaius Petronius had remarked merely that the woman was no longer bound. Though he remained her patron, as was customary, no record was kept of the manumission date. Nor, if she bought herself, did Vitalis have a receipt. Thus the sole proof rested on the word of witnesses who allegedly were present at the time; and witnesses were notoriously easy to buy.

The suit was brought before the local Herculanean magistrates, who declared that they lacked jurisdiction over the matter. The case therefore was transferred to Rome, before the tribunal of the city judge, or praetor, in the Forum of Augustus. Subpoenas were issued, the witnesses took the stand, and all testimony was recorded. A parade of pros and cons followed, with the

A divan of modern type was discovered in the House of the Carbonized Furniture. The divan was luxuriously upholstered, and had delicate spindle legs (now enclosed in plastic). Beside it was a round, three-legged wooden table set with dishes for a light luncheon.

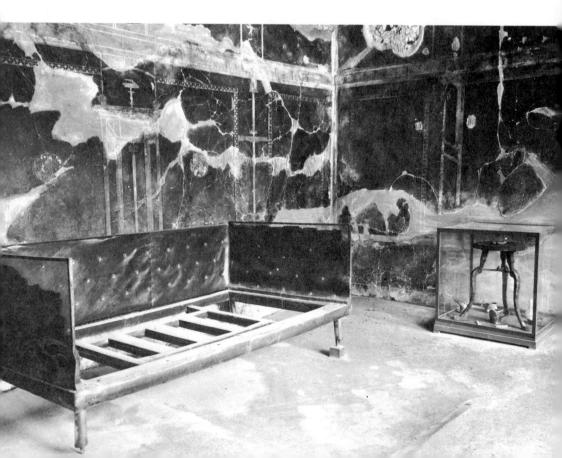

STORY OF A ROMAN LAWSUIT

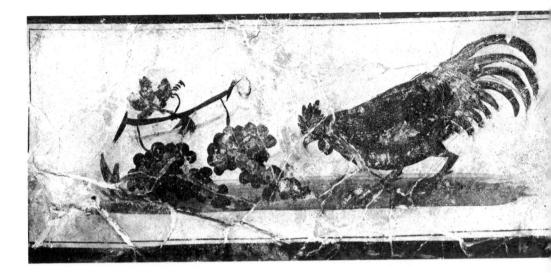

Birds, fish, and wild game were favorite subjects for little pictures in Herculaneum dining rooms. Glass bowls, wine flasks, and fruit were repeated in still life. Chickens very often appear, plucked or in feathers. Here a rooster picks at grapes.

declarations canceling one another. One of the witnesses against Justa was an illiterate, who claimed to have had the confidence of Gaius Petronius; but his testimony was so garbled that even with professional aid it was impossible to put his statements into grammatical, much less credible, form. His evidence, nevertheless, was admitted. The case bogged down, a morass of confusions.

Suddenly a new witness appeared—an authoritative witness who blew away the swampy miasma and cleared the air. He testified in favor of Justa. He was Telesforus, the administrator-manager-bailiff-foreman who had served Gaius Petronius for many years. He was a freedman, and though he still served Calatoria, he dared to testify against her. Moreover, he had come into Gaius Petronius' house through Calatoria, for in her girlhood he had been her tutor. His declaration was matter-of-fact and precise. He had handled the negotiations for the return of Justa to her mother, he said. It was then acknowledged that Justa had been born after the manumission of her mother. The Roman court, he said, should now make the same acknowledgment.

For all of Justa's pleas, the Roman court was not prepared to reach a rapid decision. The judge wished to take the matter "under advisement," to appraise carefully all the possible angles of the case. No decision would be possible be-

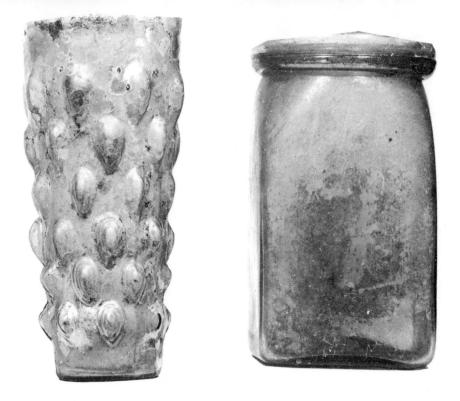

Glassware typical of Herculaneum and Pompeii. Bowls and vases not infrequently were made of crystal. Glass was sometimes clear, sometimes colored. The jars were in commercial use, for jams, marinated vegetables, etc.; thousands have been found.

fore the end of the next year's court session . . . or the end of the year after that . . . or the year after that. The courts, after all, were so heavily burdened. . . .

The depositions in Rome had begun, as shown by the consuls in office, in the year we designate as 75, and carried over into 76. When Vesuvius erupted and buried the records of the case in 79, apparently a decision had not yet been rendered. We shall never know whether Justa was freed or reduced to slavery.

Interesting speculations remain. Why was the administrator Telesforus suddenly moved to testify against his patroness at the moment when it seemed that Justa's case was going badly? What did Justa's status mean to him? Nothing in his declaration had been in the least sentimental or personal. Yet, in describing Petronia Vitalis he had used a curious phrase: he had called her *colliberta mea*—his colleague in liberty, his co-freedperson.

It seems unlikely that class identity would be strong enough to motivate

testimony so obviously against Telesforus' own private interests. He must have had another motivation, a deeper motivation, which made him willing to take the consequences of Calatoria's inevitable animosity toward him. Perhaps his description of Petronia Vitalis was an involuntary admission that he was the unknown father of Justa. If the master Gaius Petronius had been the father, no effort would have been made at concealment; nor would Justa have been relinquished to her mother at any time, in all probability.

When the young slave-woman Vitalis came to the house of Gaius Petronius, Telesforus was an older man, but not himself a slave. As Vitalis was a slave, she could be seduced but not married. Telesforus was the freedman of greatest importance in the household, in a position to use his influence in Vitalis' behalf. Evidently he did so. Very soon Vitalis was freed; perhaps Telesforus pro-

Oil lamps, bronze, almost identical. The left is from Pompeii, the right from Herculaneum. The fuel was olive oil, which burns with a clear light and without fumes. Lamps were used individually, or hung in clusters on lamp stands.

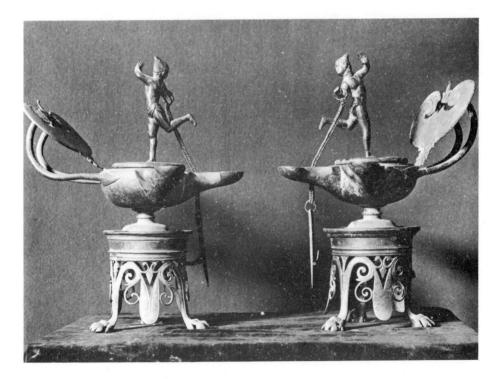

STORY OF A ROMAN LAWSUIT

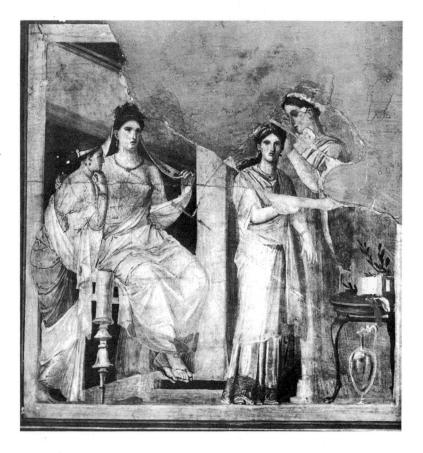

Fresco shows Herculaneum matron supervising toilet of her daughters. One, hair done-up with a ribbon, watches while a maid combs the other's hair. Their clothing is of thin fabric in pastel shades. They wear earrings, necklaces, bracelets. Note the design of the matron's sandals, and the glass pitcher under the table.

vided the money for her self-purchase. When the child Justa was born, she was taken into the household "like a daughter." And finally, it was Telesforus who had carried on effectively the negotiations that returned Justa to her mother. Always, in the background, Telesforus was there; to Justa he assumed the image of a patient and loving father.

The records found in the House of the Bicentenary may well have belonged to the wife of Gaius Petronius, Calatoria. They had been deposited not far from the room of the cross. Was this, then, the family that worshipped in that tiny chapel? Admittedly, Gaius Petronius and Calatoria do not have the character we usually associate with the early Christians. What of the possibility that Telesforus and Petronia Vitalis, "co-liberta," had been converted to the Christian faith? To us today this would seem the more probable. But would a Roman master of the lower middle class designate an entire room of his rented house as a religious center for his freed servants? Hardly. Even the doctrines of Paul—though distinctly not revolutionary in contrast to rival Christian teaching—seemed radical and dangerous to a stereotyped Roman mind. Paul did not question the institution of slavery; but rare would be the master who approved even the slightest hint of rebellion.

In addition, membership in the Christian movement was dangerous. The persecutions of the time of Nero, when the mad emperor flung Christians to the wild beasts and made living torches to light the spectacles, were fresh in everybody's mind. Gaius Petronius and his wife gave no evidence of the stuff of martyrs. Nor would he and his wife have been happy to lose their investment in their servants, should their servants prove willing to be martyrs.

Nor can it be assumed that Calatoria had moved from the house, and some new Christian family had taken possession. Certainly Calatoria would not have left the court records behind. Had she died, the records would have been disposed of. So we can only conclude that the house was shared with some other family, openly and defiantly Christian, and very modest of circumstance. Perhaps the seal of Marcus Helvius Eros provides a clue to that other family. The name indicates that the owner was a freedman, probably Greek in origin. The seal was found on the upper floor, in one of the rooms of the small suite adjoining the "chapel." As a man's seal was very important to him, it was always guarded jealously. Only in so great a crisis as the eruption would it have been discarded. So we may safely assume that these rooms were occupied by a family other than Calatoria's. Considering the arrangement of the upstairs rooms and the juxtaposition of the "chapel," it is an almost inescapable deduction that the upstairs tenants were associated with the new cult-or in any case had responsibility for the use of the room. We may be reasonably certain, therefore, that this family, known only by the abandoned seal, was Christian.

Calatoria left us the complex documentation of a sordid and selfish lawsuit. The other family, unknown in detail but acknowledging the brotherhood of man, left us the simple documentation of the mark of the cross—a cross hurriedly saved—while others left silver and gold behind.

7

Х

HOUSES OF THE MIDDLE CLASS

WHILE SOME PATRICIANS OF HERCULANEUM WERE BEING FORCED TO RENT PORTIONS of their homes, the prosperous upper middle class built or bought houses of their own. Rather surprisingly, their houses do not display the new-rich vulgarity described by Petronius in his hilarious account of Trimalchio's dinner in *The Satyricon*. It is worth quoting a paragraph or two to savor Petronius' satire on a merchant prince of the time of Nero, and thus not far removed from the time of Vesuvius' eruption.

Now that the guests were all in their places, the hors d'oeuvres were served...On a large tray stood a donkey made of rare Corinthian bronze; on the donkey's back were two panniers, one holding green olives, the other black. Flanking the donkey were two side dishes, both engraved with Trimalchio's name and the weight of the silver, while in dishes shaped to resemble little bridges there were dormice, all dipped in honey and rolled in poppyseed. Nearby, on a silver grill, piping hot, lay small sausages, while beneath the grill black damsons and red pomegranates had been sliced up and arranged so as to give the effect of flames playing over charcoal. We were nibbling these splendid appetizers when suddenly the trumpets blared a fanfare and Trimalchio was carried in, propped up on piles of miniature pillows.... He was picking his teeth with a silver toothpick.... A tray was carried in and set down before us. On it lay a basket, and in it a hen, carved from wood, with wings outspread as though sitting on her eggs. Then two slaves came forward, and, to a loud flourish from the orchestra, began rummaging in the straw and pulling out peahen's eggs which they divided among the guests.

Perhaps the middle-class merchants and bankers of Herculaneum, unlike Trimalchio, were not yet rich enough to afford dormice and peahen's eggs; but they were rich enough to afford such luxuries as bronze portraits and mosaic-inlaid fountains. As Herculaneum was not essentially a commercial town, the possessions of the commercial classes are not as extensively represented as at Pompeii, where Trimalchio was proud to own gardens. Nor do the middle-class houses yet approach the elegance of the rich patricians; the cleavage in Herculaneum is more marked. In Herculaneum the members of the middle class are still climbing; in Pompeii they have arrived. With increasing wealth, the houses of the Pompeiian middle class often become difficult to differentiate from the houses of patricians. Certain aspects, however, all enjoy in common, such as the paintings of fruit, fish, or game, which frequently enlivened their dining-room walls—like the dining rooms of nineteenth-century England and America.

In Herculaneum, all the middle-class houses struggle with the same critical architectural problem: lack of space. Some resign themselves to the old architectural forms and remain content with small or even tiny rooms in regular order. Others abandon old concepts, develop new solutions, and unwittingly forecast some of the houses to be built in centuries to come. The space problem remained acute so long as cities and towns confined themselves within the cramped limits of city walls. The ultimate resolution in Herculaneum, as on the island of Manhattan, was to build upward. For the middle classes an extra story or two became desirable; for the small merchants and artisans extra stories became inescapable.

With the space problem resolved, after a fashion, the middle-class house owners could turn to the problem of decoration. In this they followed the same tastes displayed in the patrician houses. That is, they attempted the same types of decoration, frequently with success. Sometimes their resources were not sufficient to command quality artists or craftsmen, and their decorations suffered. Nor could they be so lavish in scope. Sometimes they concentrated on limited wall areas, or on a single fountain or shrine. It is to their honor that the results, though not grandiose, so often are truly distinctive.

One of the first houses of this group to be discovered was the "House of the Skeleton" (Casa dello Scheletro), where in 1831 a skeleton was found in an upstairs room. The exhumation was not completed, however, for nearly a

HOUSES OF THE MIDDLE CLASS

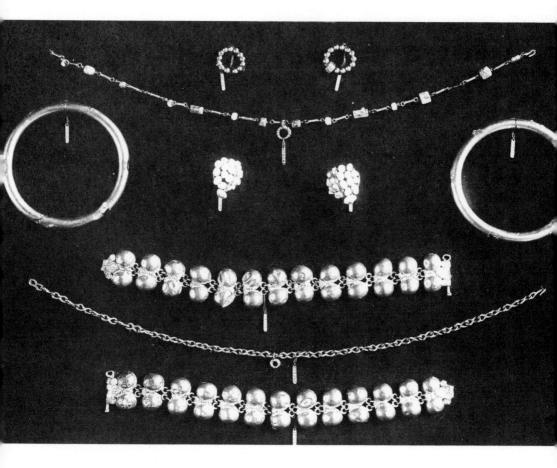

Jewelry worn by the women of Pompeii and Herculaneum was of gold (as here), silver, ivory, crystal, or ceramic. The goldsmith's art was one of the most highly skilled and ancient of all, and probably was well established by the earliest Greek settlers in the region of Naples.

hundred years. The house is small, with many well-decorated rooms. Unfortunately the upper story, where the early excavations centered, was not properly protected, and as a result has crumbled to ruin.

Here, in very limited space, the architect attempted to create the illusion of unlimited space. As land was not available for either portico or garden, the designer compensated with tiny courtyards and light-wells, which were dis-

Silver mirror decorated on the back with a scene called "Dido Abandoned." A woman, perhaps the famous Queen of Carthage, swoons from unrequited love, as is shown by the perplexed Eros at her knee. The man involved might well be the Trojan Aeneas, who had abruptly sailed away. The silver disc, showing the god Pan in a pensive mood, is probably the back of a man's mirror. Sitting on a lion's skin, he plays a lyre near a woodland herma, with a sacrificial bowl before it. guised as rustic grottoes sacred to nymphs (*nymphaea*) or as shrines or as gardens with painted flowers. The *nymphaea* were bordered with seashells and decorated with mosaics and are highly reminiscent of the grottoes so frequently constructed in Italian sixteenth-century villas.

As an atrium with the traditional impluvium was impractical, the roof was covered completely, and the slope directed toward the street, as in some modern houses. The largest courtyard was entirely covered at the top by a horizontal iron grill to bar intruders from adjoining buildings. The problem of tranquil, relaxed dining was solved by attaching a *nymphaeum* with two little fountains and a wall painting of a garden.

On hot days the owner of this house could return from business for lunch and an afternoon nap (as small-business men still do in Italy) feeling that his house was as cool, quiet, and shady as a villa. Like the richest of his fellow citizens, he could drop off to sleep to the soothing rhythm of running water, and awake refreshed. However limited his means, this unquestionably was a pleasant house in which to live—and die.

In Herculaneum, as in Rome, all classes mingled—and so did houses. The small house adjoining the patrician Samnite house was built much later than the Samnite house, for its walls employ the old tufa columns of the Samnite peristyle as fill. The middle-class owner seems deliberately to have constructed a more elegant entrance than his Samnite neighbor. So successful was he that today his place is known as the "House of the Grand Portal" (Casa del Gran Portale).

Indeed the portal is beautiful and impressive, and to us it is very familiar. We have seen its form and proportions repeated again and again in copies that have been handed down to us through Ostia and Rome, through Renaissance Vicenza and Georgian Britain. (The author, while driving through a tiny Vermont village, once saw an Early American house with a wooden front door that was an exact copy of a Pompeiian door.) The entrance is flanked on either side by a round brick half-column with Corinthian capital embellished by a Winged Victory. Above, a simple Doric architrave uses conventional terracotta mutules as blocks to ornament and break the line. The columns originally were covered with fine stucco and painted red—altogether a very satisfactory entrance for a man who wanted his house to appear imposing.

In consequence, the interior is a disappointment, for it does not live up to expectations. Insufficient space was available for even the traditional form of the Italic house, and a small open courtyard was forced to act as an atrium, catching rainwater for the cistern and admitting light and air. Nor could the courtyard be set in the center of the house, but of necessity to one side. A covered vestibule, overlooked by the various rooms, in turn performs the functions of a courtyard. The reception and dining rooms were combined into one. To compensate, the room was decorated with a good painting of Dionysus, Silenus, and two small satyrs. Dionysus holds his long staff, the thyrsus, topped with a pine cone—the symbol of fecundity. (No doubt the Puritans would have been shocked to learn that the pine cones on their four-poster beds were Dionysian sexual symbols.)

The effect of all the decoration was to create an illusion of lightness and space in an edifice lacking both. A small but elegant sitting room is lightened with a frieze of theatrical curtains, with birds and cupids in a flowering garden in the background. One wall of the vestibule reveals slender architectural forms painted on a black background, with a picture of birds pecking at cherries while butterflies flutter gaily. Another room presents a picture in the marble pavement; draped curtains are painted on the walls. All this is in the "third" or impressionistic style.

As for the service functions, the kitchen, latrine, and storage room are grouped as in much grander houses, and are about the same size. Three amphorae in the kitchen are labeled "chick-peas," "flour," "rice." So long as servants worked in the kitchen, nobody paid much attention to kitchen arrangement, decoration, or view. Only since the end of World War II has the idea of a truly modern kitchen, as a pleasant room and integral part of the house, begun to penetrate Italian formal architecture. This of course reflects significant changes in the economic structure, the new Italian industrial revolution, and the rise, for the first time, of a numerous middle class with few or no servants.

The "House of the Bronze Herma" (Casa dell'Erma di Bronzo) illustrates the conventional dwelling in which the space problem was solved by building smaller rooms or by simply eliminating rooms, so that the house consists of only an entrance corridor and two tiny flanking rooms, a small atrium, a smaller tablinum, a miniature courtyard for light and air, and a dining room on the ground floor, and tiny bedrooms upstairs.

But despite its small size, and the fact that it was plundered by the tunnelers, this house has a number of interesting characteristics. The bronze portrait of the owner, placed on a herma, escaped pillage, though the dedicatory inscription and the owner's name did not. The bronze bust, obviously of local workmanship and crudely done, reveals the character of the man. The face is a very Roman face: thin, elongated, prominent Adam's apple, Roman nose,

Bronze colander of intricate design shows care lavished on Herculaneum household utensils. Buckets were fashioned of bronze or silver and embossed with scenes such as "Aphrodite at the bath." The silver spoons are for table use. Small forks of multiple prongs were a development of the Middle Ages. Roman knives were of steel, with gold, silver, ivory, bone, or wooden handles—but rarely used at table, as meat was sliced before serving.

ABOVE. Plates and cups of silver were exceptionally graceful. These are samples from complete services that have been recovered from houses buried by Vesuvius. Their discovery in the 18th century had a profound effect on silver design.

BELOW. Folding stool with bronze legs in the form of bird beaks. The wood and canvas are restorations. Other stools with thin bronze legs were almost identical with modern metal terrace furniture.

HOUSES OF THE MIDDLE CLASS

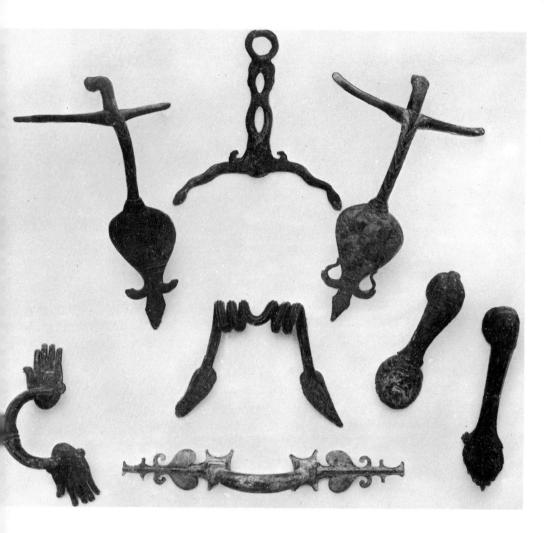

Bronze handles for doors and chest drawers. Hinges swung on bronze pins of various types; some were the ancestors of what were called "HL" or "Holy Lord" hinges in Colonial America.

close-set eyes, tight mouth, hair cropped short (not so short as a slave's, of course) and combed forward.

This face is all the more intriguing in comparison with those Greek–Campanian faces which appear so often in the wall paintings of Herculaneum and

HOUSES OF THE MIDDLE CLASS

Pompeii. In the paintings we see round faces set on stocky necks, abundant dark curly hair, bronzed complexions, large dark eyes set wide apart under heavy eyebrows, full sensuous lips. These faces are the prototypes of the faces of the fauns and the satyrs, the heroes and the athletes—all preserved for comparison with the southern Italian faces of today. Only among the upper class, and especially among the remnants of the aristocracy, are found faces akin to the long, thin, cold, almost ascetic face of the undeniably Roman owner of this house.

How did it happen that a Roman came to inhabit a Samnite house? For the House of the Bronze Herma was one of the oldest houses in Herculaneum. The atrium is in the Etruscan style, unmodified. The impluvium was made of thin tufa slabs, the oldest thus far discovered. The doorways are all of pre-Roman height and proportion. The jambs of the entrance portal are held secure by the

Medical instruments uncovered in Herculaneum and Pompeii were identical, but this more complete set came from Pompeii and show the high level of Roman surgery. Shown here are a vaginal speculum; an anal speculum; suction cups used in the treatment of pleurisy; forceps; catheter; sounds; pincers; a clipper; a dilator; pins; spatulas; cauterizers; needles; knives used in brain surgery; clamps; oculist spoons.

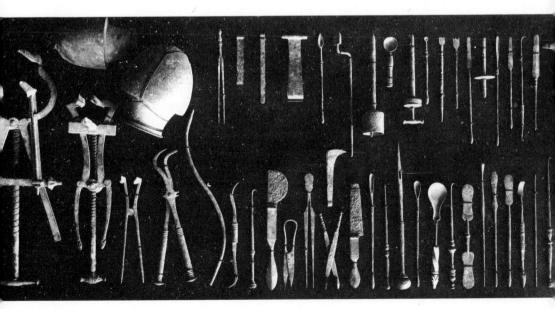

oldest type of construction: squared blocks of tufa. The wall decorations are in the "second" style of literal architectural forms.

So perhaps this house was a reward to some Roman official or petty administrator of the army, after the successful conquest of the Campanian towns by the legions. Perhaps the house was passed from generation to generation, until the current owner's portrait was placed on a herma as was customary. Perhaps the lost or stolen inscriptions someday will be found, and such speculations will be resolved.

From a group of middle-class houses in Herculaneum has been derived most of our practical knowledge of Roman furniture in wood. Though Roman houses in general, like Greek houses, were sparsely furnished, the individual pieces often were extraordinarily fine. Thanks to the matrix of mud, we can actually touch the same furniture used by the ancient inhabitants of Herculaneum; and though the wood is largely carbonized and the finish and upholstery have disappeared, we can easily visualize the appearance of the original. Because Italy was, and is, a country of marble, and because there are many remains of marble tables, benches, and shrines, it can be inferred that wooden furniture was luxury furniture. Roman literature records some of the extravagant prices paid for elegant inlaid tables of rare woods—for, like silver table services, they were a status symbol. (Cicero paid 500,000 sesterces for one table.)

In the "House of the Wooden Shrine" (Casa del Sacello in Legno) was preserved a very rare specimen of ancient furniture—a combination cupboard and shrine. The house itself is an almost pure example of Roman house planning in the time of the Republic: simple, sedate, austere. The shrine, with its double function, exemplifies Republican thriftiness. Its form is that of a temple, with the pediment supported by two intricately carved and fluted columns. The double doors open in such a way as to reveal the statuettes of the gods within. Below, closed shelves held, and still hold, perfume flasks, buttons, pincers, a strigil. Added are dice, a glass fruit bowl, a dish of garlic, and a statuette of Mercurius.

In another room is a good example of the small round wooden table favored for placing bowls of fruit, flowers, wine flasks, or candles. It most nearly resembles the type of table called a candlestand in early America, but is more elaborate and has three legs joined to the top instead of a central stem. Each of the graceful legs has its foot carved in the shape of a griffin's head. The whole was probably polished to a high gloss. It now holds a woven straw basket and a cup of pine nuts. In an upstairs room a large number of wax tablets with illegible writing were found under a bed. Had they been in the wooden cupboard they might have been better protected. The owner of the house was Lucius Autronius Euthymius; his seal survived.

In the house next door was a record of gladiators who fought in the amphitheater (where?), including Herculanese. (Gladiatorial combats were introduced to the Romans by the Etruscans, but the Greeks never accepted the custom.)

Bedroom furniture was preserved in houses of all class levels in Herculaneum, and offer comparison with one another. There were some double or three-quarter beds, but most were single. In the upper-class House of the Wooden Partition the bed stood on legs shaped by a lathe and was ornamented with filigree metal trim. Wooden panels at the head and on one side protected the occupant from the damp of the wall. The mattress, probably of fine-combed wool, was placed on a grill of varying square and rectangular slats—the rectangular section so designed as to support the torso comfortably. In the middle-class "House of the Alcove" (Casa dell'Alcova), two beds at right angles were preserved in an elaborately decorated bedroom of the "fourth" style. Possibly they were inlaid with fine woods. Their legs, too, are shaped to points. Their mattresses were placed on wooden slats; other beds were designed for ropes slung between the frames. In the small houses and shops of artisans similar beds, though usually without inlay or veneer, are to be seen.

Still in its original place, in the "House of the Carbonized Furniture" (Casa del Mobilio Carbonizzato), is a dining couch or divan, with an individual luncheon table of wood standing nearby. Though this was a prosperous house-hold, lack of space precluded a courtyard and the attendant summer dining room. When a house lacked a courtyard or open-air terrace, it was the custom on hot days for the master to take his meals in the shadiest and coolest room. In such a room, with a mullioned window overlooking a small court with a flower bed, was found a divan of an unusual type. It had high back and sides, which were richly veneered. It was well upholstered and cushioned; after dining, the occupant had only to stretch out for a comfortable nap. The hand-some little table, with a beveled top, has finely carved feet in the shape of greyhound heads. The table is still set with terra-cotta dishes and glassware. Elsewhere is a painting of an eager Pan approaching a sleeping, unwary nymph. Perhaps the occupant of the couch was given to such daydreaming while he waited for his noon meal that sultry August 24th.

The "House of the Mosaic of Neptune and Amphitrite" (Casa del Mosaico di Nettuno e di Anfitrite) offers in one structure all the chief characteristics of middle-class house design and furnishings, including a connecting shop. Though the contents and decorations are remarkably well preserved, the quixotic volcano either pushed out the street wall with the wave of mud, or shook it down with an earth tremor. In any case, the front wall is sheered off as if Vesuvius had planned to place the house and its contents on display—an effect familiar to us from wartime bombings. On the upper floor, visible from the street, is a bedroom with its wooden bed, bronze candelabrum, and marble single-legged table undestroyed by the disaster. To the right, the latrine is laid open and the pipe to the sewer is visible. One expects to see curtains flutter, dust settling, and the inhabitants cautiously returning from a bomb shelter.

Surviving on one wall is a list of wine deliveries, with their dates. On another is a list of spelling words to be learned by some harassed schoolboy.

The rest of the house deserves attention in detail, as it is justly famed for its precious mosaics and other decorations. The walls throughout are skillfully frescoed and additionally adorned near the household shrine by marble panels painted by Greek artists. A handsome bronze herma of Hercules and a notable bronze statuette of Jupiter stand in the spacious atrium. But dominating all else is the open (summer) dining room, where the owner compensated for the lack of portico and garden by an almost pyrotechnic display of multicolored mosaics. The result would have been suitable for the grandest patrician house.

Around an L-shaped marble basin, supplied with a jet of water from an intricately carved small column of marble, the walls gleam with mosaics. Blue and gold are the dominant colors. At one end is a large *nymphaeum* with a central apsed niche flanked by two smaller rectangular niches. The apsed niche was designed for a now missing statuette; the niches on the sides still hold marble pedestals. The entire *nymphaeum* is covered with mosaic floral designs, which surrounded two panels of deer being chased by hounds. Festoons of fruit and flowers are surmounted by peacocks. Scallop shells frame the edges, and colored masks cap the pediment. The whole effect is theatrical, and any nymphs residing here most certainly would have been at home on the stage.

The owner was not satisfied with this spectacular *nymphaeum*, however, and placed another vivid mosaic on one wall: a nude Neptune and his seminude wife Amphitrite. His Greek name was Poseidon; her Roman name, Salacia (our word "salacious" is derived from this goddess of salt water). Logically the house should be known as that of "Poseidon and Amphitrite" or "Neptune and Salacia." Salacia was given to holding aphrodisiac fish in her lap. They stand side by side in a formal pose, in glittering gold, against a conch shell framed by a columned panel. Intricate stylized floral designs in red, blue, and gold surround them; no living flowers could equal such brilliance.

So at last the owner rested content. With what reluctance he must have fled, leaving behind such glory! And if he saw the front wall of his house collapse, he might have reflected with irony that Neptune was not only god of the sea but earth-shaker too—whenever he chose to remind mere men of their inability to control the forces of nature...

XI

THE PLEBS—HOUSES AND SHOPS

IN HERCULANEUM THE DWELLINGS, SHOPS, AND WORKSHOPS OF THE LOWER MIDDLE class and artisans—the plebs—are easy to recognize. The small merchants tended to reside in small houses that were connected with or close to their shops. The artisans tended to live in cramped quarters to the rear, or on a mezzanine above their workshops; and sometimes, too, the ground space was utilized for both work and selling. As for the slaves, they inhabited whatever quarters might be assigned to them, usually the smallest rooms or those near the kitchen.

Two unique "plebian" buildings have been uncovered in Herculaneum: a true apartment house for low-income families and a cheaply constructed two-family dwelling. These two structures are very important in the history of urban construction. The apartment house is the prototype of the multiple tenement, which in the second and third centuries dominated the populous cities of Italy. (The six-story buildings which had existed in Carthage were razed to the ground by the Romans in 146 B.C.) It is the direct ancestor of the nineteenth-century tenement. The two-family dwelling is the only known complete example of a light, inexpensive, rapid-construction Roman housing unit, though the details of its method were described in 16 B.C. by Vitruvius. Fragments are to be seen at Pompeii and in other Herculanean buildings.

The apartment house is impressive: its frontage is over 265 feet, its remaining height almost 40 feet. Structural reinforcements at the base indicate that the height was considerably greater, but the upper stories were destroyed in the eruption. In Rome, five- and six-story apartment houses were common. Some were taller, though Augustus had issued an edict limiting their height to 70 feet. Most of the urban population lived in apartment houses. By the end of the third century only one private house existed in Rome to every twentysix blocks of apartments. Their exteriors were handsomely decorated.

The ground floor of the Herculaneum apartment building was given over to shops. The upper flats were reached by at least two entrances, with wooden stairs leading to various landings. Part may have been used as an inn for transients. Details of the water and latrine system are not clear, but perhaps they were not dissimilar to the American tenements of the 1880's—with a single supply of water. It is impossible to say whether latrines existed on each floor; but latrines in upper stories are not uncommon in Herculaneum. The large vaulted sewer, which served the area, has been explored. It is easy to imagine washday, then as now in Naples, with clothing hanging from balconies. Baskets would have been let down on cords from upper windows; and the mingled odors of garlic and various herbs in sauces cooking on kitchen stoves would have been no different.

The two-family house, in contrast, was as fragile as a bird-cage, yet miraculously it survived in far better shape than the massive apartment building. It adjoins the patrician House of the Wooden Partition, and could hardly be in greater contrast. One wonders: were the children of these two houses allowed to play together? It would be interesting to know. Normally, Romans of all classes rubbed shoulders without distinction.

The structure is called the "House of Opus Craticium" (Casa a Graticcio) because the phrase is the Latin designation for the type of construction, though sometimes it is called simply the "Trellis House." It is nothing more than a wooden skeleton of square frames, with each square filled in by stones and mortar crudely thrown together. Inner partitions frequently are flimsy laths of cane, thinly plastered. The general appearance is not unlike an English half-timbered house, though the roof is not gabled. This technique was developed in response to the growing population and housing crisis, which accompanied Roman expansion. In Republican times structures were firmly built of heavy stone. After Augustus, brick and marble were the preferred materials of the Empire. But an economical, fast method of construction was needed, and *opus craticium* was the result. Vitruvius takes the trouble to point out its disadvantages: lack of permanence, dampness, danger of fire. It would astonish him to know that one such house had survived two thousand years.

The Herculaneum jerry-built house was designed for one family on the ground floor (with some upstairs rooms), and another family on the upper

8

floor. They shared only the cistern. The upper apartment was reached by a stair with a separate entrance. The front was only twenty-two feet, including the two doorways. An enclosed inner courtyard with overlooking windows provided light and ventilation for both families—in embryo the courtyard of modern blocks of flats. All the rooms are small—averaging 10 feet square—and the ceilings are low. The upstairs kitchen overlooked the street. On the ground floor one room was used as a tiny shop.

Surprisingly, this flimsiest of all Herculaneum buildings preserved not only its form but its furnishings. The beams were carbonized and have been reconstructed. Some of the steps in the wooden staircase are the original, still usable. The upstairs bedrooms in one flat have retained the red coloring of their walls. The wooden bedsteads, the wooden clothes cabinet, the wooden cupboard with utensils and statuettes of the household gods, the marble tables—all remain in their original places. Only the mattresses and bed linen are missing.

Snack bar, now called the Sign of Priapus because of the god's image crudely painted on the shop's wall. The scroll-like device is a modern roll of canvas for protection against fading. On the counter are some of the walnuts found in the shop and utensils that were on the charcoal stove.

THE PLEBS-HOUSES AND SHOPS

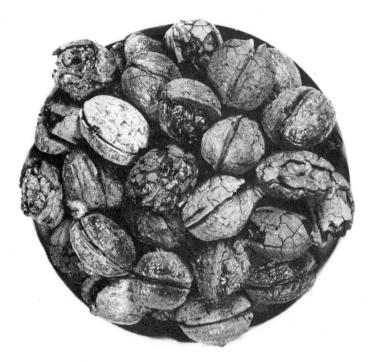

These walnuts (the type we call "English" walnuts) remained nineteen centuries in a Herculaneum container. Even the nut meats have survived inundation by Vesuvius' scorching mud.

And the original rope, slightly scorched, is still wound on the original windlass for the well. The working people or small traders who lived here reclined at meals like patricians or the rich middle class, as is proved by a still-intact dining couch. Also remaining in the upstairs flat is a wooden shrine, a bust carved of wood, and half of a marble *oscillum* with a horse carved on it. Evidently discarded from some patrician house when broken, the marble fragment might have been retrieved from the junk heap by a youngster and brought home as a trophy. The "backgammon" set is identical with that found in the patrician house next door. The glassware is good. The thumbtacks are still capable of performing their function, and the wool is waiting to be carded. On a wall, someone—apparently a young man—writes that his friend Basileus still remains in Puteoli. If the former occupants could return, they would find little difficulty in resuming their lives in this simple house.

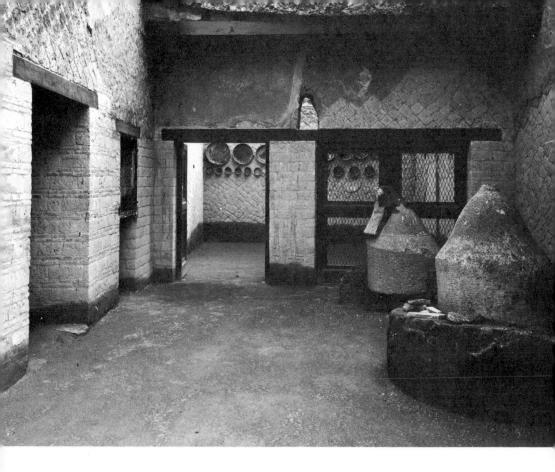

Bakeshop of Sextus Patulcus Felix, with his bronze cake pans hanging on the back wall. In the foreground are the mills that ground his flour. In the room opening to the left is the intact oven, guarded by two immense phalli over the iron door.

There are many houses of about the same economic level attached to shops. They are scattered indiscriminately among the patrician houses, as if constructed at later dates in response to the growing demands of trade. Some are meaner, others much more elaborate. One, the "House of the Painted Papyrus" (Casa del Papiro Dipinto), though very small, boasts a painting of a scroll with a poem lettered in Greek. The name of the author, Eutychos, is unknown to us in Greek literature. Might this house have been the habitation of a schoolteacher rather than a tradesman?

Shops and workshops vary greatly in size and equipment. All the small merchants were not equally successful, all the artisans not equally in demand. It would appear that competition was fierce among them. Similar shops and artisans can be seen on the back streets of any Italian city today, and especially in the south.

The largest shop thus far discovered at Herculaneum is the corner shop just across the street from the entrance to the Palaestra. It was a strategic location, justifying two spacious entrances. The counter was faced with irregular pieces of polychrome marble, and eight large jugs (dolia) are inserted into the counter itself. They contained various cereals and vegetables, as has been shown by analysis. Another larger jug perhaps contained olive oil. Other jugs and amphorae may have been for other types of oil or for sauce. A stove behind the counter was in use; varied dishes were kept simmering in terra-cotta casseroles over the charcoal fire. Since this was not a tavern, the food was probably taken out, or eaten while standing, as in the modern Italian *tavola calda* (hot table). Behind the shop are rear shops, storage rooms, and the merchant's office.

These walls are rich in graffiti. Not far from a phallus, the despondent Severus scribbles: "To live is vain." And in perfect Greek is written a quotation from the famous Diogenes, of the fourth-century B.C., who allegedly went about Athens with a lantern looking for an honest man: "Diogenes, the Cynic philosopher, seeing a woman swept away by a river, exclaimed, 'Who escapes one misfortune will be carried away by another misfortune!'" Perhaps this graffito, too, was the work of sad Severus, considering its tone. For an idler in a bar in a small town, he was either astonishingly literary or an amateur philosopher.

Apparently the bar prospered, for the house (of which the shop was part) has good pavements, a marble-faced impluvium, and two handsomely decorated rooms. In fact there was a room to spare, which the owner rented to a wine merchant—as is indicated by the large number of wine amphorae found in that shop. This wine merchant may have been one of those wine exporters of Campania whose amphorae, marked in the Oscan language, have been found in sunken Roman ships off the southern coast of France.

The typical wine shop or snack bar (*thermopolium*) had a standard arrangement. Almost invariably its counter was faced with marble fragments. Its jugs contained wine, kept fresh by the cool stone in which the jugs were embedded. The counter displayed a variety of delicious snacks: cheeses, walnuts, almonds, dates, figs, raisins, cakes, and similar delicacies. Hot drinks also were served, for the Romans were very fond of mulled or spiced wines of many sorts, often sweetened with honey.

Most of the snack bars, of which there were a large number, are identical or very nearly so—sometimes even conveying the impression of a "chain" under single ownership. (What seem to be competing shops in Italian small towns today are often under the same ownership.) One of Herculaneum's snack bars, however, is distinctive. It is easily identifiable by the Priapic figure with exaggerated phallus, which the proprietor had painted in red on the wall behind the counter. Painted too is a large jug, and a female figure holding a purse and a little bell. All were believed to be effective against the Evil Eye.

Shop of the gem-cutter. The skeleton of an adolescent boy still lies on the elegantly inlaid bed. To the right is a bronze candelabrum, a small loom (restored), and the original inlaid stool on which the weaver sat. Close by are the remains of the chicken that had been prepared for the sick boy's lunch.

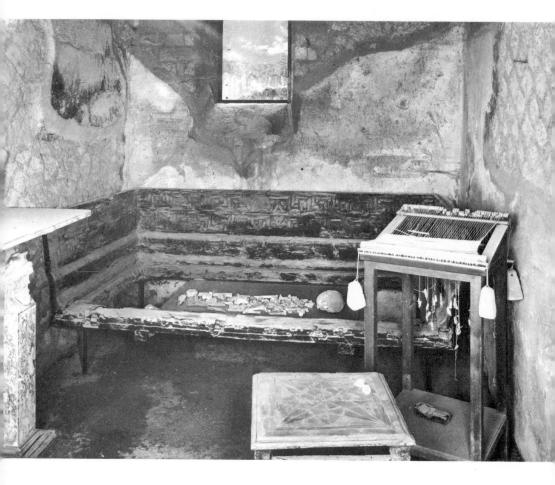

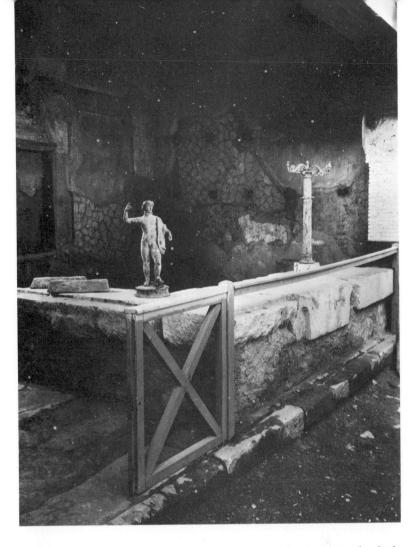

Tinker's shop, with bronze statuette of Dionysus and a lamp stand, which had been left near the forge for repair. On the left of the counter are two metal ingots from a neatly stacked pile.

On the counter are displayed the original walnuts discovered in a large jar. Also found were bronze utensils, lamps, and a water tank made of lead. The house in the rear is not large. It is difficult to assess the quality of the decorations, as the walls were largely ruined by the Bourbon tunnelers. Undestroyed was the spy-hole in the wall, through which the proprietor kept a wary eye on the shop. Possibly he had trouble with little boys who snatched walnuts and ran away.

A few doors down the street is the shop of a cloth merchant. The establish-

THE PLEBS-HOUSES AND SHOPS

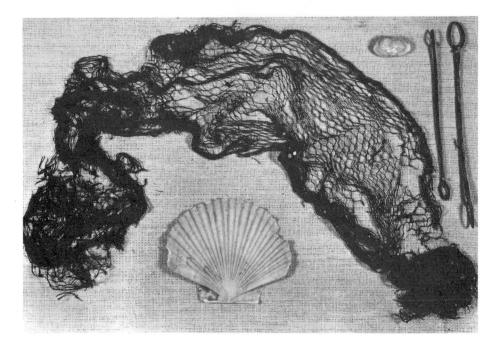

Fish net nearly two thousand years old, from a Herculaneum shop. To the right are bronze instruments used in mending the nets. Today the design is the same, but the instruments are of plastic. The shells were part of the shop's collection.

ment is conservative: a small front room for customers, a larger adjoining room (painted in the fantastic "fourth" style) for display of merchandise. Behind is a corridor leading to the living quarters on the ground floor, a stairway to the mezzanine, and another stairway to the upper floor. In this shop the modern excavators made an exceptional find: remnants of the ancient cloth itself. It is displayed in a glass case, and the wavelike design is still discernible.

The amount of material in Roman garments was considerable, and quality had to be high so that they would be long-lasting. The cloth was of wool, linen, or cotton; silk was an expensive luxury. In remote Republican times, the predominant color was white or near-white. Foreigners or slaves, chiefly from the East, wore colored robes or tunics. But with prosperity women grew tired of the sameness of their clothes, and though the cut of their garments remained the same, finer materials and more and more colors were introduced. Later, men began to wear color in their dinner clothes. The colors chosen by respectable women were subdued pastels, while prostitutes went in for bright colors and flamboyant combinations. To meet the new demand it was necessary for the dye industry to expand, and in so small a town as Herculaneum several dye works already have been found. They are recognizable by the type of furnace used to heat the dye. A shellfish, the murex, was the source of the costly purple dye. From literary descriptions of colored clothing, it appears that the dyers attained great skill. Wool was dyed in the fleece; silk, cotton, and linen were dyed in the thread. Clothes cleaners, fullers, were also in demand, and a few of their shops are evident in Herculaneum. They used, instead of soap,

> This cloth press in a cleaner's shop is one of the rarest finds of ancient technology. The press, not restored but still intact with its original wood under glass, works on a worm screw. It closely resembles the earliest printing presses developed fourteen hundred years later.

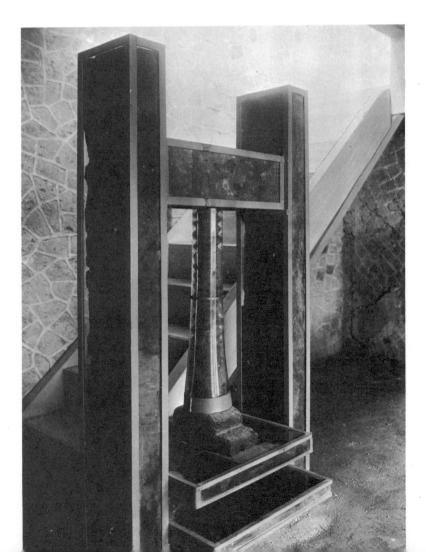

carbonate of soda, potash, or the alkaline clay which is called fuller's earth.

Like the dye works, the bakeries are marked by their ovens. Even today Italian towns are served by small neighborhood bakeries, which produce their wares during the early hours of the morning. And loaves of bread are still made in exactly the same shapes as the bread found in Herculaneum—round, with division marks, so that it can be broken easily into sections.

The largest bakery used a charcoal oven very similar to the Neapolitan pizza oven—in appearance a stone igloo. Its iron door is tightly closed, and the leaden water tank used for dampening the oven broom still stands nearby. The long wooden pallets used for removing the loaves have disappeared. (Along with the usual types of bread, the Romans also baked dog biscuit for their pets.) In this bakery the grain was milled in the courtyard. Two mills were turned by blindfolded asses, the diminutive breed still seen in the environs of Naples. Their bones were found where they died, harnessed to the mills. Behind the bakery were both stables and the baker's lodgings. He must have prospered, for he lived in handsome vaulted rooms with fine pavements and wall decorations. He could also afford a graceful wooden table with feet carved as griffins' heads—a table any patrician would have envied.

The name of one baker of Herculaneum is known: Sextus Patulcus Felix. His seal was found in his shop. Apparently he specialized in cakes, for he had twenty-five bronze baking pans of various sizes, from about four inches to a foot and a half. When he escaped he left behind not only pans hanging from the rack and in the oven, but considerable supplies of wheat and stacks of money. Relinquished too was a bronze statuette of a female nude—one of the shop's treasures. In the front of the shop were the mills. To one side, in a sooty two-story vaulted room, was the rotund oven and its lofty chimney. It is perfectly preserved. Though this baker's name was "Lucky," he took no chances with his luck. Over the oven door he placed two phalli, side by side, to protect his baking from being spoiled by witchcraft. And in the dough room (the mixing bowls are on a shelf) he placed two more phalli in ceramic: a large phallus with the hind legs of an ass and its own phallus. Thus Felix did not make assurance doubly sure, but quadruply sure. Those guardian phalli are still on duty.

Next door to Felix's pastry shop was a wine shop, which boasted a certain elegance. A niche, stuccoed as a seashell, sheltered a statuette (now missing) of one of the gods. Above and around the shrine was a fine fresco (now barely visible) of a robed Hercules pouring a libation between a nude Dionysus and a nude Mercurius—who, among other things, was the patron god of shop

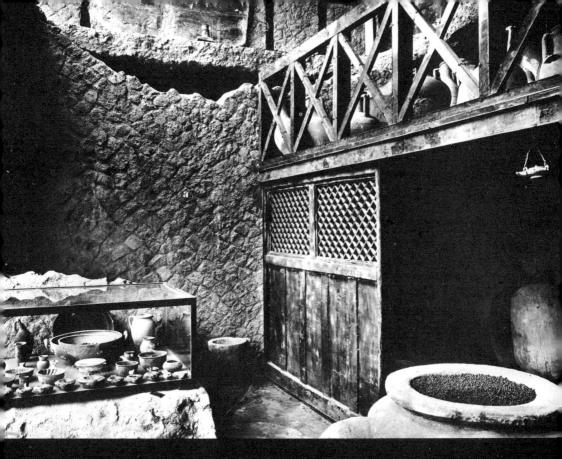

Most complete ancient shop ever discovered was found in space remodeled from the House of Neptune and Amphitrite. Lamps and utensils are on counter at left; large jug in foreground is still full of cereal; wooden grill and mezzanine with amphorae are the original. keepers. This fresco must have been the pride of the shop. In the rear is a wooden bed, a charcoal stove, and a sink. The amphorae of wine were laid lengthwise on a supporting wooden scaffold, cut to fit their shapes. They were reached by a ship's ladder of wood, which now dangles in space, carbonized. Perhaps here was sold the famous Falernian red wine, or the celebrated white wine made from grapes grown on Vesuvius. One amphora is marked with an inscription, quickly brushed in red: L. R. ANTIGONI.

A couple of doors up the street was another shop whose owner is known from his seal. Aulus Fuferus rushed off without seal and silver rings. His specialty was cereals and vegetables, and perhaps fruit—almost all locally produced (rice was imported from northern Italy). The cereals and the beans remain, but the vegetables were more perishable. His stock was probably green beans, beets, carrots, herbs, mushrooms, cabbage, onions, celery, chicory, cucumbers, capers, parsley, lettuce, leeks, parsnips, truffles, turnips, olives plus marinated asparagus, which was out of season, and hearts of artichokes in olive oil, for fresh artichokes were yet to come.

Melons of many varieties would have been piled in wicker baskets. The first grapes of the season would have been on display, plus pears and early apples. Figs and plums would have been in plentiful supply, and possibly late peaches. Blackberries would have been fully ripe. Preserved cherries, apricots, and peaches would have been in glass jars. Shopkeeper Fuferus would have had dates imported from North Africa, and local dried figs stuffed with almonds. Later he would have raisins cured with spices, and pomegranates. As the Romans were enthusiastic beekeepers, honey would have been in combs and large bronze jars (more than once it was preserved thus from antiquity). Almost all Roman roast meat was cooked with honey, to bring out the flavor. Fuferus' shop at the noon hour would have had few patrons, for shopping was done early while vegetables were still fresh with dew. Many were the cookbooks two thousand years ago; only one has survived—The Art of Cooking, by Apicius. But one was enough for us to know what items Fuferus probably offered for sale, and the ways they were prepared. Aside from exotic recipes for stuffed flamingos, truffles, snails fed on milk, and the like, many recipes were simple and are still cookable. Example: "Turnover as a sweet: toast pine kernels and broken nutmeats, pound with honey, nutmeg, spices, milk, eggs, a little wine and olive oil. Cook in a shallow pan and turn out on a round serving dish."

Not far from Fuferus was the luxury shop of a gem-cutter whose name we do not know. Yet we know more about his private life. He had a considerable

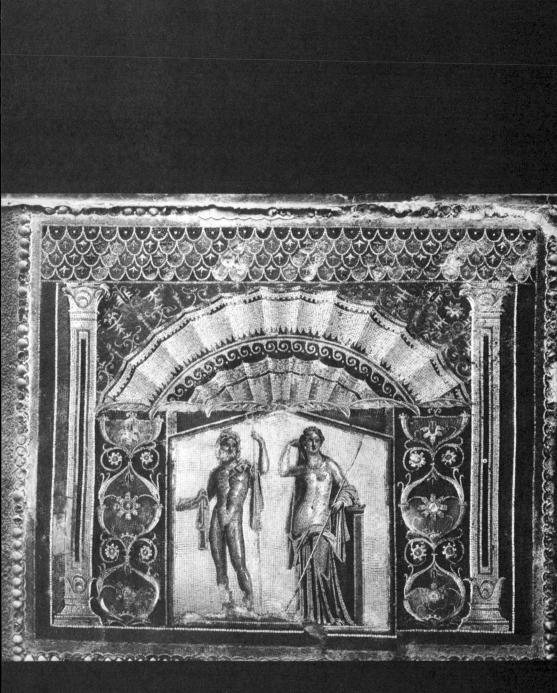

Mosaic of Neptune and his wife Amphitrite (Salacia)—an extraordinary example of middleclass taste—decorates outdoor dining room of the house that connects with the cereal shop. The brilliant colors are undamaged by long immersion under hardened mud. supply of gems (to be carved for rings or signets). His wares he displayed not on a counter, but on a spacious marble table. In his rear shop he left behind a marble portrait bust with a damaged nose. In his front shop, in a small room partitioned from the rest, he also left behind a child. There an adolescent boy lay on an elegantly veneered bed. Nearby, a woman (a slave or an old freedwoman?) sat on a square inlaid wooden stool, weaving on a small loom. A graceful bronze floor-candelabrum stood in a corner. For the sick boy's lunch, chicken had been prepared and portions (in soup?) brought to the bedside. How did it happen that in the moment of panic the boy was abandoned? Was he paralyzed in the legs? Were his father and mother absent, and the woman weaver too old or unwilling to carry him away? While the mud rose, he must have waited frantically for the rescue that never came. His bones lie there still, with the chicken bones . . . equally preserved.

Across the street from the Samnite house, on the corner, is a snack bar with small rooms in the rear. Here on a wall a schoolboy painfully wrote out one of his daily lessons in its entirety. And near a niche a young girl printed: HYA-CINTHUS WAS HERE. HIS VIRGINIA SALUTES HIM.

Not infrequently, beautiful objects are to be found in these dwellings of the poor. Nor is this surprising, as the artisans were the actual creators of the beautiful objects in the houses of the rich. If the taste of the patricians inspired the creation of art, and patrician money paid for art, nevertheless only the long training and skill of the artist made possible those masterpieces, which have never been surpassed in any civilization.

In Herculaneum one such ancient workshop continues to exist. Fronting on the Forum was a workshop remodeled from the patrician House of the Bicentenary. Here labored an artisan of talent and skill: a painter of wooden panels for insertion in the walls of the well-to-do. One such panel, encased in a wooden frame, was almost finished when the painter dropped his brush. It depicted cupids at play; it is precious because it reveals so much about ancient painting techniques. In the rush to safety the painter ignored not only his handiwork, but also a handsome little wooden shrine in the form of a temple, which he himself perhaps had decorated. And as he ran, it is not unthinkable that he hailed the nearby tinker, in whose shop stood the bronze candelabrum and statuette of Dionysus waiting for repair. As fellow artisans, they might have fled together.

From a shop once a part of the patrician House of the Wooden Partition came a unique technological find of antiquity: a cloth press. The whole mechanism, some six feet high and two-and-a-half feet wide, is constructed of wood (oak or beech), including the large worm screw. The shop may have been that of a clothing merchant. The most intriguing fact about the cloth press is that its appearance is so similar to the printing press invented thirteen hundred years later. With the application of a little imagination, the Roman press could have been adapted to the needs of printing not only wooden blocks, but movable metal type. That the basic principles of type were already understood is clear from the bronze seals with the names of individuals—the letters were raised from the surface and in reverse. (They were used as rubber stamps are today.) But the press and the type inexplicably remained apart. Such a technological lag of over a thousand years is almost as depressing as it is bewildering.

All the foregoing shops suffered greater or lesser damage from the eruption or from the Bourbon tunnelers. One shop, luckily, came through almost unscathed. It is the most completely equipped and best preserved of all those discovered at Pompeii and Herculaneum. It was installed in a front room of the House of Neptune and Amphitrite and has a door opening into that house so we may assume that the owner of the glittering mosaic *nymphaeum* was also the owner of this thriving shop. The original decorations of the house walls remain on the shop walls, and the shop's installations have been made without regard to them.

This was a cereal and wine shop; some of the merchandise was sold precooked. The wooden scaffolds holding wine amphorae and the wooden staging for shelves remain intact. The cross-hatched wooden grill separating a part of the shop remains unbroken. A coiled rope hangs on a pin. A lamp hangs from its usual hook. Charcoal in the stove is prepared for a rekindled fire. The plumber has repaired the drain in the sink. The usual containers are full of cereals. Beans and chick-peas are on the counter, for sale. This shop is open and ready for business. At the ping of a coin, the proprietor will appear.

Surely the common people of Herculaneum are not dead nineteen hundred years. After their afternoon naps, won't they all yawn, stretch, and resume work . . . ?

XII

THE BATHS— Everybody's clubs

BATHING, FOR THE ROMANS, WAS A SOCIAL OCCASION. THE BATHS WERE THE PLACES everybody went almost every day. Some baths were communal and some were private enterprises; some were expensive and some were very cheap indeed. Few houses had private baths, and none could compare with the attractions of the public baths—for the public baths were used collectively, and nothing is so interesting to human beings as the bodies of other human beings. The citizens of Herculaneum were no less addicted than the citizens of Rome. We can only marvel at their costly and elegant bathing establishments.

No people in European history have been so clean as the Romans, for no other people have gone to such lengths to provide mass bathing facilities. After the fall of Rome, bathing came to be literally abhorred in the West until modern times. The early Christian abnegation of the body had much to do with the indifference to filth. But to the Romans, as to the Greeks, the body was an object of admiration and veneration: so they kept it clean.

In the great cities, apparently men and women bathed together until about the time of Emperor Hadrian (ruled A.D. 117–138), who forbade mixed bathing. The Roman population explosion placed great pressure on all public facilities, and brawls began to occur at the formerly well-regulated baths. Though women wore a light covering garment, and men wore brief leather loincloths while bathing in mixed company, the growing crowds placed too much of a strain on public restraint. Literature reveals, too, that pimps and prostitutes began to make a nuisance of themselves at the baths, and some official action became imperative. In small towns, as at Herculaneum, men and women tended to have separate sections of the same establishment, or to use the facilities at different hours. The well-to-do usually were accompanied to the baths by their slaves.

Bathing, for all its primacy, was only part of the attraction of the public baths. Most were equipped with a gymnasium of one sort or another, with one or more courts for ball games. A favorite was bladder-ball (*pila*)—a game played with inflated animal bladders, often painted green. By the end of the first century, exercise attracted more and more women; they not only played ball but even went in for fencing. When the exercises were completed, the body was rubbed with olive oil, then scraped with a strigil (*strigilis*), a curved instrument of bone or bronze that somewhat resembled a boomerang. Massages were popular; among the most recurrent jokes were those about the ladies and their male masseurs.

After exercise came the bath. In the apodyterium, patrons undressed and waited their turn to go into the warm room (tepidarium) or the hot room (*cal-darium*), according to their preference. From either, they hurried to the frigidarium with its cold-water plunge. From the cold plunge they emerged for a quick rubdown by attendants, dressed, and relaxed in the garden in conversation with friends. They were not content with a fresh-scrubbed smell, and perfumes were liberally used by both women and men.

Light snacks were provided for patrons who were hungry. Some baths had "relaxing rooms" for those who wished to hear poetry recited, or read the latest books from the baths' library. Every effort was made to decorate the baths as beautifully as possible. In the cities the baths had arcades or garden paths for strolling, fountains and music for soothing harassed nerves, statuary and paintings to please the eye. The bath itself was invigorating, cleansing, restorative. A visit to the baths was both a physical and aesthetic satisfaction . . . and sometimes a sexual satisfaction as well, as we learn from graffiti on a Herculaneum wall.

Even so lightly populated a town as Herculaneum was equipped with two sets of baths—one near the center, now known as the Forum Baths, and one on the marina outside the walls, now known as the Suburban Baths. As no dedicatory inscriptions were found in the Forum Baths, apparently they were a municipal enterprise; but there is reason to believe that the Suburban Baths were a gift of Proconsul Balbus to the town, and were run as a kind of municipal country club chiefly for the wealthy.

The Forum Baths occupied the southern end of a whole block, fronting on three different streets. Thus several entrances were practical and convenient.

9

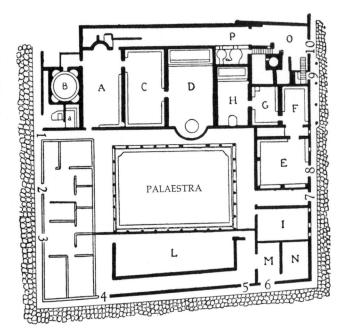

Ground plan of the Forum Baths: 1: Entrance to the men's baths. a: Latrine. A: Waiting room of the men's baths. B: Cold room of the men's baths. C: Tepid room of the men's baths. D: Hot room of the men's baths. 7: Entrance to the palaestra (open gymnasium). 8: Entrance to the women's baths. E: Vestibule of the women's baths. F: Waiting room of the women's baths. G: Tepid room of the women's baths. H: Hot room of the women's baths. I: Waiting room of the palaestra. L: Ball court (?). 9: Storage room. 10: Entrance to the furnace room. O: Well and water tower. P: Furnace.

A patron could go direct to the Baths, or to the open-air palaestra if he preferred. The entrance hall to the gym has preserved the usual scribblings by people bored with waiting: names in Latin and Greek, and such doodles as the inevitable phallus. The garden was surrounded by a columned portico, from which opened dressing rooms, administrative offices, and storage space. To one side was an open exercise and playing area. As the space was not adequate for ball games, a covered "penthouse" court was built on an upper story of the structure. The staff's living quarters were also on the upper floor.

These Baths were well planned, and were built as an integrated unit early in the Augustan period, probably sometime between the years 30 and 10 B.C. They were redecorated in the time of Claudius or Nero. Of the graffiti in the waiting room to the women's section, at least one may have existed before the refurbishment: a salute to the poet Ovid written with carbon pencil. Ovid had been sent into exile by Augustus, according to gossip, because of the effect his book *The Art of Love* made on Augustus' headstrong daughter Julia. Thus the sympathy of the Herculanean lady was definitely on the licentious Julia's side. Other graffiti in the women's waiting room perhaps were of later date:

Two skeletons remain where found in the men's waiting room of the Forum Baths. The floor is of segmented marble. Around the walls are seats, and above are shelves for clothes. The round marble basin is for washing hands, the rectangular basin to the left for washing feet, before entering the other rooms. These baths are typical of baths built throughout the Roman world.

a quick sketch of a naked girl; several phalli; the Latin alphabet as far as Q. Was that the letter on which Vesuvius exploded . . . ?

The plan of the Forum Baths follows the standard Roman pattern. Off one entrance is a doorkeeper's cubicle and the latrine. The latrine was economically flushed with water flowing from the cold plunge. The men's dressing room is about 20 by 40 feet, with a marble bench running along three sides and a marble shelf above with individual recesses for clothes. The ceiling is vaulted, with stucco ridges smoothed into wavelike flutings. The pavement is composed of irregular pieces of black, gray, and white marble, and is slightly convex to make the floor easy to wash. In an apse at one end is a basin of fine marble, and in one corner, another, lower, basin. One basin was used for washing hands, and the other for washing feet before entering the adjoining chambers of the Baths. The entire room was lighted by a large round window high in the south wall.

In this room were found two skeletons—a man and a woman. They might have been custodians. In any case, they did not flee, thinking they would be safe under the massive thickness of the vault. But they reckoned without the rising mud. Indeed, the vault remains, and so do they.

Water valve of bronze still functions. Roman water pipes were of lead, and either elliptical or round. Aqueducts brought water to water towers with filtration systems. Pipes had "decompression" chambers of lead. Hydraulic engineering had reached a level not to be equalled until the 20th century.

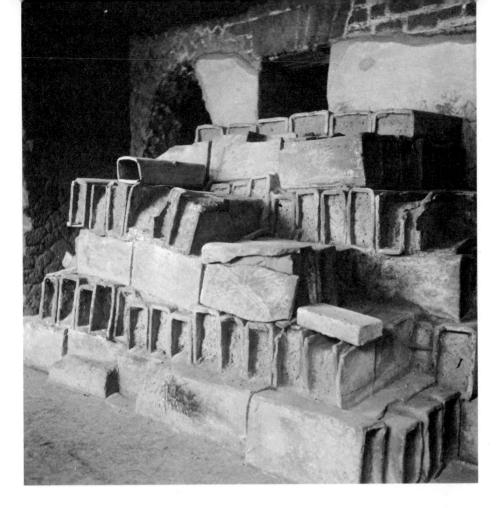

Tubular bricks are still stacked in the Suburban Baths, ready for repairs in progress nineteen hundred years ago. Most remain filled with the mud lava that poured down from Vesuvius. Size is evident by comparing the ordinary brick to the right.

The warm or tepid room opens off the dressing room, and has marble benches and shelves on all four sides. The floor was hollow for the passage of hot air, and has collapsed from the weight of the mud. The design, set in black mosaic, is relatively undamaged: a huge Triton, whose legs are curling sea serpents, is surrounded by leaping dolphins.

Next to the tepid room is the hot room. Here the vault has collapsed, revealing terra-cotta hot-air pipes laid regularly in the walls. At one end is a round marble basin, like a large birdbath, which contained cold water to wash sweat from the eyes. At the other end is the hot-water immersion tank, a rectangular marble basin elevated on several steps.

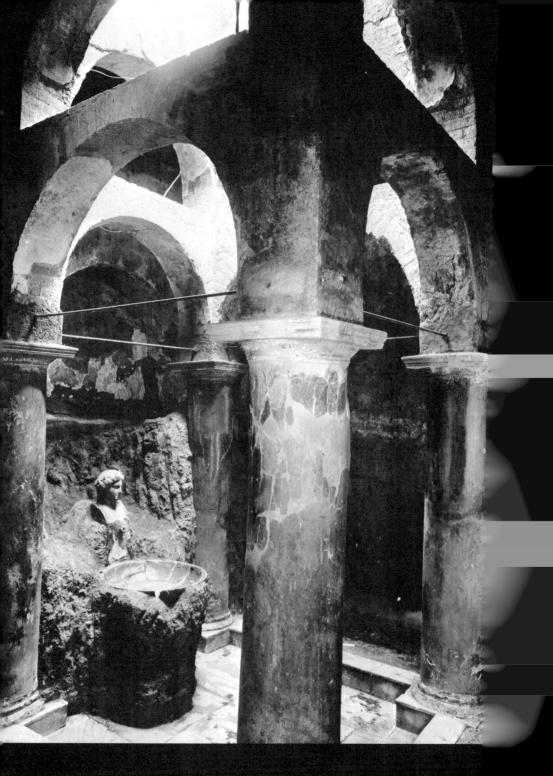

Vestibule of the Suburban Baths in process of excavation. The hardened mud chipped away from the fountain of Apollo. The arches are stacked one on top of to permit the opening of a central skylight. The four columns are painted a glossy

THE BATHS - EVERYBODY'S CLUBS

The cold room with the cold-water plunge adjoins the dressing room. It is round and vaulted with skylight above. Four niches afforded seating space for those who wished to tarry. Bronze candelabra stood between the niches, proving that the Baths were used at night as well as during the day. The walls are polished dark red, the niches a golden yellow. On the blue-gray vault are crudely painted marine creatures—various fish, lobsters, a moray eel captured by an octopus. They reflected in the water of the green pool below.

The women's section of the Forum Baths is similar to the men's, except that it is smaller and lacks a cold room and plunge. Clearly the women did not want a frigidarium. They also have a nude Triton in black mosaic on white. The hotair system in the walls and floors follows the same pattern, though the wall pipes may be more concentrated. The women preferred their water hotter than did the men, as is indicated by a separate boiler for their unit.

The hydraulic system was severely damaged by the Bourbon tunnelers, and parts of the heating system were carried away entirely—for example, the boilers. The water was furnished from a well over forty feet deep. It seems that the water was raised by a kind of bucket system to a water tower, whence it was distributed through lead pipes by gravity to the boilers and the various tanks. Fortunately for our knowledge of Roman technology, the tunnelers missed two of the heavy bronze grooves into which eighteen-inch wheels were fitted on a rotation beam to revolve the buckets. All the hydraulic equipment was of bronze or lead. The men's furnace, however, had a door of iron; and near it lay the long iron poker just where it was dropped when the attendant jumped and ran.

In contrast to the Forum Baths, with their standard pattern, the Suburban Baths are unique. Their position, outside the town walls and overlooking the marina, is most unusual. They are exceptional, too, both in plan and in their stucco decorations, and no comparable public baths are known to exist anywhere (though small private baths have been found decorated with stuccoes). To cap all, in spite of extraordinary difficulties in excavation, their state of preservation is almost incredible.

The main route to the Suburban Baths led through the Marine Gate and down a long ramp to the entrance courtyard. This ramp also led to the waterfront. On the town wall above the ramp an odd graffito has survived: "And willingly we perform the act to which the permissive Longinus consented with pleasure: quick carnal union. STURNUS—lover."

On the right, on a slightly elevated terrace above the beach, was a row of structures now called the Sacred Area. Here are several arched halls, once

THE BATHS-EVERYBODY'S CLUBS

frescoed, and with wooden installations of some sort. In one, a large round wooden tabletop survives; in another, a rectangular marble table with two elephantlike legs stands in the center. The purposes of these buildings are unclear, but they may have been chapels and the largest, a meeting hall. At the least, they prove that extensive social activity went on outside the walls along the marina; so it may not be surprising to find an elaborate public bath in such a location.

Counterposing the Sacred Area, on the opposite side of the final flight of steps to the beach level, are the Suburban Baths. The entrance courtyard also is an elevated terrace, and once was paved with a light material. In it stood a statue of the Proconsul Marcus Nonius Balbus, now lost, and a memorial (a funeral altar) to the Proconsul, now largely intact. The inscription relates that Balbus at his own expense had restored the Basilica, gates, and walls of the town (after the great earthquake); he had borne the expense of the youth games; he had aided in the erection of a heroic statue of the Emperor Vespasian; and an equestrian statue had been erected in his honor. A list of the Proconsul's titles was given. Two words were misspelled—the process of vulgarization of Latin already had begun.

It would appear from the choice of site for the memorial that the Proconsul was also the donor of the Suburban Baths. Further, the external and internal connections between the Baths and the House of the Relief of Telephus are such that the owner of the house must have had a very active influence in the construction of the Baths. The marble grand salon of Telephus overlooks the roof of the Baths; and this roof, on a lower level, serves as a huge terrace (approximately 65 by 90 feet) for the House of Telephus. A connecting staircase and two ramps have been discovered thus far; the underlying rooms along the town wall have not yet been excavated.

One of these ramps to the House of Telephus also has left us a graffito:

Portumnous loves Amphianda Januarius loves Veneria We pray Venus That you should hold us in mind— This only we ask you.

Though the torrent of mud swept away the walls of the House of Telephus, the snugly placed Suburban Baths lost hardly a stone. But nature, as if to thwart the archaeologist, gave the volcanic mud here the density of rock, and with the passing centuries, changed the water table. As a result, excavations were extremely slow and difficult and could not be completed until a modern drainage and automatic pumping system was installed. Otherwise the present visitor would find himself sloshing about in four or five feet of water.

The entrance originally was a spacious arched portal flanked by two halfcolumns. But at some point, perhaps after the earthquake A.D. 62, the arch was filled in and the door space made much smaller, though the portal decorations remained. A short flight of steps leads down into an architecturally notable vestibule. A square skylight illumines four massive red columns placed at the corners of a square white marble fountain. Above, the columns support a double row of small arches over arches. Below, water flows from a spout in a herma of Apollo into a small round basin, in turn overflowing into the square basin. The bust of Apollo, in the style of the fourth century B.C., is expertly sculptured from Greek marble. And the Roman valve, which controls the flow of water to the fountain, turns off and on with all its ancient ease.

Notable, too, are the frames of all the openings into this vestibule: they are not of the usual volcanic stone or marble but of wood—wood one foot wide and with multiple bevels like elaborate picture frames. We realize at once that we are entering a structure that, though small in comparison with big city baths, is the ultimate in luxury.

Two cloakrooms, their openings framed with the beveled wood, flank each side of the entrance stairway. Here clothing was discarded, and the patron probably wearing a linen wrap or towel—passed directly through the cold room to a waiting room, which was heated in winter by hot-air pipes in the walls. As these Baths had no cutdoor palaestra, the waiting room—or more likely the large cold room—may have been used for light exercise.

The waiting room is one of the great finds of archaeology. It is intact except for the decoration of the vaulted ceiling—destroyed by the tunnelers, who got no deeper. The light is derived from a glass-enclosed window in a ceiling niche. Here on the floor no flamboyant Tritons thrash rampant among sea creatures, but discreet black marble squares, separated by narrow white marble bands, form the pavement. Graceful white marble benches are set against varicolored marble on three walls. Above, in framed white stucco panels, bearded and clean-shaven naked warriors in bas-relief alternate with one another—each some two and one half feet high. The warriors assume different positions and all are modeled with exceptional skill. In one panel, two winged cupids, plump and bare, play some game. At the top of the panels, a blood-red frieze supports a stucco spiral running all around the room. The wooden doors are handsomely paneled; they remain in their original place, on their original hinges—and are not carbonized. This is a room in which, no doubt, the latest gossip of the day was exchanged among the waiting patrons; and the wooden doors and stuccoed walls served acoustical as well as decorative purposes. But above all, it is a room of grace and elegance, which might well have adorned some splendid edifice in Rome.

The tepid room is also a room of taste. The walls are decorated with architectural forms in the "fourth," or fantastic-architecture, style. These walls, too, are heated with inset terra-cotta tubes. Recesses with seats flank the long sides of a rectangular plunge, which in fact is a heated swimming pool, 16 by 24 feet and 5 feet deep. To one side is a small round sweat room, or sudatorium, with seats in four apses. Here the heating pipes are concentrated.

The hot room, which opens off the waiting room, is conventional in design. It has the usual marble pool for hot-water immersion and the usual round marble basin for cold water. The heavy iron clasps used in fixing the positions of the heating pipes can still be seen. This room graphically illustrates the force of the mud. The steaming mix flowed in through the window, overturned the massive marble basin, carried it across the room, and left it immobilized and balanced on edge.

The plunge in the cold room is not round, as was customary, but a rectangle about half the size of the tepid plunge. Its sides are colorful with red marble; the steps are white marble; the bottom is paved with white marble squares. In this room, too, the vault decoration was destroyed by the tunnelers.

The belvedere, for relaxed conversation or a bite to eat, connects with both the hot room and the corridor of the entrance vestibule. It has two wide picture windows, which once overlooked the sea, and a third which overlooked the marina. They were probably fitted with clear glass of high quality. The whole room is elegantly decorated with half-columns and stucco designs painted in blue and red; but only suggestions of the frescoes remain, and the statuary, if any, has disappeared. Probably the room was equipped with wicker lounge chairs and small tables for flasks of wine.

But the Suburban Baths offer additional surprises. The furnace room opens off the entrance vestibule, and is complete with its pipes, boiler, and wood still stacked for the fire. The water supply arrived from the town aqueduct through channels not yet explored. In one room off the corridor is a heap of hollow bricks almost exactly like those of today. They were waiting to be used in certain reconstruction work in progress. In the back corridor the wooden scaffolding is still stacked against the wall—uncarbonized. Also uncarbonized

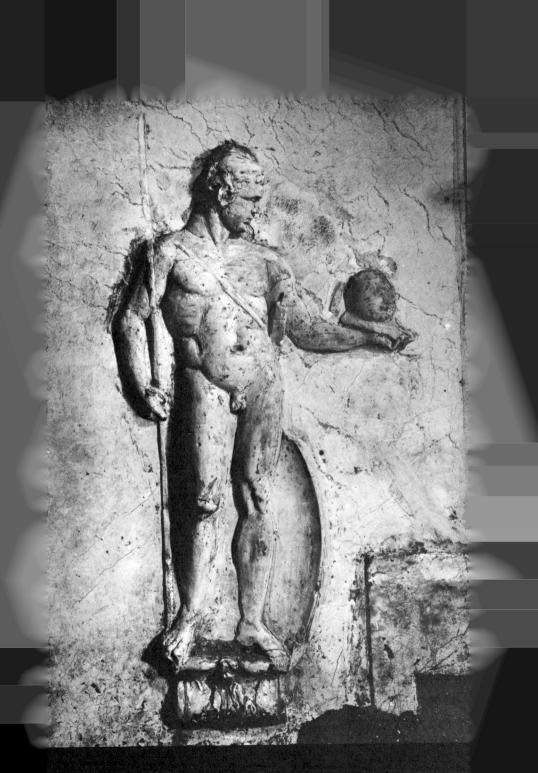

Stucco warrior, one of several in high relief, adorns the waiting room of the Suburbar Baths. These stucco decorations, extremely rare, are almost perfectly preserved, as are are wooden shutters, exactly like those of today, which had been removed from outer windows. Farther down the hallway, in a small service room, are thirty-five roof tiles stamped with the name of the manufacturer: M(arcus) AC(cius) AMP (liatus).

At the end of the corridor is a room that is officially indicated as "use unknown." Its use becomes clear, however, from the cluster of graffiti on its walls. Though the Suburban Baths had no women's section, it cannot be assumed that women never appeared here during the men's hours. One certainly did, to visit a male friend. Funsters drew caricatures of them on the wall: the lady is shown with nose absurdly prolonged, and wearing a crown of vine leaves; the gentleman is shown with a weak chin, wearing an affected highcombed and curled hairdo.

Indeed, these white walls seem to have been as tempting a surface as a modern blackboard. A slave left this record of his visit to the little room: "I, Hermeros, slave of my mistress Primagenia, came from Puteoli to Timnianus Street and am looking for the bank messenger, the slave of Phoebus."

Another graffito concerns the expulsion of one Epaphroditus: "Two companions were here; and, after the bad guidance of Epaphroditus in everything, they tardily threw him out—then with the girls they joyfully consumed 105 1/2 sesterces."

And finally, a pair of graffiti about the subsidiary activities in the back room:

"Apelles the waiter dined most pleasantly with Dexter the slave of Caesar, and they screwed at the same time." (Or perhaps together.)

"Apelles the Mouse" with his 'brother' Dexter lovingly screwed the two twice."

Evidently both the food and the girls served at the Suburban Baths were equally satisfactory to the customers.

XIII

SPORTS-THE PALAESTRA

ONE OF THE FAVORITE ROMAN MAXIMS WAS *Mens sana in corpore sano*, "A SOUND mind in a sound body." The Greeks held to the same belief, but without moralizing. The Greek tradition of athletic games, after the fashion of Olympia, blended in southern Italy with the Roman tradition of sporting events at festivals. The importance of sports can best be gauged by the size of the Palaestra, or public gymnasium, in so small a town as Herculaneum. To the Bourbon tunnelers, the impression was bewildering: they thought they had stumbled on a great temple or a vast private villa. The first impression of the modern visitor is disbelief.

The Palaestra occupies an entire block, with a street frontage of 360 feet and a depth of 260 feet. The section along the street was given over to shops, which were rented to help maintain upkeep; and above was the apartment building or inn, which may well have been the largest in Herculaneum. Within the Palaestra proper, a columned portico surrounded the open sports area on three sides; on the north was an enclosed portico with windows. Above was a spacious loggia from which official and select guests watched the competitions. And adjoining the loggia was a large and beautifully decorated meeting hall, which could seat hundreds. Only two sides, including the closed portico, have as yet been excavated. In one of the rooms off the closed portico, the Bourbon tunnelers left their names and the date—1750. Before the door of another room was found a Priapic bellpull, with bells attached to arms, legs, and phallus.

The main entrance to the Palaestra is like a majestic columned cella, or inner portion of a temple. It had a black tessellated pavement with portions set in marble, white walls relieved by architectural motifs, and a decorated vaulted ceiling. All was spacious and imposing. Alas, the tunnelers perforated

SPORTS-THE PALAESTRA

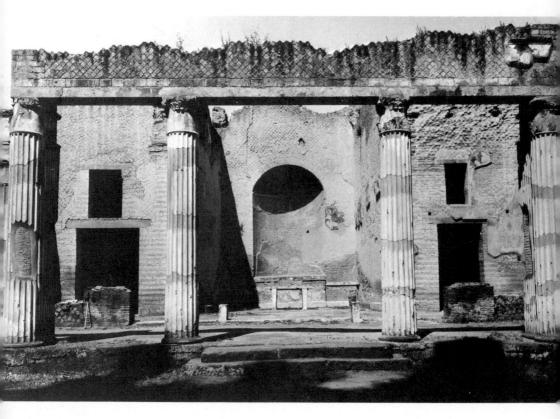

Athletic competitions were held in the grand hall of the Palaestra or public gymnasium. Winning athletes were awarded olive-wreath crowns, which were placed on the marble table in the center. A statue of Hercules or an emperor stood in the niche. Remaining height of the hall is over 40 feet, though the vault has collapsed.

and reperforated the walls and vault, and with the removal of the mud matrix the whole ceiling collapsed—so that only a hint of the former grandeur remains. Portions of the vault reveal that the eight-rayed stars in wine red, olive green, and chrome yellow were painted on a background of pale blue. As for the statuary, which once must have stood along the walls, there is no trace.

Other parts of the structure are better preserved. An apsed hall, some forty feet of its height still remaining, opens off the center of the columned portico. A huge niche, now empty, dominates the back of the apse. Here certainly once

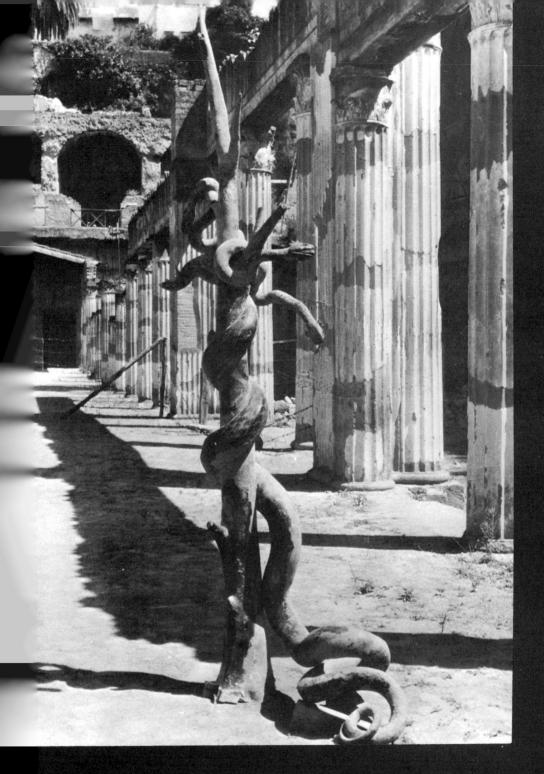

Bronze serpent with five heads sprayed water into the Palaestra's cross-shaped swimming pool. Here removed from the pool, it is photographed against the columned portico that bordered he playing field of the Palaestra. The serpent is now replaced in its original spot though the

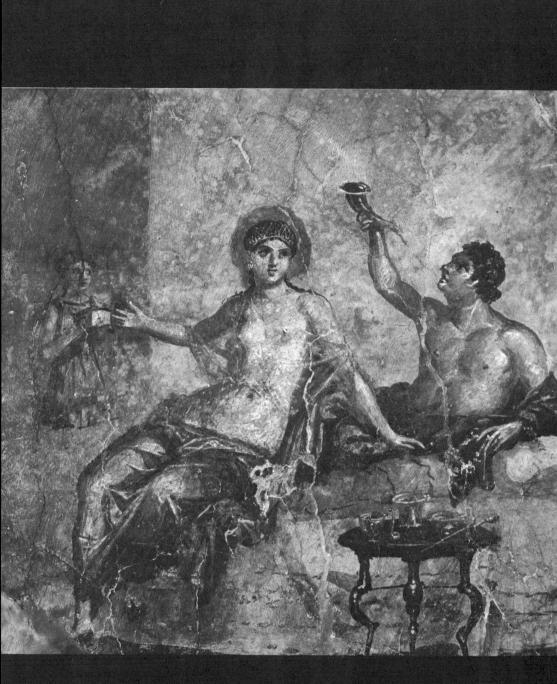

Convivial scene almost identical with the fresco still on one wall of a large room in the Palaestra. In both, a servant brings a casket to the lady. The muscular, bronzed young man is drinking wine. Perhaps he was a successful athlete, and this was the victory celebration.

SPORTS-THE PALAESTRA

stood the heroic statue of an emperor, or perhaps Hercules himself, who served not only as patron of Herculaneum but of all palaestrae. None could be complete without his image. Before the niche, in the center of the apse, still stands the heavy marble table, with legs terminating in eagle claws, on which the victors' olive crowns and other awards were placed. The crowns were made of wreaths, perhaps cut from wild olive trees with a golden knife, by a wellformed boy whose parents were living—after the Greek manner.

Into this room marched the glistening naked athletes, accompanied by trumpet players, as suppliants for the blessing of Hercules at the beginning of the games. Here too sacrifices may have been offered, probably kids or lambs, and the conformation of the entrails inspected to learn if the sacrifice was pleasing to the deity. By the first century after Christ, educated Romans no longer placed the slightest faith in such rituals. Nevertheless, here stood the priests of Hercules, arms raised and palms held upward, while the smoke from sacrifice and incense ascended before the image of the hero-god. Then the boys and young men marched out again, around the arena, and the games began. The games were accompanied by the music of flutes.

The sports events were underwritten by some wealthy citizen, usually a patrician, as the feasts that followed the events were paid for by rich freedmen. As we know, the Proconsul Balbus was one of those who sponsored the Herculanean games. Apparently on the day of Vesuvius' eruption a competition was in progress. Games normally were part of the celebration of the Emperor Augustus' official birthday, in mid-August, and lasted for a week or more. On that fatal morning the stone-throwing competition must have been the next event on schedule, or actually under way, for the excavators found the rough round stones weighing about five pounds not in storage but laid out for use.

On either side of the lofty apsed hall are other vaulted rooms with lower ceilings. Their precise purpose is unknown, though in two remain the headless statues of robed female figures. Probably statues of Hermes and Hermaphroditus were included. Somewhere was a statue of Hygeia, the goddess of health, as is known from an inscription. (Usually Hygeia held a serpent in one hand and a bowl in the other. Today, serpent and bowl are interpreted in psychiatry as male and female symbols, indicating Greek and Roman belief that the essence of good health lay in satisfactory sexual union.)

The use of the rooms adjoining the apsed hall could not have been too solemn, for on one wall is a painting, well preserved, of a convivial scene. This was one of four similar paintings found resting on the pavement in 1757, and has been returned to the wall. It portrays an athletic, bronzed young man,

10

naked to the waist, lying on a couch with a beautiful woman. His right arm is about her shoulders. They are attended by two servants, one of whom has opened a box, which may be a jewel casket. The woman is placing something in the young man's left hand. Perhaps he was a victor in the games and is collecting an extra reward.

The playing field was more than spacious. There was room for a row of decorative trees—probably umbrella pines. Their roots have been found. The field was easily adequate for most of the exhibition sports: footraces, wrestling, boxing, discus hurling, the javelin toss, and a combination of wrestling and boxing. But here at Herculaneum, with its copious water supply, swimming must have been added. In the center of the field was a swimming pool in the form of a cross, some 160 feet in length with an intersecting arm of 100 feet. At the ends were fountain jets. In the center was a giant bronze serpent, coiled on the limbs of a tree, and from whose five crowned heads water sprayed into the pool. The serpent, overlooked by the Bourbons, has been restored to its commanding position. A second pool, rectangular and smaller, may have been used by the younger boys for competitions.

The mountain of hard mud has not been removed from above the cruciform pool, but merely hollowed out like a cavern over the central portion. It is possible, in addition, to traverse the length of the pool. Here the volume of the alluvial mass is best realized, and also its force. Carbonized beams, chunks of marble pavement, bits of mosaics, fallen columns—all are scattered as if stirred by some giant's child into an enormous mud pie and baked until dry and hard.

Here one recognizes with a certain awe the magnitude of the work thus far accomplished by the patient and dedicated Italian archaeologists . . . and the magnitude of the work yet to be done.

XIV

CURTAIN TIME-The Theater

ROMAN DRAMA AND THE ROMAN THEATER ARE THE DIRECT ANCESTORS OF OUR OWN. But, for an ancestor, Roman drama is very much alive on the modern stage from *Amphitryon 38* to *A Funny Thing Happened on the Way to the Forum* we have witnessed and laughed at Roman comedy. At Herculaneum both the Theater itself and the performance would have seemed familiar to us, though some aspects of each would have struck us with their novelty.

Perhaps the greatest tragedy in the history of the theater is that the one ancient theater that could have come down to us intact, at Herculaneum, has not done so. True, it was discovered entire. The mud rose higher and higher on the outside, until it flowed over the upper edge as into an open bowl, sweeping away only the statuary that crowned the structure. All else was preserved, either in the original position or not far from the original site.

It was quite beyond the imagination of the Austrian Prince d'Elbeuf to recognize the stage, with its richness of marble and statuary, for what it was. For seven years he stripped away the rarest of polychrome marbles, the most delicate of stuccoes, the finest bronze and marble statuary—anything and everything movable. What he could use for his villa, he used. The rest he dispersed throughout Europe as presents to aristocrats. The case histories of a few are known.

The best statues were sent to Prince Charles Eugene of Savoy. At the death of Charles Eugene, they were bought by the King of Poland. On the Prussian invasion of Poland, they were stolen by Friedrich II of Prussia for his villa, "Sans-Souci." Some of the statues are now in the Dresden Museum. A group

of eight statues in marble was brought up from the Theater on another occasion. The prince carelessly left them for some time in the streets of Resina. Then he sent four to his own villa and four to the palace at Portici. Some ended up in Vienna. In fact, the Prince d'Elbeuf's depredations were little different from the robberies of Egyptian, Greek, and Etruscan tombs. We can only lament his lack of understanding, and resent the extent of his greed.

In 1738 the Princess Maria Amalia Christine of Saxony married Charles III, the young king of Naples. He was twenty-three, and had ruled four years before taking a wife. She became fascinated with the beautiful art objects from antiquity which she found in the palace grounds at Portici. When she learned that they had been recovered from a well dug at nearby Resina some years before, she urged her husband to search for more. Both had read widely on the subject of antiquity. Thus the king authorized the first of Alcubierre's tunneling activities.

Alcubierre was anything but a scholar, as his diaries of the excavation testify. When confronted by a Latin inscription, he admitted helplessly, "I don't understand what significance it holds." The king called in the royal librarian, the scholar and humanist Don Marcello de Venuti, to supervise the finds and read the inscriptions. Discovered were the torso of a bronze horse, some frescoed columns, and three marble portrait statues draped in togas. The queen was entranced, and the royal couple came to the site to inspect. De Venuti came too, and had himself lowered into the fascinating hole by a rope. Almost at once he recognized the character of the underground structure. And soon after, an inscription was uncovered that stated that the Theatrum Herculanense had been built by Lucius Aeneas Mammianus Rufus, *duumvir*, with his own funds, and by the architect Numisius. (A *duumvir* was one of the two highest officials in the municipality.)

To some extent de Venuti was able to protect the Theater from the kind of depredations that d'Elbeuf had inflicted upon it. But in spite of his good intentions, and the efforts of Weber and La Vega to draw up plans and elevations, the Theater remained in essence a quarry for ancient art and marbles. Charles III abdicated the Neapolitan throne in 1759, to become king of Spain. Under Charles' lumpish son Ferdinand I (King of the "Two Sicilies") its glories were scattered once again. And as late as 1770, the king was casually tossing bronze fragments into the melting pots, to reappear as candlesticks for the royal chapel at Portici.

Alcubierre managed to clear the entire stage by 1739. The records for 1740 have been lost. By 1765, a circuit of the exterior had been made; and the square

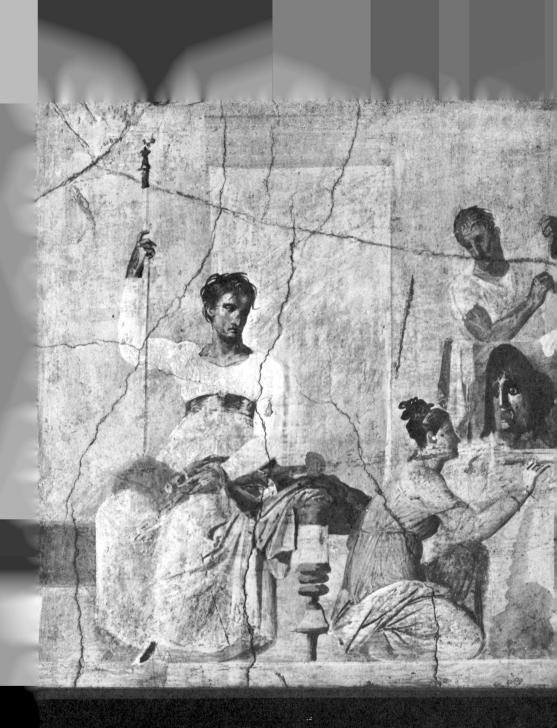

The "Actor-King," one of the finest of the few small paintings that have survived from intiquity, is sometimes called the "Roman Hamlet." It was found stored in an undecorated Herculaneum room. The actor, evidently backstage, remains seated in regal costume, a white chiton with golden belt and mauve cloak. With his right hand he holds a long scepter; with his left, the scabbard of his sword. The young woman writes an inscription under a tragic mask. The male figure in the background is unfinished

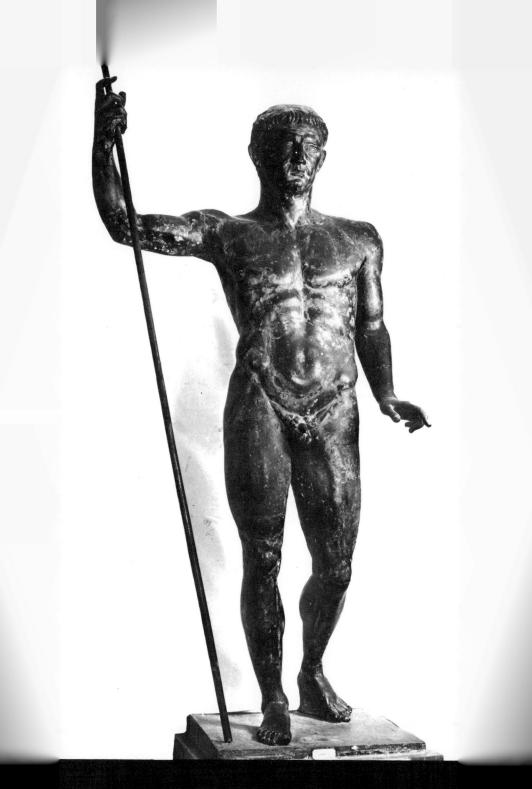

Ieroic bronze statue of the Emperor Claudius, probably from the Theater. The read of the indecisive, timid, scholarly Claudius, with its large protruding ears a clearly recognizable. The body—of an athlete—is not. Claudius was sedentar portico behind the stage, where the patrons gathered during intermissions, had been partially explored. For almost forty years the tunneling in and out of the Theater went on. It is the opinion of modern archaeologists that in less time, and probably at no greater cost, the whole structure could have been excavated—despite the fact that the orchestra lay buried under almost ninety feet of hardened mud. Had it been revealed and not plundered, it would today be an archaeological wonder of the world.

Revealed would have been an important Graeco–Roman theater at the moment of rehearsal for an afternoon performance. Theatrical presentations were regularly part of festivals, sponsored, like the youth games, by some leading citizen of the town. The old Greek dramas as well as the Roman product were favored by the Greek-speaking inhabitants of southern Italy; and Herculaneum, close to Neapolis, with a theater seating 2,500 people, would have drawn the best troupes of tragic actors from Athens, Alexandria, and Rome.

Comedy and farce also were in great demand. Pantomimes had assumed increasing importance in the Roman theater, and except for the gladiatorial combats and chariot races at the circus, were the most popular of all types of spectacle. Little or no spoken dialog was used in the pantomime, but there was a great deal of singing—especially chanting by a chorus and, later, by the principals. Dancing assumed a more and more significant part. In the old Roman theater, all roles had been played by men; but by the time of the Empire, actresses had come into their own, especially in the pantomimes. Masks were dropped, and actors faced the audience just as actors do today. Successful mimes became almost as idolized as winning gladiators, and commanded both astronomical wages and the beds of fashionable ladies—even, on occasion, the bed of an empress (or an emperor). Nevertheless, the social stigma of the theater was never overcome. Rigid laws regulated the matrimonial rights of actors, and set them apart from the rest of the population.

By the year of Vesuvius' eruption, the pantomime had become the prototype of modern American musical comedy. The leading actors and actresses were singing and dancing stars. Much emphasis was placed on nudity, especially among the chorus girls, though such a male role as that of Apollo also was played in the nude. Satyrs wore goat tails, and goatskin loincloths with erect leather phalli. Essential was the erotic by-play, both gags and gestures, which evoked laughter from the notoriously noisy and disrespectful audiences. Even humor so broad and so graphic as that portrayed in Lucian's *The Ass* was not too much for the Roman stage. (In Lucian's tale, a well-born lady fell in love with an ass, who was in fact a man transformed; and when the man miraculously resumed human shape, she rejected him as inadequate for her needs.)

Perhaps someday, further excavations will tell us exactly which play or pantomime was in rehearsal in the Herculaneum Theater at the time of the immersion. Certainly all the typical equipment of a Roman theater must have been present and functioning: the colored awnings slung from masts to protect the audience from the sun; seat cushions; the skin bottles of saffron-scented water used as spray to freshen the air; the vendors' trays of sweets and nuts; the undistributed tickets for future performances; the curtain, with its mechanism for descending into the pit; the trap doors in the stage; the cranes for flying the gods through space; the bronze drums for making thunder; the revolving scenery, the musical instruments, the high-heeled shoes, the costumes, the masks, the wigs, the paint, and even the scripts.

And the Theater itself was an architectural jewel. After the fall of Rome, such theaters as this were not to be seen again in Italy until the sixteenth century. The Herculaneum Theater had been built in the time of Augustus, and redecorated not long since in the time of Claudius or Nero. It was not cut into a hillside, as in Greece and at Pompeii, but stood independently like the theaters of Neapolis and Rome. It was a semicircle, supported by a double order of arches and pillars, with nineteen arches to each order. The arches and pillars were adorned with a painted facing in the "fourth" fantastic-architecture style, plus elaborate stucco work. All the decoration throughout the entire Theater was sumptuous, as can be seen from the fragments remaining here and there: a few fine capitals of marble columns, bits of stucco revetment and splashes of color, damaged pieces of polychrome marbles.

But it was the stage that displayed the true pomp and elegance of the edifice. It was a permanent architectural background of rare marbles and statuary. Statues of the finest quality stood in alternate curved and rectangular niches. Walls and columns were faced with marbles of black, yellow, purple, and porphyry red. Some were faced with alabaster. Only the marble work in the baroque churches of contemporary Naples can give an approximation of the appearance of the Herculaneum stage. For all its magnificence, a second curtain—as in other Roman theaters—must often have been raised in front and painted scenery placed in position. The Romans always preferred realism in theatrical settings.

Above the orchestra, stone seats filled the auditorium (*cavea*) in semicircular tiers. Flights of steps led to the various seat groupings. The first four rows were reserved for local magistrates, officials from Rome, and distin-

CURTAIN TIME — THE THEATER

guished citizens. The next sixteen rows were reserved for members of the Senatorial and Equestrian orders (normally, only fourteen rows were so reserved). The remainder of the seats were separated by a parapet about a yard high; here sat ordinary citizens, women, and children. Until a decree by the Emperor Augustus, women had sat with men in all theaters, just as they mingled with men at other public functions. The decree remained in force long after Augustus' death.

All seats were free, and only slaves were barred. The highest officials sat in segregated boxes over the entrances to the orchestra, at either end of the

Bacchic procession of the type that set the tone for the satyr plays. The wine god Bacchus, or Dionysus, is preceded by two of his worshippers during the Bacchic rites: a frenzied Bacchante with cymbals and a pointed-eared faun playing the double pipe. The god as always is accompanied by his pet panther and carries the thyrsus topped by its fecundity symbol, the pine cone.

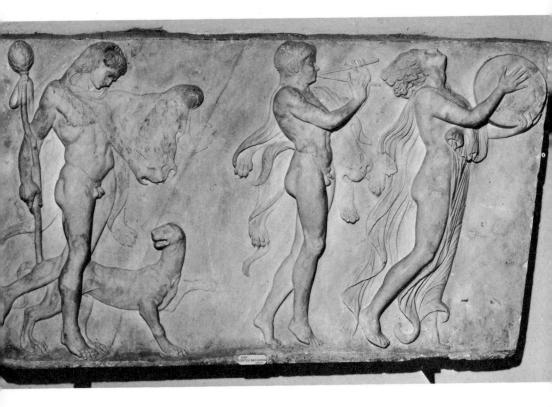

stage. One no doubt was reserved for Proconsul Balbus and his family, for his rank was far above that of any local magistrate. These seating arrangements in a Roman theater are in significant contrast to seating in a Greek theater, where citizens of all class levels mingled freely.

Incidentally, the theater exits (at Herculaneum, there were seven) were called *vomitoria*, for obvious reasons. For years it has been the sport of the guards at Pompeii and Herculaneum to have their private jokes with visiting tourists and this word. They tell the gullible that the Romans gorged themselves at meals, then vomited to eat more—and point out various apertures in private houses as *vomitoria*...!

On the crest of the Theater semicircle were three rich shrinelike structures, each flanked on both sides with gilded equestrian statues. The spaces between were filled with larger than life-size bronzes of emperors and important municipal personages, a notable mingling of national and local interests. Of these bronzes, five were recovered and remain in the Museum in Naples. The five were portrait statues in the most realistic Roman manner.

The Romans never made the slightest effort to soften ugly truth or prettify a face, though the emperors' bodies, when nude, often were glorified and made heroic. But even so vain an emperor as Tiberius is shown with flaccid cheeks and petulant mouth, as his Herculanean statue proves. (As a young man, he markedly resembled his mother, the Empress Livia.) Of the other statues, Antonia, Claudius' mother, is depicted with the coldness she revealed toward her son. Another woman, with cloaked head, is unknown by name; today she is called simply "the Vestal," but the face obviously is a careful likeness. And finally, there are two prominent citizens of Herculaneum: the shrewd, sharpdealing businessman Lucius Mammius Maximus, who was honored because he built at his own expense a covered market for the town; and the patrician Marcus Calatorius, whose portrait is notable for its furrows, hard mouth, and the prominent wart under the right eye. (The Calatoria involved in the lawsuit against poor Justa was probably his freedwoman.)

It was the statues of Lucius Maximus and Marcus Calatorius that produced something resembling trauma in the famed eighteenth-century German art historian Johann Joachim Winckelmann, who did so much to stimulate neoclassicism. His studies of art in antiquity had been concentrated on a limited number of Greek statues of idealized faces and figures, and he went so far as to state that "men like gods" must have lived in ancient Hellas. After irksome difficulties in obtaining permission to visit the Bourbon palace at Portici, he finally was allowed to inspect some of the objects brought up from Herculaneum. Among them were the portraits of Maximus and Calatorius. Winckelmann could hardly believe what he saw. Their solid provincial air of respectability, their distrustful expressions, their ordinary ugliness, among the glorious Greek divinities and athletes, was almost too much for him to bear. Also, unfortunately for his knowledge of antiquity, he was not allowed to see the erotic sculptures; the prudish King Charles had ordered them locked away and guarded. Winckelmann's open letters, "The Discoveries at Herculaneum," the first of which was published in 1762, were justifiably critical of the management of the Herculaneum explorations. Aside from the antipathy the letters aroused among the Bourbons, they helped to alert the world to the true significance of the finds which had been made.

The names of two additional Herculanean personalities honored with statues in the Theater are known, but the statues have disappeared. The bases, near the main entrances to the orchestra, remain with their inscriptions. One is dedicated to Appius Claudius Pulcher, who is thought to have been Consul in 38 B.C.; the statue was dedicated after his death, for unknown reasons. The other is inscribed to Proconsul Marcus Nonius Balbus, whose name reappears so many times as a leading citizen. A life-size portrait statue of Balbus wearing a toga, now in the Museum, may have come from the Theater, but the records are incomplete. Also, the remarkable portrait bust of the playwright Terence, known to be from Herculaneum, most logically would have come from the Theater.

Today, the Prince d'Elbeuf's well and Alcubierre's tunnels, crisscrossing the Theater, remain much as they were when the explorations finally were abandoned. From them the present visitor derives the most vivid impression of the conditions under which the Neapolitan *cavamonti* worked so deep underground. Mists and vapors slither like ghosts through the corridors; water and slime drip from the ceilings and walls; the air is dank, bone-chilling.

Even with electric lights the tunnels disappear abruptly into the mysterious sepulchral darkness of twenty centuries. The imprint of a face in the matrix of mud, perhaps that of the Dionysus who was hurled down, leers with grotesque malevolence. But above all, the horror of the eruption becomes real as the echoing laughter of a theater crowd turns abruptly to screams.

All the seats are empty now.

XV

THE BASILICA— A Roman courthouse

NO BRASS OR BRONZE SPITTOONS HAVE BEEN EXHUMED FROM THE HERCULANEUM Basilica. Perhaps they are unique to the history of small-town courthouses in America. If the courthouse—the Basilica—in Herculaneum was typical of small towns in Italy under Roman rule, very few small-town courthouses today could stand comparison.

In ancient Greece the *basilikos* was the "King's house"; in Italy its kingly aura came to be transferred to the courts of law. It usually followed a standard design: a rectangular hall or nave, ending in an apse, and flanked on either side by a colonnaded aisle. Sometimes galleries for spectators were erected on the sides. The judge, a prefect, sat in formal toga in the apse, at a level above the plaintiffs and defendants, their lawyers and witnesses. The early Christian churches were directly derived from the plan of the Roman basilica.

To the Basilica in Herculaneum came Justa in defense of her rights. The courtroom must have hummed with the whispers of lawyers and clients, which have accompanied lawsuits in all times and all places. The curious spectators, unless the courtroom was cleared, must have gawked at the pretty young girl and shaken their heads disapprovingly at the persecuting Calatoria. During testimony, little attention could have been paid to the impressive lines and ornament of the building. Yet, in its very dignity it upheld the Roman tradition of the majesty of the law, which has had so profound an effect on the Western concept of justice under law—however imperfectly realized.

Today the tunnels to the Basilica, which were bored erratically between the years 1739 and 1761, are heaped with their own rubble and closed to any passage. They were refilled because the mud cake is less thick at this point, and

the houses of Resina above were said to be in danger of collapsing. It is still possible, however, to penetrate a little way along one line of massive columns. They remain locked in the clutch of the mud, some askew on their bases, some stripped of their capitals, but all conveying the impression of a great building of a great civilization. How many supreme courts in how many lands are architectural descendants of the Roman basilica ...?

The Herculaneum Basilica was not explored and measured with the same thoroughness as the Villa of the Papyri, but a rough plan does exist. Estimates of the length vary from 125 to 200 feet. While the tunnels remained open, two curious French travelers, Cochin and Bellicard, made their way about the buried courthouse with torches and afterward wrote a detailed description of their awesome experience. They reported a large rectangular hall divided by two lateral rows of columns into a central assembly space. On the long sides of the rectangle were walkways, or porticoes, enclosed by the outer walls and inner columns. Along the walls, between alternate pillars and half-columns, niches held statuary. At the rear was a large central apse, which evidently displayed the heroic statue of the Emperor Vespasian. On either side were large semicircular niches with frescoes.

These frescoes, curved to fit the niches, are now among the treasures of the National Museum in Naples. One portrays the Centaur Chiron instructing the nude youth Achilles in the art of playing the lyre. Another portrays, allegorically, an incident from the life of Hercules.

A sun-bronzed Hercules, shown from the rear and wearing only a garland and a quiver, stands before a draped female figure representing Arcadia with an eagle at her feet. In the background are a tranquil lion (subdued by Hercules), a young satyr playing the pipes, and a winged female figure. The latter directs Hercules' attention to a naked little boy being suckled by a doe, while the doe lovingly licks his leg. The boy, Telephus—one of Hercules' many illegitimate sons—had been abandoned in the wilds of Arcadia on a mountaintop. Telephus' mother was Auge, a virgin priestess of Athene. She was violated by Hercules in the temple grounds. Some versions of the affair state that Hercules was drunk; others say that as she made no cry, she was not raped but met Hercules secretly and willingly. When her father discovered her pregnancy, she was sent away. She bore Telephus while traveling, and left the baby in a thicket.

The third fresco, "Theseus Triumphant over the Minotaur," is even more interesting for its expert composition. Theseus has just issued from the labyrinth, where the monster with the head of a bull lies dead. The hero, carrying the lethal weapon, his staff, is nude except for a purple cloak flung over his left arm. His vigorous body is rendered almost as if it were a statue of red bronze—a technique later to be so effectively developed by Michelangelo. Naked youths kneel before Theseus and kiss one hand and knee, while in the background an awe-inspired crowd looks on. It was this painting that elicited from Alcubierre one of his most characteristic remarks. There in the darkness of the tunnel, holding up a flickering lantern the better to view the dramatic body of Theseus, Alcubierre exclaimed: "The artist surpasses Raphael!" Years later, in 1816, Stendhal, the urbane French writer far more acclaimed in our day than in his own, saw the painting at Portici, and thereupon wrote that the "Theseus" showed "noble simplicity, nothing of the theatrical," and "proved the existence of a very elevated style" in antiquity. The same theme is handled in a similar manner at Pompeii, but much less effectively.

Who was the artist? Unfortunately the frescoes are unsigned. But certainly they were not painted by an ordinary journeyman; for, if not by Raphael or Michelangelo, they are of very great skill indeed. They may reproduce sculpture groups famous in antiquity on the same themes, and the artist or artists perhaps were recruited from Neapolis. It is known that art studios flourished in Neapolis, for in the second century after Christ the orator Philostratus compiled a list of all the paintings then on exhibition at the civic picture gallery. If a microcosm like Herculaneum could command such artists for its courthouse, then what of the great cities? The Herculaneum Basilica was decorated with other frescoes of outstanding merit; some of these were detached, then lost or destroyed. Some undoubtedly remain. Those recovered are considered the best examples of ancient painting that have survived.

The Basilica was remarkable also for an external bronze: the largest fourhorse chariot of which any portion has come down to us. It probably crowned the entrance. Swept away by the remorseless mud, fragments have been found in several different places. As each new piece appears, the patient work of reconstruction continues. One horse is now complete in the Naples Museum, and is a superb example of the bronze casters' art. Another head has been recovered entire. The quadriga was not merely four horses drawing a chariot. Grasping the reins was a large sceptered figure (a deified emperor?)—as six major fragments prove. It is clear, too, that the figure was modeled with the highest skill. The chariot itself was decorated with statuettes, of which five have been found, representing Alexander the Great and other famous personalities. Of the chariot itself, the yoke, the pole decorated with a griffin, and the hub of one wheel thus far have been discovered. The rest may turn up when the Basilica is someday fully excavated.

Bronze portrait statue of Marcus Calatorius, one of Herculaneum's leading citizens, in he oga. His statue stood in the Theater among such notables as emperors empresses mothe

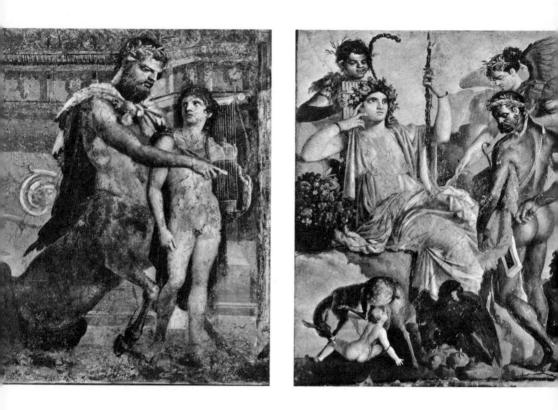

LEFT. The celebrated old Centaur Chiron instructs the youth Achilles in the art of playing the lyre. Achilles, for his safety, had been dressed as a girl and hidden among girls, hence needed a manly tutor for all the manly arts. This fresco is in the Herculaneum Basilica.

RIGHT. Hercules and his illegitimate son Telephus—a large curved fresco that decorated a niche in the Basilica. Hercules, burned almost black by the sun, watches the boy being suckled by a doe. The female figure is the personification of Greek Arcadia, in whose forests the boy had been abandoned.

THE BASILICA — A ROMAN COURTHOUSE

The entrance was flanked by two notable equestrian marbles—none other than our old friend the Proconsul Marcus Nonius Balbus and his son. Within were the marble portrait statues of the entire Balbus family, slightly larger than life. They were found still standing on their pedestals, or fallen nearby. (All are now in the National Museum in Naples.) Along an architrave, red letters chiseled in marble formed an inscription stating that Marcus Nonius Balbus had rebuilt the Basilica with his own money. (This inscription is in the Museum, too.) In gratitude, apparently, the town had erected the Balbus statues. These statues have exceptional interest because of the insight they give us into a leading Roman family. The name "Balbus" is an example of one of those nicknames which (as in Italy today) actually became an identification name—it means "stutterer." We know, from an inscription, that the family the gens name was Nonius-came originally from Nuceria, another Campanian town not far from Vesuvius. It seems that they were not an old patrician family but had been wealthy for several generations. Only fairly recently had they entered patrician ranks; there is reason to believe that the Proconsul's mother was a freedwoman.

Of the references to the name "Balbus" in Roman literature or history, we cannot be sure how many, if any, were directly related to that Nonius Balbus of Herculaneum who became a proconsul, as none also bear the name "Nonius." But, as in the Calpurnius Piso family, there may have been close interconnecting links even when the gens name was not involved. One Balbus, a banker, was one of the financiers who backed Julius Caesar's march on Rome and subsequent dictatorship. (This Balbus also seduced his son's bride on the first night, before his son could take her to bed.) A Balbus from the provinces married Caesar's sister, Julia, and thus became the grandfather of Octavian (Augustus), who was reviled by Mark Antony for this ancestry. Antony said that Octavian was no more than the grandson of a baker and the keeper of a perfumery shop—which was true, for Balbus was a small-business man. Another Balbus built a theater in Rome near the Circus Flaminius; it seated 7,500 people, half the number of the Theater of Marcellus.

So it may be considered no accident that in the civil wars Marcus Nonius Balbus supported Vespasian, who was the son of a tax collector, and—though a soldier—very business-minded. The new and wealthy middle class had become the new and wealthy patricians. And above all they wanted stability to enjoy their wealth... and to make more money.

On their handsome marble horses, the Proconsul and his son are dressed identically in thigh-long tunics, soft riding shoes, breastplates, swords in

11

scabbards, cloaks thrown over the left shoulders and left arms. The left hands hold the reins. On the third finger of each left hand is a large signet ring. The right hands are raised aloft in gestures of imperial command. The Proconsul's hairline is receding. The son's abundant hair is cut short and combed forward in the Roman fashion. The Proconsul's face conveys all the haughty authority of a high Roman official who is an overseas administrator. The son's face conveys uncertainty, distaste for an assumed role, and resignation. The Proconsul's tight lips are curt with self-assurance and executive drive. The son frowns, and the full lips almost tremble with petulance.

If the sculptor has told the truth, here indeed was a son in severe conflict with the father or other members of the family. But of the Proconsul's face a final judgment can be made only by comparing it with the "togaed" portrait that exists, for the head suffered an accident as senseless as the Allied bombing of Pompeii in September of 1943. During the revolt of 1799 against the Bourbons, when a short-lived Neapolitan Republic was established, cannon were brought up before the Royal Palace at Portici—though the king had galloped away. In the ensuing fusillade one ball struck and shattered the head of the Proconsul Balbus—an ominous portent of the decapitations King Ferdinand was soon to order cold-bloodedly for the revolutionaries. Later, when an uneasy calm again prevailed, the Balbus head was restored with the help of fragments. The restoration strongly resembles the other portrait. Nonetheless, confusions about these equestrian statues still continue, and probably will continue until another portrait of Balbus Senior is found, or the honorary inscription dedicated to Balbus Junior, now lost, reappears.

As for the rest of the family, they stand unscathed and are represented with the usual chilling Roman realism. The wife,Volasennia, is not wholly certain of identification because of the distance her statue had been carried from its base; but both stylistically and pictorially she fits into the Balbus group. She is a conventional Roman matron, wearied with middle age and official life. Traces of reddish-blond paint remain on her hair. Thus it is indicated that she may have used the blond dye known as "German soap," which became so popular among Roman women in the time of the Empire. Or, as an alternative, she might have worn a wig of blond hair—hair once the property of some barbarian German woman.

The two daughters perhaps were called Nonia the Younger and Nonia the Elder, in accord with old Roman custom. They are subdued and overwhelmed with propriety. Their hair has been parted in the middle and brushed back in close-fitting waves to a tight bun on the neck, though a few strands are allowed

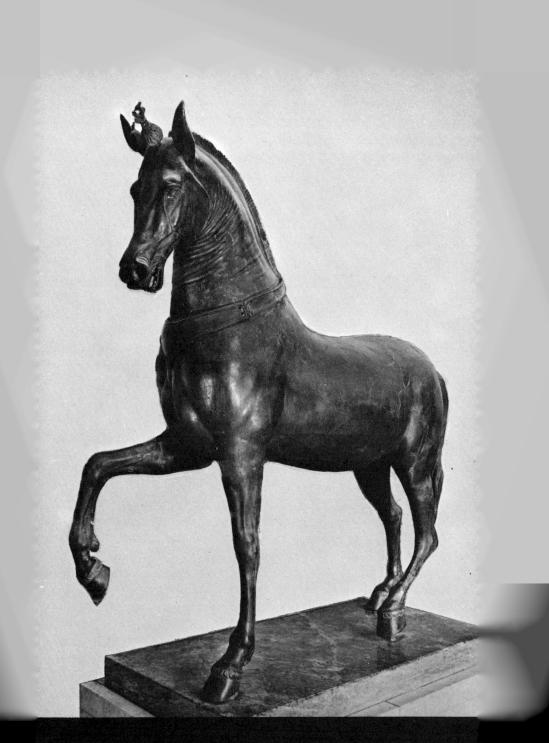

Bronze horse, one of four, was harnessed to the great bronze chariot that probably toppeche entrance pediment of the Basilica. The driver was a finely cast heroic figure, perhapsed deified emperor. Gradually, parts of other horses, the chariot, and the driver are being

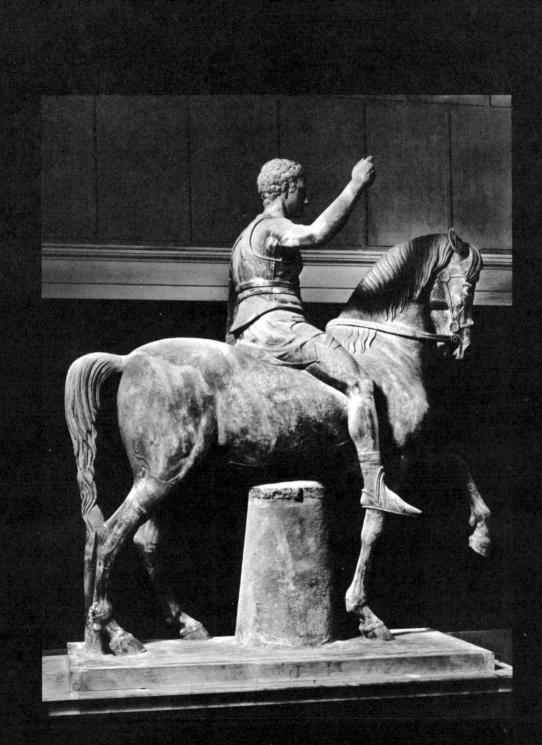

Marble equestrian statue of Marcus Nonius Balbus Junior, one of the statues erected in the Basilica honoring the entire Balbus family. Marcus Junior is paired with his father on horse-back; the women are portrayed standing.

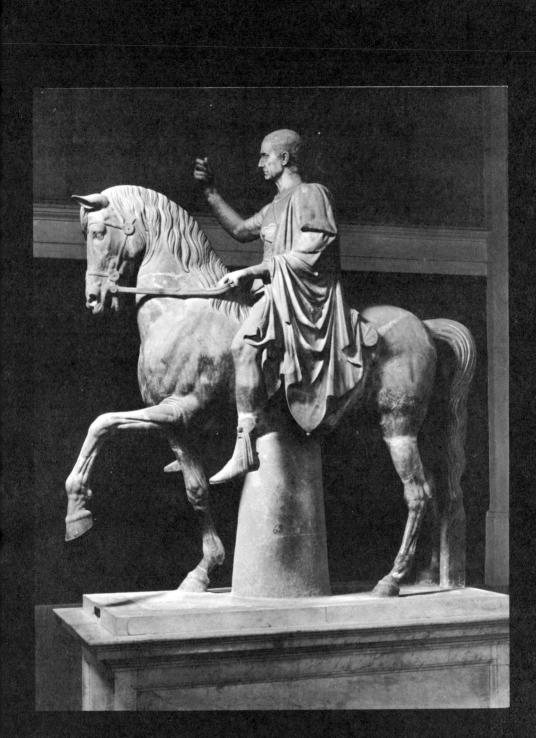

Equestrian statue honoring Proconsul Marcus Nonius Balbus. From inscriptions it appears that Balbus was the richest and most influential citizen of Herculaneum. At his own expense he rebuilt the Basilica after it was damaged by an earthquake.

to descend. The elder is resigned, bulky with growing maturity, and may already have borne children. Slight traces of paint reveal that she may have colored her hair like her mother. The younger daughter is sweetly unsophisticated, shy, rather withdrawn. Both are plain, but the younger is much the prettier.

It is the grandmother Viciria, mother of the Proconsul, who is a true masterpiece of the Roman portrait art. She towers as a Republican matron of the old school, harsh, puritanical, dominating, demanding, and ruling—a kind of female Cato the Censor. Her stern, austere features are accented by a Gargantuan nose. Her mouth is inflexible; her jaw is set; her opinions unalterable. She must have been both pious and rigid in her religion. She stares down from her pedestal, her heavy body swathed in a stola. A hood partly covers her head; her hair is parted in the middle and brushed severely back. Her strong right hand is raised almost to her chin. From her face it is possible to understand some of the tensions so subtly expressed in the faces of the other members of the family. The Balbus household no doubt was well managed by Grandmother Viciria; it could hardly have been a happy one.

Written on one wall of the House of the Relief of Telephus—the house which probably belonged to Balbus—are two proverbs in minute but regular letters:

"Who does not know how to defend himself, does not know how to survive."

"Even a small danger becomes great if neglected."

Who in that house, other than Marcus Junior, could see himself as so threatened . . . ?

It is extraordinary that all the members of such a family should have been exhumed from antiquity. After studying their statues for a while, they become living personalities. It is easy to imagine them at the Theater in the loggia of the Palaestra, moving about the Forum, conversing at the Suburban Baths, dining in the fountain-splashed courtyard of their luxurious house above the marina. Away from public gaze their conflicts flash like summer lightning; but Grandmother Viciria controls and dominates them all. Yet surely, underneath, in the younger sister or Marcus Junior, smolders the possibility of successful rebellion.

What a sight, in 1748, to have viewed the parade of this family issuing from the millennial darkness of the Basilica, through the tunnels into the glaring light of day . . . ! How curiously they remain fixed in time, their problems eternally unresolved.

XVI

MAIN STREET AND The forum area

A ROMAN TOWN WITHOUT A FORUM WOULD NOT BE A TOWN AT ALL. THE FORUM WAS the center of civic life, of banking, of exchange, and a fount of economic and political information. The Forum was the head of the body politic. In Herculaneum, despite the labyrinth of tunnels and shafts, early information gleaned on the Forum was scanty indeed. Yet a town with public buildings so grandiose as the Basilica and the Palaestra was sure to have an impressive Forum, and the over-all plan of the new excavations was to dig steadily in the direction where the Forum was thought to be.

When the main street (the *decumanus maximus*) was discovered, leading from the large assembly hall of the Palaestra in the direction of the Basilica and the Theater, it was evident that the Forum could not be far away. The old La Vega map drawn on the basis of the tunnels had indicated a main street and an open area that might have been the Forum. But they were not precisely placed in relation to the Palaestra, and furthermore they appeared to be under one of the most congested areas of the Resina slums. So demolition was necessary before the dig. It has been a slow and costly process, so that only the southern side of the street and a portion of its length are today revealed. The Forum proper is yet to come.

Compared with the other streets of Herculaneum, Main Street is very wide —about forty feet. Included are sidewalks of ten or twelve feet on both sides. It was a pedestrian paradise, as carts, wagons, chariots, were banned from the area. (Vehicular traffic was banned from all the streets of Rome, except at night. Chariots were banned at all times, except during a Triumph.) Stone steps or stone pillars effectively blocked the street. The curbstones are low, and the gutters are of brick; the paving is not of the heavy stones intended to support wagons. The sidewalk on the southern side was protected by overhanging roofs, some of which were supported by carved wooden beams still to be seen. On the northern side, a covered portico with columns and pillars protected the pedestrian from inclement weather. Here the wall of solid mud prevents access.

The street actually begins with a little square in front of the assembly hall of the Palaestra, marked by a public fountain with a jet of water flowing into a rectangular trough from a crudely carved head of Hercules. Farther down the street, strategically placed, is a similar fountain with a representation of Venus. Nearby is a painted shrine with serpents. The street is bisected at intervals by the smaller streets leading down toward the town abutments and the marina. Such intersections proved ideal spots for town bulletin boards of course, stone pillars. One such is posted with a town ordinance against litterbugs: the penalty was a fine or corporal punishment or both.

The commercial nature of this section of the street is indicated by the continuous line of shops and workshops opening on both sides, interrupted only occasionally by the portal of a patrician house. (The artist's shop and the tinker's shop are already familiar.) Advertising here is much more restrained than in Pompeii, where both politicians and merchants went in for the hard sell. In any case, one ad proves that nobody felt it improper to use religion to promote a product or a store. The god Bacchus is painted on the wall of a wine shop with a half-dozen samples of various types of wine. The wines are listed, and the clear implication is that these wines are fine enough for a god. The slogan is short and modern in its impact: COME TO THE SIGN OF THE BOWLS!

In a large, well-equipped snack bar on one corner, idlers gathered for the morning and afternoon wine breaks. Salacious humor was to be expected. One graffito has survived. The doodler has scratched a phallus on the wall with the instructions: HANDLE WITH CARE.

The old map indicates that a great temple is to be found at the end of the street, but that temple remains far distant. At the end of the short section thus far excavated, a massive four-way arch dominates the street. Originally it was faced with marble and decorated with stuccoes; as only traces remain, evidently the Bourbon tunnelers got here first. Indeed, when they arrived the four statuary bases flanking the main openings still supported equestrian bronzes, as we know from fragments of the feet. It was an impressive arch, and probably was dedicated to an impressive personage; but the inscriptions are gone with all the rest. Nevertheless, some portions of the ravaged marble have been found, and part of the facing has been replaced on two of the statuary bases.

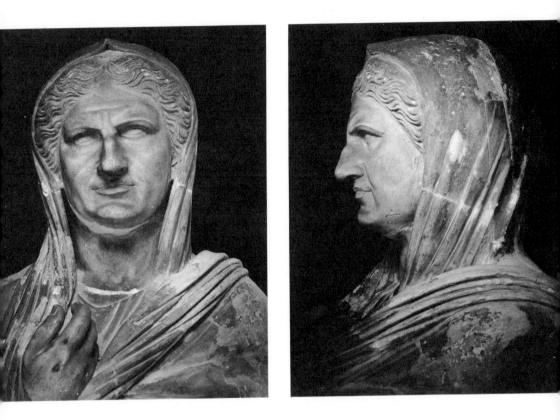

Portrait statue of Proconsul Balbus' mother, Viciria. This is Roman portrait realism at its most candid. Viciria is the epitome of the old Roman matron of Republican times: stern, dominating, inflexible, puritanical, and pious.

Close-ups of Balbus and son. Their horses, poses, breastplates, cloaks, short tunics, and swords are identical. Father Balbus was a great success with officialdom in Rome as an overseas administrator; son had yet to prove himself.

A structure of such dignity would seem to be a major entranceway to the Forum itself. A handsome marble pavement leads inward and is lost in the mud. It whets the appetite for more. Overlooking the arch are two of the structures most recently excavated: a patrician house, and the shrine of the Augustales.

The "House of the Tuscan Colonnade" (Casa del Colonnato Tuscano) has all the characteristics that have become familiar from other Herculaneum houses of the "poor" patricians, except that its plan is most irregular. Its interesting features are exceptionally well preserved, especially the frescoes, which have been cleaned and polished and restored to their original glowing colors. A painting of a boy faun and a nymph has particular charm. In the dining room, Dionysus and Apollo are portrayed against an architectural background of the "third" impressionistic style; and above the panel, a peacock struts across the wall. The table is round, made of beveled gray slate on a marble base. In another room a table is supported by a bearded Hercules carved in rare marble.

But this house has significant features in addition to its vivid frescoes. There is a small but elegant garden surrounded by a portico. The columns retain their original coloring: alternately black or red, merging halfway down into yellow. The surrounding walls are painted with alternating red and yellow panels above a black baseboard. Upstairs, many amphorae are stored in their original places. Both the kitchen and latrine are on the upper floor. The disposal pipe leads straight down to connect with the town sewer, which at this point passes directly under the house. This house is an excellent example of Roman fusion of the functional and the elegant.

The other newly excavated structure overlooking the Forum arch is the Collegium of the Augustales, or headquarters of the officials responsible for maintaining and perpetuating worship of the deified emperors. As a shrine is part of the establishment, this building throws much light on the physical equipment of the cult.

The cult served a definite political purpose. It attempted to establish a single unifying religion, like the universality of the Latin language, among all the diverse peoples of the Roman Empire. The first of the Augustales were established A.D. 14, by a decree of the Senate, on the death and deification of the Emperor Augustus. Ensuing emperors were so powerful, so glorified, and so far removed from the lives of ordinary persons that it was easy for the distant peoples of the Empire to conceive of the Caesar as a godhead. (The farther from Rome, the more devout—as was later said of the Christian Church.) As the emperors had assumed also the title Pontifex Maximus, or high priest of the Roman religion, the apotheosis was not difficult. To accomplish these ends the Senate appointed in Rome a college of twenty-one members as administrators of the cult; and the college was duplicated in the local municipalities. Only leading citizens were elected to the Collegium, as it was of the highest social status, a kind of social register of the elite in every town. In Herculaneum we know that Lucius Mammius Maximus (who had donated the covered market to the town) and Proconsul Marcus Nonius Balbus were members. Thus the Collegium of the Augustales assumed certain aspects of an exclusive social club, and membership was accorded a great honor.

The identification of the Augustales' structure in Herculaneum is made precise by the dedicatory inscription on the wall, which states that the first banquet, on the occasion of the consecration, was given by "Proculus and Julian." The inscription fortunately was overlooked by the tunnelers, who stripped all the statuary (probably including Proculus and Julian) and the floors from this hall.

The edifice, as befitted the divine emperors, is of impressive size and decoration, though it is not meant to be a temple (the temples were erected individually to each deified emperor). The hall is somewhat more than forty feet wide and fifty feet long. Four bulky columns in the center, smooth of surface and painted a patchwork of colors, directly support the four major beams of the roof. The roof rises in short terraces to a skylight. As the columns are set well apart, the skylight is large enough to illuminate the whole interior. The ceiling on three sides is low and made of wooden beams. On the fourth, to the rear, the ceiling is missing; but here, the space from the two rear columns to the wall had been closed off to form a shrine. The floor was higher, by two marble steps, than the rest of the room; and at the back was an arched niche that had held a deified emperor—probably either Augustus or Vespasian, though at the time of the eruption Vespasian had been dead only one month. (As he sensed death approaching, Vespasian moaned, "I must be becoming a god!")

The walls are decorated with varicolored architectural forms of the elaborate "fourth" style; and on opposite sides are two large paintings of favorite Roman gods and goddesses. In one, Neptune and his wife Salacia appear; in the other, Hercules (deeply bronzed as always) sits, while Jupiter's wife Juno stands behind him and a helmeted Minerva stands beside him. Minerva was the old Italian goddess of intelligence and all the arts; gradually she became identified with the Greek goddess Athene. It is evident, therefore, that the Augustales concerned themselves chiefly with the really top echelons among the gods—suitable company for such important personages as Roman emperors.

But the Augustales of Herculaneum have left us more than evidence that they "thought big" in politico-religious matters; they also left us a mystery. To the right of the shrine one portion of the hall has been closed off by that temporary partitioning now familiar as *opus craticium*, thus forming a small room. This room, obviously hastily arranged, had a door and a small rectangular window. The window is placed high and is barred. In the room is a wooden table of good quality and an elegant wooden bed. On the bed is the skeleton of a man who had thrown himself face down in defense against the volcanic gases, or perhaps hopelessly to await the final surge of rising mud. Who was this man? Why did he fail to escape?

The supposition has been advanced that the little room was occupied by a caretaker or a priest, and perhaps, due to illness, he was unable to escape. If the man was a caretaker, why should he have a temporary room adjoining the shrine? Why furniture of such quality? If a priest, why not a room of more impressive construction? Why would the chief server at an emperor's shrine be left behind on the flight of his fellows? And if these living quarters, in spite of their hurried construction, were intended to be permanent, why no stove, no brazier for winter, no latrine?

Neither hypothesis takes account of the barred window or the evident despair in the man's position. It seems apparent that he could not escape, and no one unlocked the door. Was this man a political prisoner? Was he too important to occupy an ordinary jail, but was kept under surveillance by members of his own class? Vespasian had avoided the bloodletting which had occurred under Nero—the stabbings, the secret executions, the forced suicides by vein slashing. But banishment, house arrest, and mandatory changes of residence had remained as standard methods of enforcing the imperial will. It would not have been extraordinary for an erring member of the Augustales in Rome to have been placed under observation of provincial Augustales—for his own protection. He might even have been given the run of the town; or he might have been locked up in a place of luxury.

Agrippina, the granddaughter of the Emperor Augustus and stepgranddaughter of the Empress Livia, was banished to Herculaneum in just such fashion. As the wife of the beloved Germanicus, she was a hindrance to Livia's schemes to place her own son Tiberius on the imperial throne. Eventually she was murdered, after Augustus' death, at Livia's orders.

Whatever the offense of the man in the barred room of the Augustales, in the end he too paid with his life. Perhaps someday a chance reference in literature will provide the key to that strange little room and its hopeless occupant.

XVII

ANTIQUITY'S TREASURE Troves

HUNDREDS OF ARTICLES USED IN HERCULANEAN DAILY LIFE ARE NOW RESTING IN THE Antiquarium in Herculaneum. Thousands more are in the National Archaeological Museum in Naples. The Antiquarium is an ordinary Herculanean house, much more resembling an Italian medieval house than a Roman house. The Naples Museum began its existence in the sixteenth century as a riding school for the aristocracy. These two structures, plus the Antiquarium in Pompeii, shelter the world's most important collections from antiquity. Under their roofs are concentrated the most delicate and most valuable objects yet retrieved from Vesuvius' slopes. Each Antiquarium contains only a sample of the vast assemblage in the Museum. All are treasure troves.

Aside from statuary in bronze and marble, bits of frescoes and mosaics, here is a random list of the items on display in the Herculaneum Antiquarium: combs, mirrors, needles, earrings, beads of amber and glass, candelabra, an oil lantern of bronze and glass, double-pronged instruments for mending fish nets, wheat, beans, eggs, pistachio nuts, rope, baskets, part of the counterpane of a bed, fish net, hinges, a bronze water valve, ink bottles, silver dishes identical with New England porringers of pewter, a jointed bronze fishhook, a small Priapus with bells, a carpenter's plane, a heap of nails, money, glass jars, seals, a surveyor's triangle, kitchen pots, wax tablets, amulets, flutes, brooches, rings of all sorts, perfume flasks, pins, lamps, a chariot wheel, spoons, weights, medical instruments, a bowl of carbonized cookies baked with a flower pattern. A similar list made of the Museum contents would seem endless.

The exact sources of many of these objects are unknown, as most were

found during the period of helter-skelter tunneling. It is a pity not to know precisely where a surveyor's triangle was uncovered, or medical instruments, or some of the beautiful intaglios with their delicately carved surfaces (one, for example, is an Egyptian scene in an area smaller than a fingernail). The same lack of information also applies to many objects in the Museum.

While it is true that small objects can be displayed effectively in museum cases, such items as furniture, frescoes, mosaics, and statuary labor under peculiar difficulties. They were designed usually as adjuncts to architecture, and that architecture was not the rooms of a museum. Aside from the fact that objects of art in a museum usually compete with one another in a way not intended by the artists, they tend to lose something of their unique quality. The cold light from skylights or windows illuminating enormous dead-white chambers was not intended for a marble Aphrodite. And when two statues of Aphrodite are set side by side, the comparison is interesting, but the possibility of capturing the religious significance of the goddess is lessened. Under such circumstances an extraordinary effort of the imagination is required to visualize the goddess in her original soft and glowing colors, set against a temple background of brilliant reds, blues, and golds. The whole effect was intended to be prismatic, like sunlight. What we behold today is only a pale gray shadow (often dirty, at that) lost in sepulchral museum halls.

The bronzes fare better; but without some semblance of their original setting, their significance is muted. As for the mosaic floors, which have been carried away and reset in museums, visitors walk over them with hardly a glance. A floor that may have been beautiful in an atrium or a dining room, harmonizing with the frescoes and the statuary, loses its individuality of setting when transplanted. And so the mosaicist's artistry is no longer fully appreciated. The same point is valid for frescoes, which were created for particular rooms and not meant to be lined up beside one another on badly lighted walls. It is actually difficult to see the greatest of all collections of paintings from antiquity.

The method of display in the National Archaeological Museum in Naples seems to have been inherited from the days of the Bourbon collection in the Royal Palace at Portici. It has been conditioned by a physical plant that has undergone numerous remodelings in the transition from hippodrome to museum. And above all, the Museum has been hampered by a chronic insufficiency of funds. Even adequate lavatories for visitors are lacking. While the scholarship of the Museum's directors and staff has been brilliant, collections have been closed because no custodians are available to guard them, no personnel available to clean them, no electricity available to illuminate them. Descriptive labels, if attached, are only in one language—Italian. (Because multilingual labels are greatly in the interest of tourism, it seems shortsighted that the Naples tourist office has not provided funds for this essential project.) Vital background information is rarely given. The reason: lack of staff. It is literally physically impossible for a small group of scholars and specialists—some only part time—to take care of the meticulous and exhausting routine required for maintenance of a huge museum. All this, incidentally, in a city noted for both the quick intelligence of its people and its masses of unemployed.

The chronic lack of funds also affects the Museum in ways not readily apparent to the casual visitor. For instance, all the objects found at Herculaneum and Pompeii have not yet been photographed. Nor has a duplicate set of negatives of the existing photographs (which at Herculaneum began in 1869) been filed in a fireproof and earthquake-proof vault in some other city. Many private photographs of Herculaneum and Pompeii have been made; but if a severe earthquake and fire should sweep Naples without warning, all the official photographs, with their step-by-step recording of the excavations, might be lost. Worse still, such a disaster might also destroy or seriously damage many of the Museum's Pompeiian and Herculanean masterpieces; and under such circumstances the photographic records would be priceless. The Museum has stone walls of massive thickness; but they are far from earthquake-proof, as recent cracks, probably induced by traffic vibrations, have proved. Nor is Vesuvius dead.

In the Museum—aside from inadequacies in display—the visitor primarily interested in Herculaneum and Pompeii suffers additional frustration. All the material is scattered throughout the Museum, mixed with other pieces from other sources. Although organization of displays according to period or style is logical for most museums, and satisfactory to specialists, in the Naples Museum the unduplicable Herculaneum–Pompeii collection loses impact by losing its identity. (The Herculaneum–Pompeii collection properly includes finds from the minor excavations at Boscoreale and Stabia, for all were victims of Vesuvius.)

The mixed method of presentation is a long-established procedure, and most curators see no reason to change it. But from the point of view of the spectator who comes to the Museum seeking general information or a general impression—and such visitors are in the thousands—the "Victims of Vesuvius" story could be told with much greater effectiveness if exhibited as a unit.

Two versions of the goddess of love, Aphrodite, are both copies of the same Greek original dating from the 5th century B.C. Aphrodite, or Venus, often shown nude, was also greatly favored in thin, revealing draperies. The statue at the right was found at Pompeii; the left, at Herculaneum. The goddess in Herculaneum, dropping her garment below her left breast, had become a little more voluptuous.

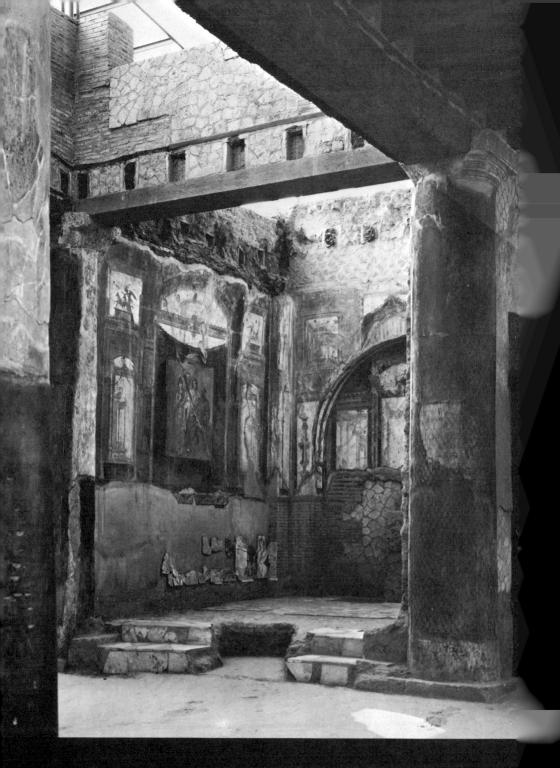

Shrine of the Augustales, the officials responsible for the cult of deified emperors. The building, among the newest excavations, is well preserved. A statue, removed by the 18th century tunnelers, stood in the shrine. The wall painting is Hercules with Juno and Minerv. The skeleton of a man lies face down on a bed in a small barred room to the right. To a certain extent this grouping has been achieved naturally—in the technological and fresco sections, for example. So little material from other sources exists in these categories that Herculaneum and Pompeii inevitably dominate.

On the other hand, the scattering of statuary becomes exceptionally confusing. Logically, if the great Herculaneum–Pompeii finds should not be dispersed throughout Europe—and surely they should not—neither should they be dispersed throughout a single museum. The more erotic items remain segregated in the "secret museum," unavailable to the public but not denied to specialists or scholars. Many of these objects, such as lamps, fountain pieces, and bellpulls, were part of ordinary daily life in antiquity, and can hardly be termed obscene in Roman eyes. Perhaps current attitudes should be re-examined—could the obscenity lie in us?

If the statuary, frescoes, mosaics, marble pavements, furniture, and personal objects must be taken from an ancient room to a modern museum, then why not transport the room itself, keeping together everything as it was found? Or, for that matter, the whole house. Such a display would be infinitely more meaningful to beholders and might indeed enhance the fame of the museum. To transfer selected rooms or small houses has proved entirely practical in other museums—given the funds and necessary staff.

Of course the better solution is to accomplish the stated ideal of the modern excavators: to leave every object, insofar as possible, where it belongs. In this procedure the excavated site itself becomes the museum, a living testimony to a dead past. The beholder not only receives a more meaningful vision of antiquity, but appreciates much better the archaeologist's difficulties. Such verisimilitude grasps the viewer's imagination far beyond the possibility of formal museum halls. By entering an intact Herculaneum house, with its furnishings and decorations, the visitor literally walks two thousand years into the past. Only the dullest of spirits can fail to be deeply moved, for that past is our own. We can identify and understand.

All this is easy to say but difficult to accomplish. Even Amedeo Maiuri, with all his experience and passion for reconstruction, was able to achieve only limited objectives. At his recent death, Pompeii was falling to pieces—a heap of rubble, like a bombed-out city, overgrown with weeds and vines. At great effort, certain portions were being preserved; but Maiuri's fight was a losing battle. To a lesser extent Herculaneum was faced by the same problems; but, as it was smaller, it was more controllable. Even so, weeds grow in its gardens, and frescoes and irreplaceable wood go inadequately protected. The basic difficulty, of course, is lack of funds. Such archaeological sites as Herculaneum and Pompeii, so full of rare and valuable articles, must be constantly guarded—especially if the finds are to be left in position. At Pompeii, even with the help of dogs at night, the guard detail is so small that items constantly disappear. And at Herculaneum, recently it has been necessary to remove objects as large as marble bas-reliefs from houses to the Antiquarium. There they may languish, but they are safe. The situation is the same: lack of funds.

It is true that in archaeological sites Italy suffers an embarrassment of riches. To appropriate adequate funds for all the sites that should or could be investigated, plus adequate upkeep for all the hundreds of museums and libraries, would be an enormous drain on the national budget of a country harassed by such immediate and costly needs as adequate schools, hospitals, housing. Such an admission does not, however, countenance the existence of a ravenous bureaucracy or the maladministration or misappropriation of national funds. The Herculaneum problem, viewed in the light of the real situation, becomes in essence: How can any progress be made—even the slightest?

Today, excavation has stopped. The Italian Government, since World War II, no longer approves funds for regular exploration at Herculaneum. An appropriation is provided for limited maintenance, such as repairs when roofs collapse, or reconstruction of the colonnade of the "House of Argus" (Casa d'Argo —one of the houses uncovered, and largely ruined, in the first open excavations). Obviously, houses as old as these require more than normal maintenance. Even upkeep of the electric system in the Theater tunnels has proved too costly, and the public—except with special permission—is now denied the extraordinary experience of groping about an ancient stage, far underground. Frescoes fade from lack of simple protection from the weather. The tesserae of mosaics break loose and are not replaced. Unsheltered and untreated, two-thousand-year-old wood steadily rots away. The archaeologists and the maintenance specialists bewail the situation, but can do little except shake their heads and hope.

Of late years, so erratic has been the progress of excavations that it has not been possible to recruit, and maintain over any extended period of time, a corps of skilled and responsible diggers. Instead, of necessity, private excavating firms have been called in on short-term contracts—and both their methods and personnel are subject to improvement. Far more serious is the declining graph of trained personnel available on the professional level. At the very moment of enormously increased worldwide public interest in archaeology and especially in Italian archaeology—the responsible government ministry

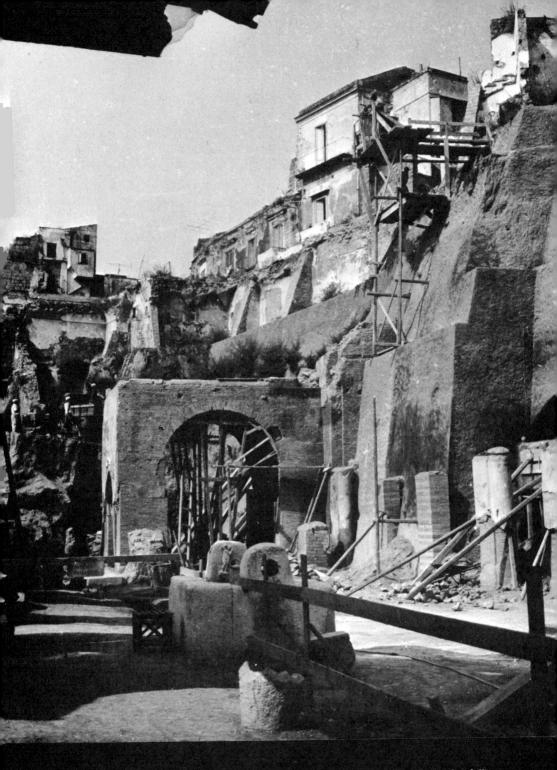

The Forum itself slowly begins to emerge from the centuries-old darkness. Here the difficulties of the excavation are clearly evident: the depth and solidity of the hardened volcanic mud, and the slums of modern Resina, which sprawl over a considerable portion of elegant has neglected to attract those additional scholars and supervisors who eventually will be needed to meet the new demand. Neither administrative practices nor specialists' salaries have kept up with the needs of the times. Scholars with graduate degrees find themselves supervising workmen's time sheets; and their salaries are quite low. Such a situation does not reflect a thoughtful, longterm "creating for the future" attitude on the part of the authorities, though Italy traditionally has been a country where the future is credited to the present.

Recently, both the Pompeiian and Herculanean digs have been able to derive some advantage from the government's special fund for the development of southern Italy (the Cassa per il Mezzogiorno). The new general director of the buried towns, the archaeologist Dr. Alfonso de Franciscis, whose title is Superintendent of Antiquities for Campania and whose jurisdiction includes museums as well as excavations, has undertaken the necessary steps for Herculaneum. With grants from the special fund, and in cooperation with appropriate government agencies, it is hoped—within five years—to demolish a few of the slum houses of Resina, resettle the occupants, and gradually continue the excavations in the direction of the Forum. Later, it is hoped to clear part of the marina in the vicinity of the Suburban Baths. More modest objectives could hardly be stated for a project of such fundamental importance.

The revelation of Pompeii is largely completed—certainly the most productive areas—but the revelation of Herculaneum is, in fact, just begun. Hence its significance. Of the eight blocks shown on the incomplete town plan made in the eighteenth century, only four have been completely uncovered. How many more are there? Of the important public structures only the Forum Baths are visible in their entirety; some rooms of the Suburban Baths are not yet cleared. And as for the suburban villas, others like the Villa of the Papyri unquestionably exist. Of the whole face of Herculaneum, we have seen thus far only the chin.

In future excavations will a small covered theater for poetry readings and other intimate presentations (like the Odeon in Pompeii) come to light? Did an amphitheater exist, for beast-baitings and gladiatorial combats, as might be inferred from some of the graffiti and also from the fact that gladiators' helmets have been found in Herculaneum? What of the covered market, which probably included the fish market and the meat market? What of the public docks? The semipublic brothels? The necropolis? And the temples, which surely could have been no less impressive than the Palaestra and the Theater? What of future paintings, statuary, and—perhaps most precious of all—the libraries . . . ?

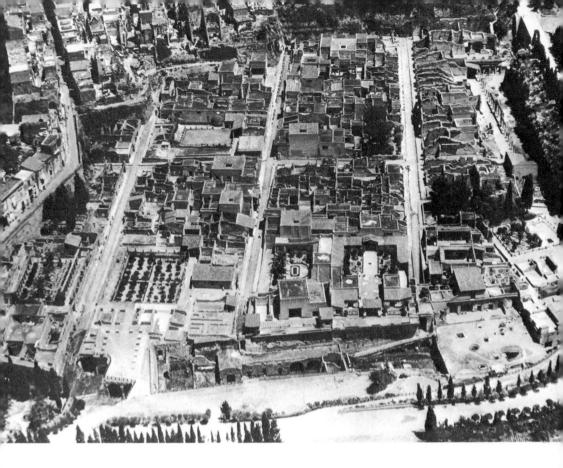

Air view of the excavated portion of Herculaneum, looking inward from the sea side. Slum dwellings of the modern town of Resina are visible in the upper left background. The road to the right is the present entrance, averaging some 50 feet higher than the level of the ancient town.

If the Italian Government is unable or unwilling to appropriate sufficient funds to continue the task, perhaps it would be possible to find supplementary funds abroad. Philanthropy, on the scale of the Rockefeller restoration of colonial Williamsburg in Virginia, might be interested. Or an agency of the United Nations, such as UNESCO, might undertake an international drive to make Herculaneum—under Italian leadership and direction—the showplace of antiquity.

In 1904 the English archaeologist Sir Charles Walston (Charles Waldstein) launched a fervent effort to renew the excavation of Herculaneum on the basis of "international cooperation under the predominant guidance of Italy." He cited the relative scarcity of important archaeological sites in other countries of Europe and their almost total absence in the United States as reasons why international support should be forthcoming to archaeologically rich but financially poor Italy. He stressed the common inheritance of the Western nations from the Graeco–Roman culture, and their enormous cultural debt to Italy and its past. Today he could add the nations of the Orient and Africa, for much of their modern technology is derived from the scientific thinking that began with the Italian Renaissance of classical culture.

Walston's effort failed, thanks to the deadweight of bureaucracy, governmental inertia, and professional jealousies. When Walston died, without yet having witnessed a pick driven into Herculaneum's embalming mud lava, his ashes were placed in an urn from Herculaneum—a token of the Italian archaeologists' respect and gratitude.

Since Walston's time the world has had more practice in international cooperation. A United Nations does exist; some of its achievements in educational and cultural fields have been remarkable. And Herculaneum itself has experienced a taste of international cooperation. The Herculaneum Academy, in a privately donated villa not far from the excavation site, each summer draws together archaeological students from different countries. And each summer, too, students representing many nations volunteer their services at Herculaneum with pick and shovel. It is a stimulating sight—those boys and girls toiling steadily under the blistering Campanian sun, pitting their muscles against the looming mass of Vesuvius. They take seriously their responsibility to history.

"Herculaneum is the one site above all others which ought to be excavated," said Sir Charles Walston. Indeed he was right. So far as is known, nowhere else in the world is such a time capsule waiting to be opened. What could be a more powerful magnet to tourists? For Italy, the steady excavation of Herculaneum would be an investment in the national economy, an investment as sound as, and perhaps more rewarding than, a new steel mill. The ancient town's development, exploitation, and conservation should be planned and administered with equal care.

Antiquity is Italy's greatest natural resource, and Herculaneum is the richest of all finds. It seems incredible to discover a buried treasure and not dig it up.

Which CIL arethe graffiti of Herculaneumin?

BIBLIOGRAPHY

- APICIUS. Artis Magiricae, translation from the Latin as "The Roman Cookery Book" by Barbara Flower and Elisabeth Rosenbaum, Harrap, London, 1958.
- BECATTI, G. Pitture murali campane, Sansoni, Florence, 1955.
- BIEBER, MARGARETE. The History of the Greek and Roman Theater (revised edition), Oxford University Press, London, 1961.
- BOARDMAN, JOHN. The Greeks Overseas, a Pelican original, Penguin Books, London, 1964.
- BRION, MARCEL. Pompeii and Herculaneum: The Glory and the Grief, translation from the French by John Rosenberg, photographs by Edwin Smith, Elek Books, London, 1960.
- BROWN, FRANK E. Roman Architecture, Prentice-Hall International, 1962.

CARCOPINO, JEROME. Daily Life in Ancient Rome, edi by Henry T. Rowell, translation from the French by E. O. Lorimer, Yale University Press, New Haven, 1940; Penguin Books, London, 1962.

- CAROTENUTO, SILVESTRO. Herculaneum—storia della antica città di Ercolano e dei suoi scavi, Naples, 1932.
- CARRATELLI, G. P. *Processo di Giusta, "*La Parola del Passato"—Rivista di Studi Classici, fasc. VIII, 1948, Gaetano Macchiaroli Editore, Naples.
- CASSIUS, DIO. Roman History, lxvi., 20–24, translation from the Latin by Ernest Cary, Wm. Heinemann, London, 1927.
- CATALANO, VIRGILIO. Storia di Ercolano, Naples, 1953.

COCHIN, C. N. Observations sur les antiquités d'Herculaneum, Paris, 1755. English translation by Cochin and J. C. Bellicard, London, 1753.

- COMPARETTI, DOMENICO AND GIULIO DE PETRA. La villa ercolanese dei Pisoni, Turin, 1883.
- CORTI, E. C. The Death and Resurrection of Herculaneum and Pompeii, Routledge & Kegan Paul, London, 1951.

COWELL, F. R. Everyday Life in Ancient Rome, B. T. Batsford, London, 1961.

DE FRANCISCIS, ALFONSO. Guide to the National Archaeological Museum of Naples, translation from the Italian by A. Rigotti, Naples, 1965.

. Il Museo Nazionale di Napoli, Di Mauro Editore, Salerno, 1965.

Museo Nazionale di Napoli, in Italian, German, English, and French, Istituto Geografico di Agostini, Novara, 1965.

——___. Pompeii–Herculaneum—Guide with Reconstructions, translation by J. B. Ward Perkins, Vision Publications, Rome, 1964.

DELLA CORTE, MATTEO. *Le iscrizioni d'Ercolano, "*Rendiconti dell'Accademia Archeologia, Lettere e Belle Arti di Napoli," vol. XXXIII, 1958.

DI CAPUA, F. Il "Mysterium Crucis" di Ercolano, "Rendiconti dell'Accademia Archeologia, Lettere e Belle Arti di Napoli," vol. XXIII, 1947–48.

ELLABY, C. G. Pompeii and Herculaneum, Methuen & Co., London, 1930.

FRANK, TENNEY. Life and Literature in the Roman Republic, Cambridge University Press, London, 1930.

FRIEDLANDER, L. Town Life in Ancient Italy, translation from the German by Wm. E. Waters, Sanborn, Boston, 1902.

GABRIEL, MABLE M. Masters of Campanian Painting, Bittner, New York, 1952.

GUERRIERI, GUERRIERA. L'Officina dei Papiri Ercolanesi dal 1752 al 1952, "I Papiri Ercolanesi," I Quaderni della Biblioteca Nazionale di Napoli, series III, no. 5, Naples, 1954.

HAYTER, JOHN. A Report Upon the Herculaneum Manuscripts, London, 1811.

LIVY. A History of Rome, translation from the Latin by Moses Hadas and Joe P. Poe, The Modern Library, New York, 1962.

- MACKENDRICK, PAUL. The Mute Stones Speak—the Story of Archaeology in Italy, Methuen & Co., London, 1962.
- MAIURI, AMEDEO. Ercolano—I nuovi scavi (1927–1958), 2 vols., Istituto Poligrafico dello Stato, Rome, 1958.

. Ercolano, "Visioni Italiche," Istituto Geografico de Agostini, Novara, 1932.

——___. Herculaneum, a guide, translation from the Italian by V. Priestley, Istituto Poligrafico dello Stato, Rome, 1962.

BIBLIOGRAPHY

_____. *Roman Painting,* translation from the Italian by Stuart Gilbert, Skira, Geneva, 1953.

_____. Un decreto onorario di M. Nonio Balbo, Reale Accademia d'Italia, fasc. 12, series VII, vol. III, 1942.

MAIURI, BIANCA. The National Museum, Naples, translation from the Italian by Q.T.S., Milano, Istituto Geografico de Agostini, Novara, 1959.

MARTIALIS, MARCUS VALERIUS. Selected Epigrams, IV, xliv, translation from the Latin by Rolfe Humphries, Indiana University Press, Bloomington, 1963.

MUSTILLI, D. La villa pseudourbana ercolanese, "Rendiconti dell'Accademia di Archeologia, Lettere e Belle Arti di Napoli," vol. XXXI, 1956.

NAPOLI, MARIO. Napoli greco-romana, Fausto Fiorentino Editore, Naples, 1959. PETRONIUS. The Satyricon, translation from the Latin by William Arrowsmith, Elek Books, London, 1960.

PLINIUS, GAIUS. Letters, Book VI, 16 and 20, Macmillan, New York, 1915.

RAMSAY, G. G. The Histories of Tacitus, Murray, London, 1915.

RICHTER GISELA M. A. The Furniture of the Greeks, Etruscans, and Romans (new edition), The Phaidon Press, London, 1966.

RUESCH, A. Guida del Museo Nazionale di Napoli, Naples, 1911.

RUGGIERO, MICHELE. Storia degli scavi di Ercolano, Naples, 1885.

- SPINAZZOLA, V. Le arti decorative in Pompei e nel Museo Nazionale di Napoli, Naples, 1939.
- SUETONIUS. The Lives of the Twelve Caesars, The Modern Library, New York, 1031.

VITRUVIUS, POLLIO. *De Architectura*, translation from the Latin into Italian by Silvio Ferri, Fratelli Palombi Editori, Rome, 1960.

VULPES, B. Illustrazione de tutti gli strumenti chirugici scavati in Ercolano e in Pompei, Naples, 1847.

WALDSTEIN, CHARLES (SIR CHARLES WALSTON) AND LEONARD SHOOBRIDGE. Herculaneum: Past, Present and Future, Macmillan, London, 1908.

WINCKELMANN, JOHANN JOACHIM. Sendschreiben von den herculanischen Entdeckungen, 1762.

_____. Neue Nachrichten von de neuesten herculanischen Entdeckungen, 1764. Pub. in London, 1771, as Critical Account of the Situation and Destruction by the First Eruptions of Mount Vesuvius, of Herculaneum, Pompeii, and Stabiae...

Achilles, 42, 46, 139, 142 Africanus, Scipio, 49, 57 Alcmene, 7 Alcubierre, Rocco Gioacchino de, 22-24, 130, quoted 140 Amphitrite, 92-93, 107 Amphitryon, 7 amphorae, 85, 99, 105, 106 animal remains, 100, 104, 108 Antiquarium, 156 Antonia, 136 apartment house, 33, 94-95 Aphrodite, 7, 35, 36, 159 Apicius, Marcus Gavius, 106 apodyterium, 111 Apollinaris, 44 Apollo, 116, 119, 153 Apollonius of Athens, 49 Arcadia, 139, 142 archaeology, 29-30, 161 Artemis, 57 artisans, 3, 34, 62, 81, 108 Art of Cooking, The, 106 Art of Love, The, 112 Ass, The, 133 athletics, 2, 3, 111, 123, 127-128 Aton, 36 atrium, 31 Attis, 62 Augustales, shrine of the, see Collegium of the Augustales

Bacchus, 7, 135, 150 "backgammon" sets, 64, 97 bakeshops, 2, 98, 104 Balbus, Marcus Nonius, Proconsul, 44-45, 111, 118, 136-137, 143-144, 147, 152, 154 Balbus family, 143-152 passim Basilica, 2, 24, 36, 138-148 bas-reliefs, 34, 42, 46, 119, 121 baths, 1, 2, 9, 31, 36, 45, 110-112 bathtub, bronze, 43 bedding, 72, 91, 156 beds, 3, 72, 91-92, 96, 100, 106, 108, 155 Biblioteca Nazionale of Naples, 54 bowls, 40, 43, 64, 69, 90 "Boy Eros," 28, 43 "Boy Wrestlers," 51, 52-53 brazier, bronze, 49, 55 bricks, 115, 120 busts, 48-49, 52-53, 57, 85-88, 97, 108, 119, 137 cabinet work, 34, 62, 67 Caesar, Julius, 55, 56 Caesonius, Lucius Calpurnius Piso, see Piso Calatorius, Marcus, 136-137, 141 calidarium, 111 candelabra, 2, 41, 64, 92, 100, 108, 117, 156 cavea, 134

Centaur Chiron, 139, 142

Charles III of Bourbon, 22, 130, 137

Christians, see Christus, cult of Christine, Maria Amalia, 130 Christus, cult of, 36, 68, 69, 79

cereal shop, 105, 109

Cicero, 55-56, 90

Claudius, Emperor, 132

170

cleaning agents, 103-104 cloth, 3, 18, 102-103 clothing, 78, 102-103 cloth press, 3, 34, 103, 108-109 cloth shop, 101-102, 109 Collegium of the Augustales, 2-3, 35, 153-155,160 compluvium, 31 couches, 40, 74, 91, 96 crucifix, imprint of, 36, 65, 68, 69 cubicula, 33 cubicula diurna, 40 cupids, 27, 41, 43, 48, 119 cups, silver, 36, 87 Cybele, 35, 62

Daedalus and Pasiphae, 68 "Dancers of Herculaneum," 52 decumanus maximus, 149 deer, 52, 55, 92 d'Elbeuf, Prince, 22, 129-130 "Diana Bathing," 40 "Dido Abandoned," 83 Dio Cassius, 10 Diogenes, 99 Dionysius of Halicarnassus, quoted 5-7 Dionysus, 2, 7, 49, 85, 101, 104, 135, 153 "Discoveries at Herculaneum, The," 137 Doryphoros, 48-49 "Drunken Hercules," 32, 43 "Drunken Silenus," 52-53 Dumas, Alexandre, 27 duumvir, 130 dyes, 103, 144 dye works, 103

Epicurus, 54 Equestrian Order, 58, 135 Ercolano, 26 Eros, 28, 43 Eros, Marcus Helvius, 69, 79 Eunomus, C. Messenius, 36 excavations, 6, 19, 22-30 *passim*, 39, 57, 161-166

fauns, statuary, 48, 52-53 Felix, Sextus Patulcus, 2, 104 Ferdinand I of Bourbon, 130 Fiorelli, Giuseppe, 27 fishing gear, 3, 18, 34, 41, 102, 156 flasks, perfume, 41, 43, 64, 90, 156 food shops 99-101, 106, 109 foodstuffs, 2-3, 18, 41, 64, 69, 99, 104-106, 109, 156 Forum, 2, 36, 149, 153, 163 Forum Baths, 111-117, 164 Francis I of Bourbon, 26 Franciscis, Alfonso de, 164 frescoes, see paintings frigidarium, 111 Fuferus, Aulus, 106 gem-cutter, shop of, 3, 100, 106-108 gladiators, 41, 91 glassware, 4, 40, 43, 76, 78, 90-91, 97, 156 gods, household, 31, 35-36, 64, 67, 96 graffiti, 44, 61, 99, 112-114, 117, 118, 122, 150 Greek culture, influence of, 7-8 hardware, 19, 41, 62, 64, 69, 88, 156 Hera, 7 Herakles (see also Hercules), 5-7 Herculaneum (see also excavations) area of, 30 burial of, 10, 17-19 economic structure of, 8, 34, 58 historical background of, 5-8 population of, 30 rediscovery of, 22 social structure of, 58, 80-81, 95, 143 town plan of, 24, 30 Herculaneum Academy, 166 Hercules, 2, 5-7, 127 paintings of, 104-106, 139, 142, 154, 160 statuary of, 36, 43, 92, 150, 153 hermae, 48-49, 52, 85, 92, 119 "Hermes in Repose," 50, 52-53 houses, 31-34, 94-97 of the Alcove, 91 of the Bicentenary, 64-70, 78-79, 108 of the Black Salon, 64 of the Bronze Herma, 85-89 of the Carbonized Furniture, 74, 91 of the Gem, 43-44 of the Grand Portal, 84-85 of the Mosaic Atrium, xviii, 14, 16, 17, 39-41

houses (cont.) of the Mosaic of Neptune and Amphitrite, 92-93, 105, 109 of the Opus Craticium, 59, 60, 95-97 of the Painted Papyrus, 98 of the Relief of Telephus, 38, 44-46, 118, 148 of the Samnite, 58-61, 63, 84 of the Skeleton, 81-84 of the Stags, xviii, 25, 27, 28, 32, 35, 41-42 of the Tuscan Colonnade, 153 of the Wooden Partition, 59, 61-64, 91, 108 of the Wooden Shrine, 90-91 human remains casts of, 18 skeletons, 18-19, 44, 81, 100, 108, 113, 114, 155 Hygeia, 127

impluvia, 31, 39, 48, 60, 62, 68, 89, 99
inscriptions (see also graffiti), 19, 35, 46, 61-62, 97, 106, 108, 127, 148
dedicatory, shrine of the Augustales, 154
of lost statues, 137
to Marcus Nonius Balbus, 118, 143
Isis, cult of, 36

jewelry, 3, 19, 36, 43, 45, 64, 78, 82, 156 Juno, 154, 160 Jupiter, 36, 92 Justa, 71-79

lamps, 41, 69, 77, 101, 105, 156 lararium, 31, 64, 68 La Vega, Francesco, 24, 130 law courts (*see also* Basilica), 2, 74-76 Leone, Ambrogio, 21 library, 24, 53-54 Livia, Empress, 155 loom, 3, 100 Lorraine, Maurice de, *see* d'Elbeuf, Prince Lucian, 133 Lysippos, 53

main street, 149-153 Maiuri, Amedeo, 28, 30, 161, *quoted* 24, 52 manuscripts, 53-54 marina, 36, 117-118 Marine Gate, 39 *Mater Deum*, temple of, 35 Maximus, Lucius Mammius, 136-137, 154 medical instruments, 89, 156 merchants, 81, 94-109 *passim* Mercurius, 36, 52-53, 90, 106 Minerva, 154, 160 mirrors, 83, 156 mosaics, 39, 41-45, 48, 62, 68, 81, 84, 92 "Neptune and Amphitrite," 92-93, 107 Triton, 115, 117 Mount Vesuvius, 4, 7-20 *passim* museums, 156-161

Naples, *see* Neapolis National Archaeological Museum, 23, 24, 156-161 Neapolis, 1, 5, 7, 10, 19, 140 "Neptune and Amphitrite," 92-93, 107 Neptune and Salacia, painting of, 154 Numisius, 130 nuts, 3, 69, 90, 96, 97, 99, 101, 156 nymphaea, 84, 92

Oceanus, 43 opus craticium, 155 oratory, 65 Oscans, 5 oscilla, 38, 45, 97 Ovid, 112

Palaestra, 2, 3, 24, 36, 123-128 paintings: Achilles, 139 "Actor-King," 131 animal, 41, 75, 81 Apollo, 153 "architectural" style, 33, 90 athlete, 126, 127-128 Bacchus, 135, 150 Centaur Chiron, 139, 142 cupids, 27, 108 Daedulus and Pasiphae, 68 "Diana Bathing," 40 Dionysus, 85, 153 dressing scene, 78 facial characteristics of, 88-89 paintings (cont.) "fantastic-architecture" style, 33, 68, 91, 102, 120, 134, 154 fish, 81, 117 fruit, 81 "garden," 62, 84 gladiator, 41 Hercules, 104-106 Hercules and Telephus, 139, 142 Hercules with Juno and Minerva, 154, "impressionistic," style, 33, 85, 153 Neptune and Salacia, 154 Pan, 83, 91 polychrome, 33, 60 Priapic, 3, 96, 100 "Punishment of Dirce," 40 "Rape of Europa," 61 satyrs, 73, 85 scroll with poem, 98 sexuality in, 34 Silenus, 85 styles of, described, 33 "Theseus Triumphant over the Minotaur," 139-140 Venus and Mars, 68 Pan, 52, 55, 83, 91 pans, 2, 98, 104 "Pan with a She-Goat," 52, 55 papyri, 18, 49, 54 pergolas, 33 Petronius, guoted 80-81 phalli, 2-3, 26, 34, 49, 98-100, 104, 112, 150 Phanias of Lesbos, quoted 7 Phidias, 49 Philodemus, 54-56 Philostratus, 140 Piaggio, Antonio, 54 Piso, Lucius Calpurnius, 55, 56 Pliny the Elder, 11-13 Pliny the Younger, 10, quoted 11-17 plumbing, 44, 95, 114, 117, 153 Polyclitus, 48 Pompeii, 5, 7, 10, 17-19, 22-27 passim, 30, 34, 81 Poseidon, 92 pots, 35, 41, 69, 156 Praxiteles, 49 Priapus, 3, 34, 96, 100, 123, 156

Ptolemy, 52 Pulcher, Appius Claudius, 137 "Punishment of Dirce, The," 40 "Rape of Europa, The," 61 religion, 31, 35-36, 153-154 Resina, 20, 22, 25, 28, 139, 163-165 "Resting Hermes," 50, 52-53 Rufus, Lucius Aeneas Mammianus, 130 Sacred Area, xviii, 36, 117-118 Salacia, 92-93, 154 Samnites, 5 Sappho, 52 Satyricon, The, 80-81 satyrs, 32, 43, 48, 73 "Satyr with a Wineskin," 32, 43 seals, 69, 79, 91, 104, 106, 109, 156 Senatorial Orders, 58, 135 sexual attitudes, 34, 127 shops, 2, 3, 94, 96, 98-109, 150 shrines, 64, 67, 90, 97, 104, 108, 150 signinum floor, 60 Silenus, 52-53, 85 silverware, 19, 40, 69, 86, 87, 90, 156 skeletons animal, 100, 104, 108 human, 18-19, 44, 81, 100, 108, 113, 114, 155 slaves, 71-79, 135 "Sleeping Eros," 28 "Sleeping Faun, The," 50, 52 snack bars, 3, 96, 99-101, 108, 150 Spartacus, 9 statuary (see also busts), 18, 24, 53, 81, 127, 129-130, 136-137, 150 animal, 43, 48, 52, 55 Antonia, 136 Aphrodite, 35, 36, 159 Aton, 36 Balbus family, 137, 143-144, 146-147, 151-152 Calatorius, Marcus, 136-137, 141 chariot group, 140-143, 145 Claudius, 132 "Dancers of Herculaneum," 52 Dionysus, 2, 101 "Drunken Hercules," 32, 43 "Drunken Silenus," 52-53

statuary (cont.) Eros, 28, 43 fauns, 48, 50, 52-53 Hercules, 32, 36, 43, 92 "Hermes in Repose," 50, 52-53 Jupiter, 36, 92 Maximus, Lucius Mammius, 136-137 Mercurius, 36, 52-53, 90 nude, 104 "Pan with a She-Goat," 52, 55 satyrs, 48 "Satyr with a Wineskin," 32, 43 serpent, 3, 125, 128 "Sleeping Faun," 50, 52 Tiberius, 136 Venus, 61, 69 "Vestal, The," 136 wrestlers, 51, 52-53 Stendhal, quoted 140 Stephanus, Gaius Petronius, 70-79 stools, 87, 100 stoves, 33, 41, 98 Strabo, 9, quoted 5 strigilis, 111 Suburban Baths, 2, 36, 45, 111, 115, 117-122, 164 sudatorium, 120 sundials, 43, 49 tables, described, 40 marble, 3, 43, 62, 92, 108, 124, 127, 153 wood, 40, 74, 90, 91, 104, 155

tablets, wax, 18, 40, 49, 70, 91, 156

Telephus, 3, 42, 46, 139, 142

Temidis, Calatoria, 71-79

tablinum, 31

Telesforus, 75-79

tepidarium, 111 Terence, 137 terra calda, 99 tesserae, 3 Theater, 2, 22-23, 36, 129-137 Theophrastus, 7 thermopolium, 99-101 "Theseus Triumphant over the Minotaur," 139-140 Tiberius, Emperor, 136 tinker's shop, 101 Titus, Emperor, 19 tools, 40, 64, 102, 156 archaeological, 29 Treatise on Music, 54 triclinium, 31 Triton, 115, 117

utensils, 40, 64, 86, 90, 96, 101, 105

Venus, 7, 41, 61, 68, 69, 150, 159 Venuti, Don Marcello de, 130 "Vestal, The," 136 Vesuvius, *see* Mount Vesuvius Villa of the Papyri, 8, 24, 47-57 Vitalis, Petronia, 71-79 *vomitoria*, 136

Walston, Sir Charles, 165-166 water clocks, 43-44 water supply systems, 1-2, 31, 49, 95, 117, 120 Weber, Karl, 23-24, 47, 53, 130 Winckelmann, Johann Joachim, 136-137 wine, 3, 99, 106 wine shops, 99, 104-106, 109, 150 workshops, 94, 108-109, 150

174